EXTREME
ADVENTURE

EXTREME
ADVENTURE
A PHOTOGRAPHIC EXPLORATION
OF WILD EXPERIENCES

PETER GUTTMAN

SKYHORSE
PUBLISHING

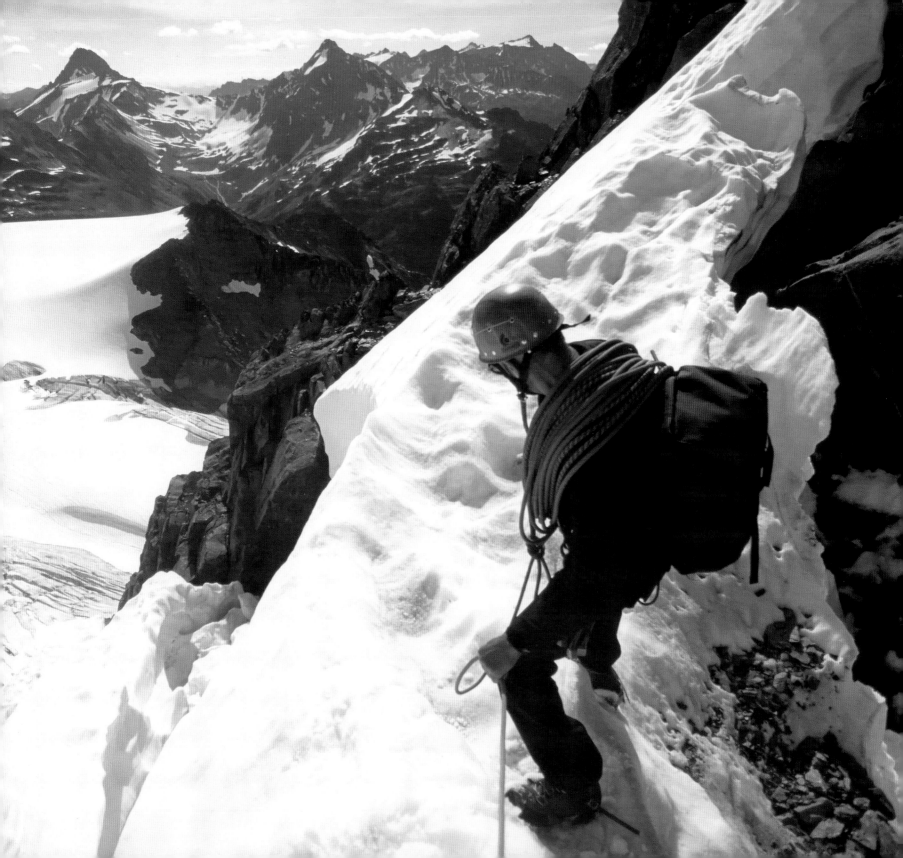

Skyhorse Publishing books may be purchased in bulk at special discounts for sales promotion, corporate gifts, fund-raising, or educational purposes. Special editions can also be created to specifications. For details, contact the Special Sales Department, Skyhorse Publishing, 307 West 36th Street, 11th Floor, New York, NY 10018 or info@skyhorsepublishing.com.

Skyhorse® and Skyhorse Publishing® are registered trademarks of Skyhorse Publishing, Inc.®, a Delaware corporation.

Visit our website at www.skyhorsepublishing.com.

10 9 8 7 6 5 4 3 2 1

Library of Congress Cataloging-in-Publication Data is available on file.

Cover and book design: Fabrizio La Rocca
Designer: Nick Grant
Flaps and back cover: Danielle Ceccolini

Print ISBN: 978-1-62914-759-8
Ebook ISBN: 978-1-62914-942-4

Printed in China

Passionately dedicated to Lori, a lifelong soulmate

who nurtured my wanderlust and helped kindle

a never-ending, fiery sense of adventure,

sprinkling it with a dash of mischief.

CONTENTS

INTRODUCTION

Extreme adventures awaken the spirit and spark imagination. They even seem to stretch our limited time on this amazing planet. To take advantage of the treasured but fleeting lifespan that we all inherit, I strive for more than a dress rehearsal because living like you really mean it is no easy feat.

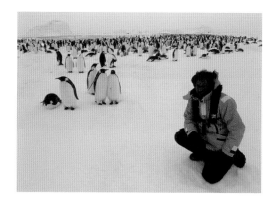

At some point, most of us get that fleeting epiphany where we realize the magnificent enormity of opportunities that exist in the world. Many might then get motivated to wait in line for sweepstake tickets, while others may diligently follow educational paths to pursue a profitable vocation. For me, it all started before kindergarten, when I was on my hands and knees studying a crinkled map of the world spread out across the living room floor. I vividly recall how enthralled I first felt staring at those multicolored jigsaw shapes that defined continents and their faraway cultures. Google did not exist then, but my hefty volumes of the World Book Encyclopedia provided a vibrant portal into the exotic lands I could only imagine.

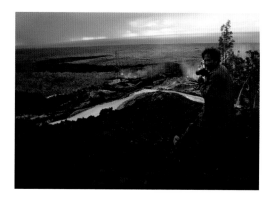

During my teens, I became inspired by the idea of crafting a life rather than making a living. Those guardrails lining my existential highway no longer reflected the urgency of conformity.

Somehow, even without a GPS, I found myself instinctively exiting onto winding lanes that led toward intense fascinations. In my early twenties, I jump-started my career as a lifelong adrenaline farmer by parachuting out of a single-engine plane to commemorate a college graduation day's shiny new geography degree. Since that time, after nurturing passions and sowing seeds of enthusiasm, I've shed more decades than I care to concede, and in the process cultivated fundamental truths about the value of memories and how our experiences can define and enlarge our existence. As a result, I admit to a stubborn insistence on staying away from the bumper-to-bumper monotony of humdrum existence that nowadays seems to proliferate faster than suburban sprawl.

In our current air-bagged society of risk aversion, it often seems easier and more appealing to channel a sense of exhilaration through our screens, vicariously YouTubing our way across invaluable, formative years. Today, devices yank our attention away from the fragrances, sounds, and textures of the gorgeous world around us. Surfing involves couch-bound tapping rather than an encounter with one of nature's great forces. Tweeting no longer signifies the music of the dawn's avian community, but is now relegated to the sound of one hand clapping for self-promotion. We seem to be sheltered by a numbing virtual reality where real living holds little virtue. I'm not certain how we became content to let our social circles be represented by the "likes" and upraised thumbs that were once used

to hitch rides to beckoning horizons and points unknown. Yet I do know that beyond our cyber-friends, it's never been more important for us to actively engage with our own primal selves through the exploits and vibrant sagas that true creativity can concoct.

During a lifetime of gathering high-voltage endeavors, I've answered the call of the wild by mushing husky teams through crystal forests, dodging molten lava flows that drooled from volcanic lips, playing a frightening game of hide-and-seek with violent farm belt tornadoes, and worming my muddy way through the quicksand of tortuous slot canyon crevices. Changing pace, I was soon rolling in creaky covered wagon convoys through a dusty prairie, iceboating at breakneck speeds down the frozen Hudson, traversing Grand Canyon's hellish maelstroms in a wooden dory, and land yachting over a scorching Mojave. Across the oceans, I've forged my way into impenetrable jungle while gorilla tracking in Uganda, trudged through subzero Fahrenheit blizzards in Antarctica to raucous penguin colonies, made my way to mud-baked Timbuktu along the untamed Niger River, and summited the glacial rooftop of a continent. When exhausted, I've rested my weary head on stilted swamp platforms just above snapping alligators, snored in arctic, breath-frosting ice hotels, dozed in sand-blown Bedouin tents nestled amongst Saharan dunes, and even caught some winks, with one eye open, in headhunter longhouses deep in Borneo's steaming rainforest.

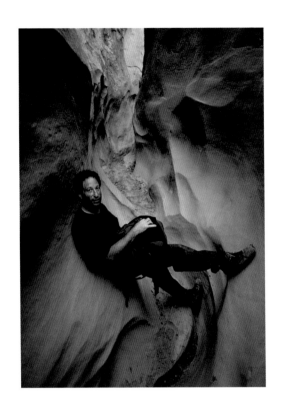

When we push the envelope with our exploits, new terrains of awareness can be conquered. As time relentlessly marches on, consider removing a hibernating dose of courage from the recesses of your psyche's safety deposit box before the locks rust or the key is lost. Let go of life's handrails, confront your fears, and, in doing so, you just might ensure that your soul won't grow gray before your hair does.

This colorfully illustrated treasury of out-of-the-box adventures gathers a trove of wide-eyed wonders that burst at the seams with the promise of hyper-caffeinated thrills, both in distant hemispheres and lurking just around the corner. Whether for an armchair wannabe traveler or an itching explorer whose packed bags are waiting by the door, these real-life dreams aim to fuel a sense of fantasy, ignite some wanderlust, and fire up a serious thirst, at least occasionally, for taking life to the extreme.

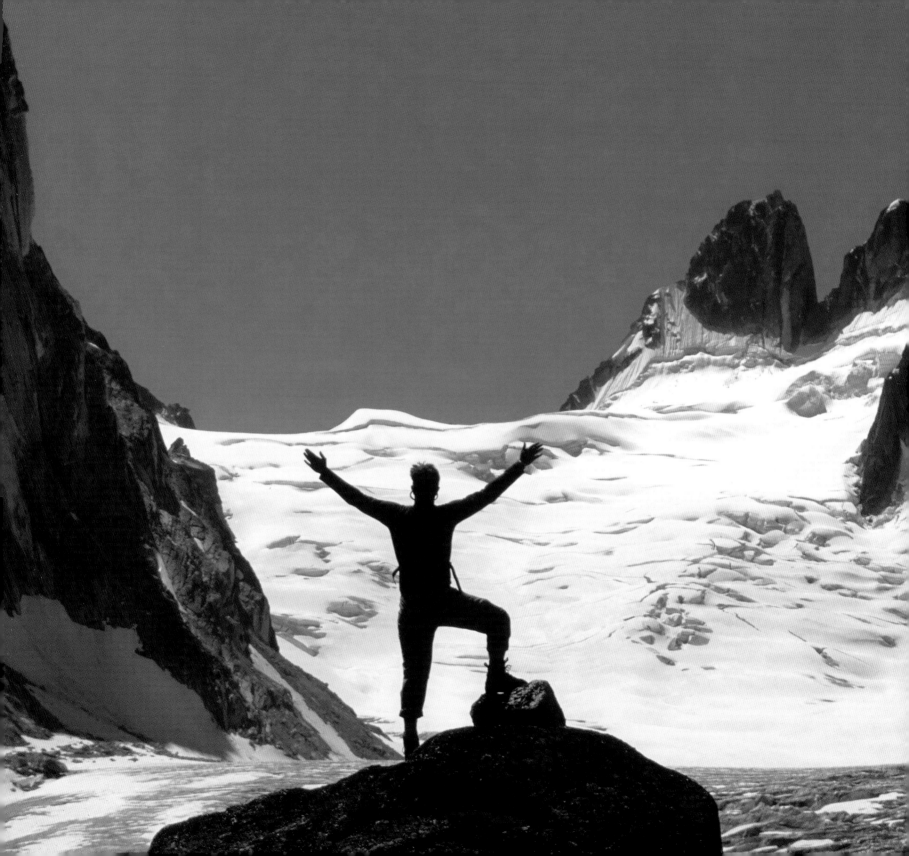

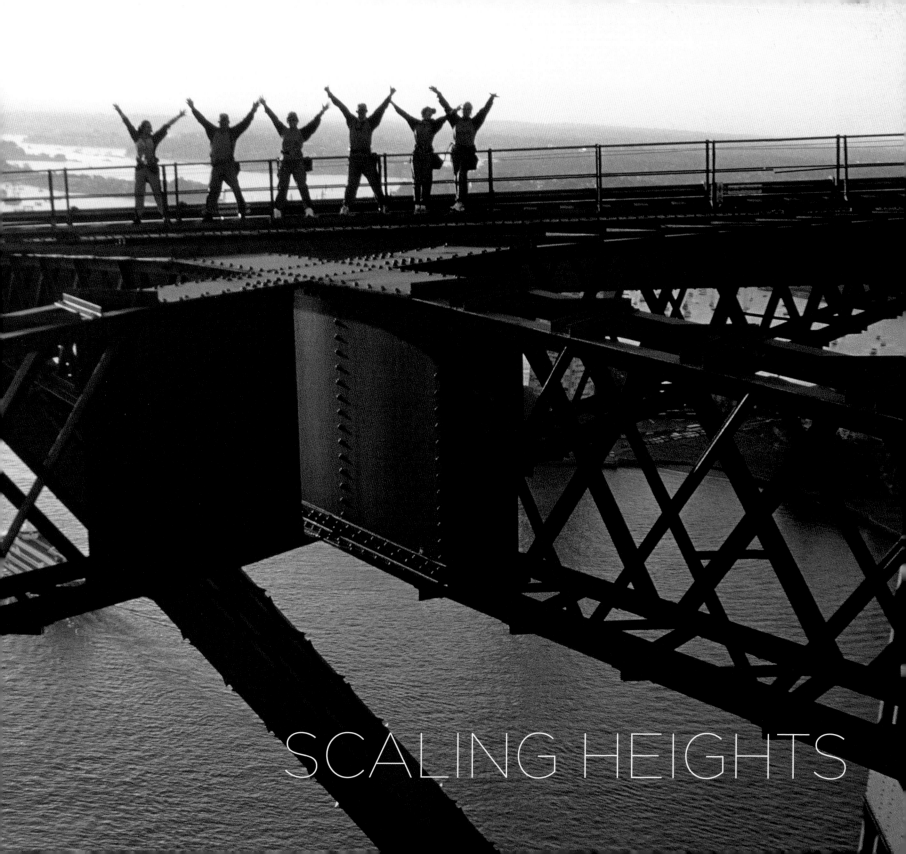

SCALING HEIGHTS

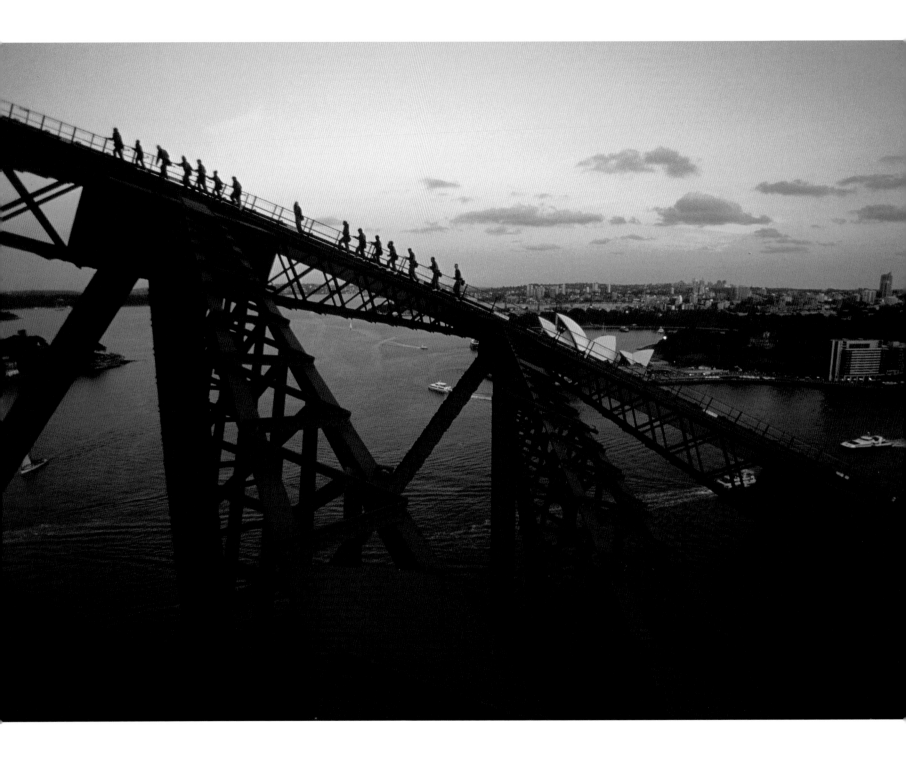

SCALING THE SYDNEY HARBOR BRIDGE

Urban explorers yearning for the privilege of climbing the tallest steel arch bridge in the world must first submit to a breathalyzer test to ensure an alcohol-free blood system. After, don essential snag-free jumpsuits, as it's mandatory to leave absolutely everything behind in the supplied lockers, especially your fear of heights. During the 1930s creation of this landmark span, sixteen men perished. Now, after ascending the iconic granite pylon, you duck beneath immense beams, leashed by a cabled lifeline to your harnessed clothing, and crawl through a narrow series of catwalks. Treading over meshed gratings, you stare directly down onto the northbound rush hour traffic, looking much like toy vehicles. Continue the 1,332-step ascension through this cathedral of steel and tackle four sets of towering ladders. The trek surveys eastern horizons, where famed Sydney Opera House, global symbol of a continent, mimics the shape of ships at full sail. Approaching the metallic summit of this erector set construction, 440 feet above the harbor, exhilaration sweeps over you as Pacific-bound seagulls soar below.

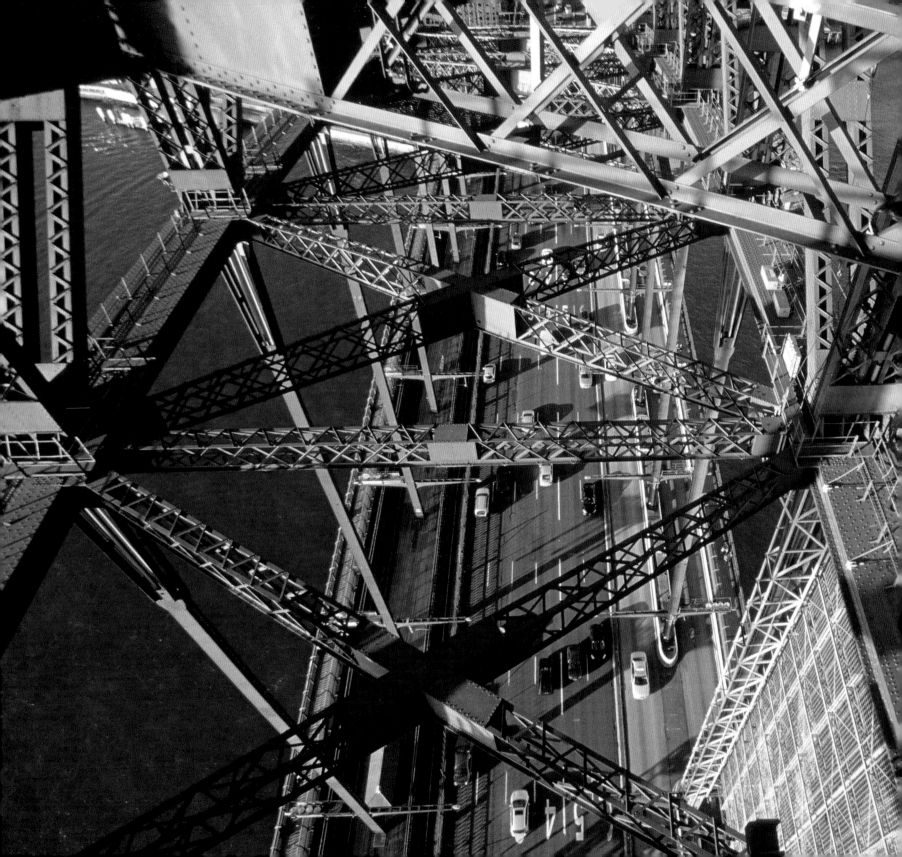

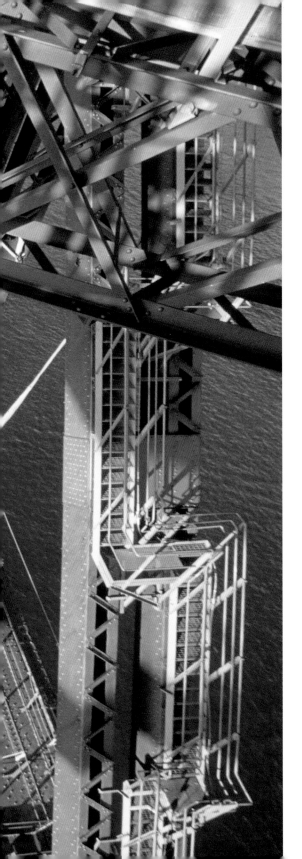
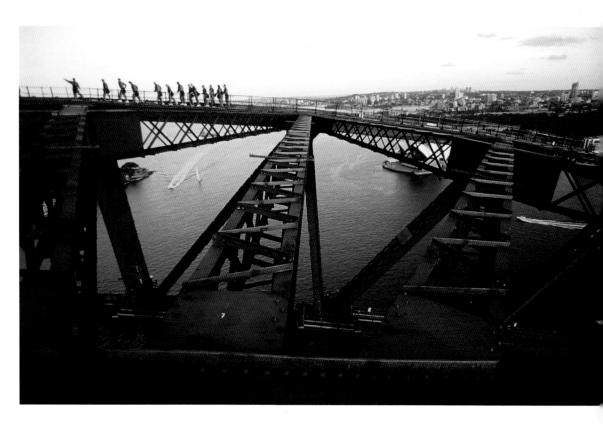

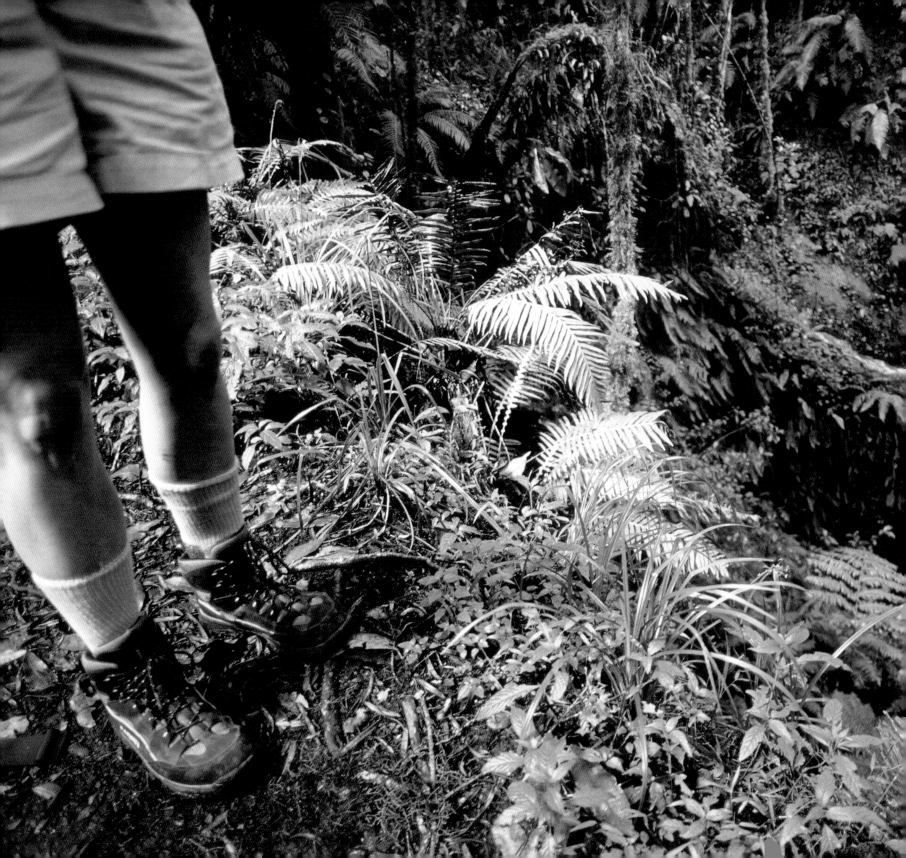

SUMMITING THE ROOFTOP OF AFRICA

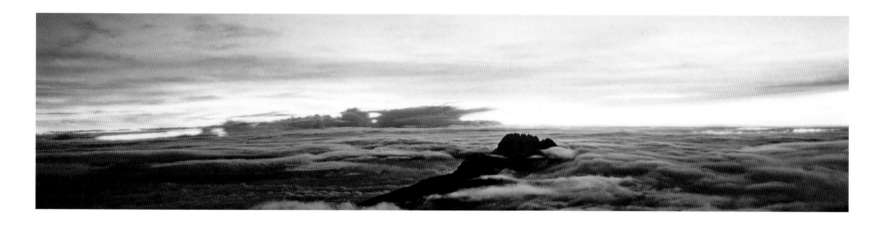

At dawn, a pink apparition looms over the plains of Serengeti. Mount Kilimanjaro is the world's tallest freestanding mountain. From the frozen ridge of its snowy skyline, you can see a new tomorrow. Yet scaling the African rooftop requires an arduous weeklong climb through six distinct climate zones. Begin your trek through steamy, waterfall-splashed jungle, where unabashed blue monkeys munch on tropical fruit beneath flitting Malachite Sunbirds. As you ascend into fragrant, fog-kissed heather, backpacks are swiftly lightened by successive additions of stored clothing layers. An olive-tan patchwork of cultivated fields spanning the Kenyan-Tanzanian border miles below finally recedes from view. After reaching eleven thousand feet, your single-file procession weaves past Zebra Rock and through haunting moorland, speckled by endemic Senecio towers that would seem more at home populating the pages of a Dr. Seuss tale. In this challenging dreamscape, their thickly stemmed, water-hoarding reservoirs hoist nocturnally shuttered, frost-protecting leaves.

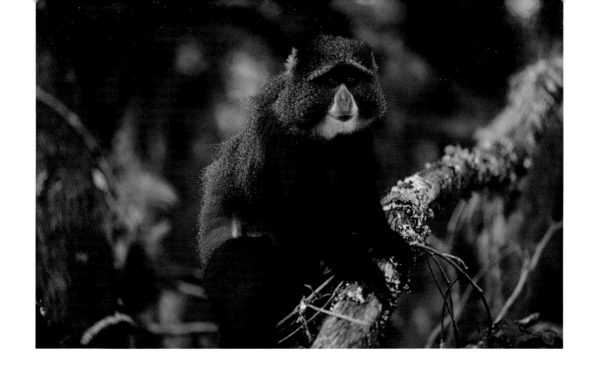

As you enter alpine desert, the endeavor quickly turns real as the frightened occupants of wheelbarrow-like stretchers race past, speeding downhill toward more pulmonary-friendly terrain and a possible prevention of fatal edema. At fifteen thousand feet, dehydration and nausea accompany you to your sleet-brushed shelter's bunk for a brief rest before the summit attempt. An assault on the monadnock's looming rampart begins in the dead of night after a light, head-throbbing three-hour nap, this evening's high-altitude stand-in for sleep. In the dark, frigid moonscape, a daunting staircase of loose scree is frozen into temporary position as its string of distant, bobbing headlamps hold the seemingly impossible promise of the heights ahead.

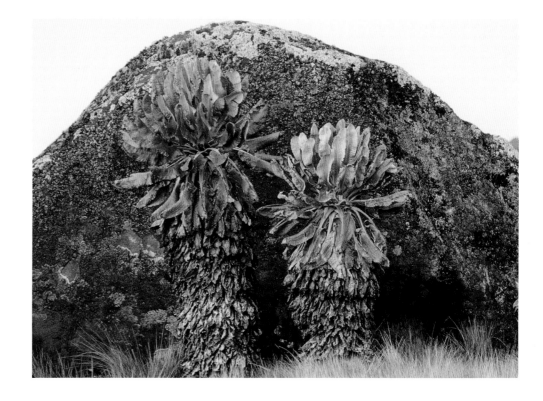

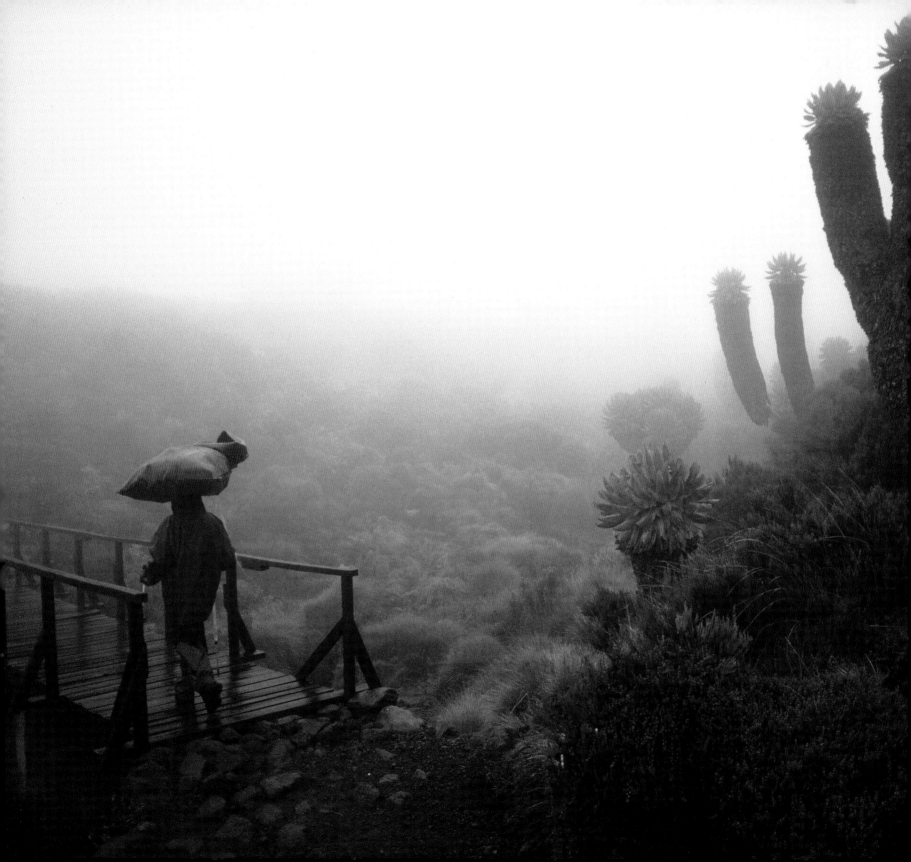

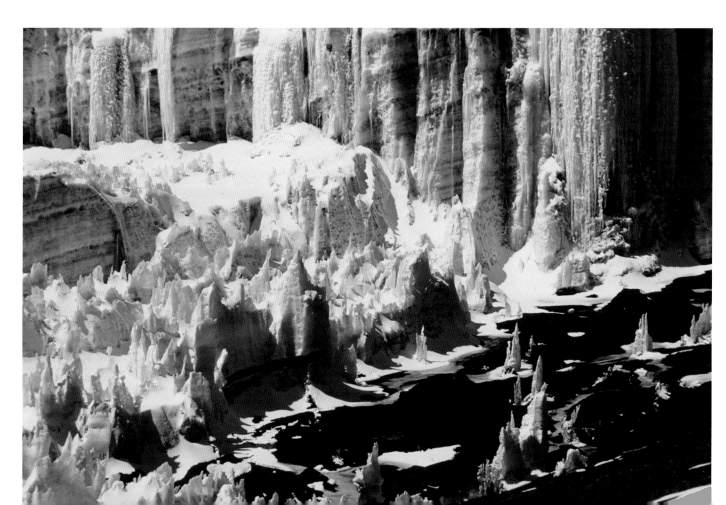

As sunrise approaches, every agonizingly slow, cement-weighted boot step ascends switchbacks up the soaring volcanic walls. With each movement, you can virtually feel your lungs' cluster of alveolar sacs screaming for still more oxygen from an ever-thinning atmosphere. Triumphantly nearing twenty thousand feet, the rim emerges for the final huffing push through a monochromatically surreal equatorial glacier. Splinters of icy stalagmites guard the edges of a rapidly shrinking icecap, the crown of a continent, and a crowning achievement for determined hikers pushing at the unknown perimeters of their own physical limits.

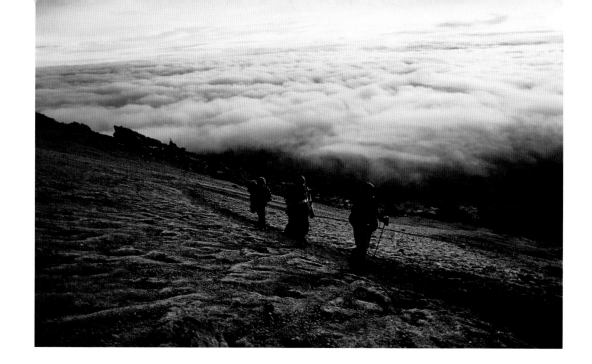

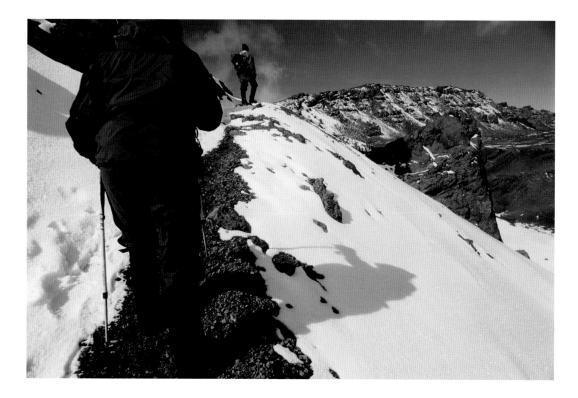

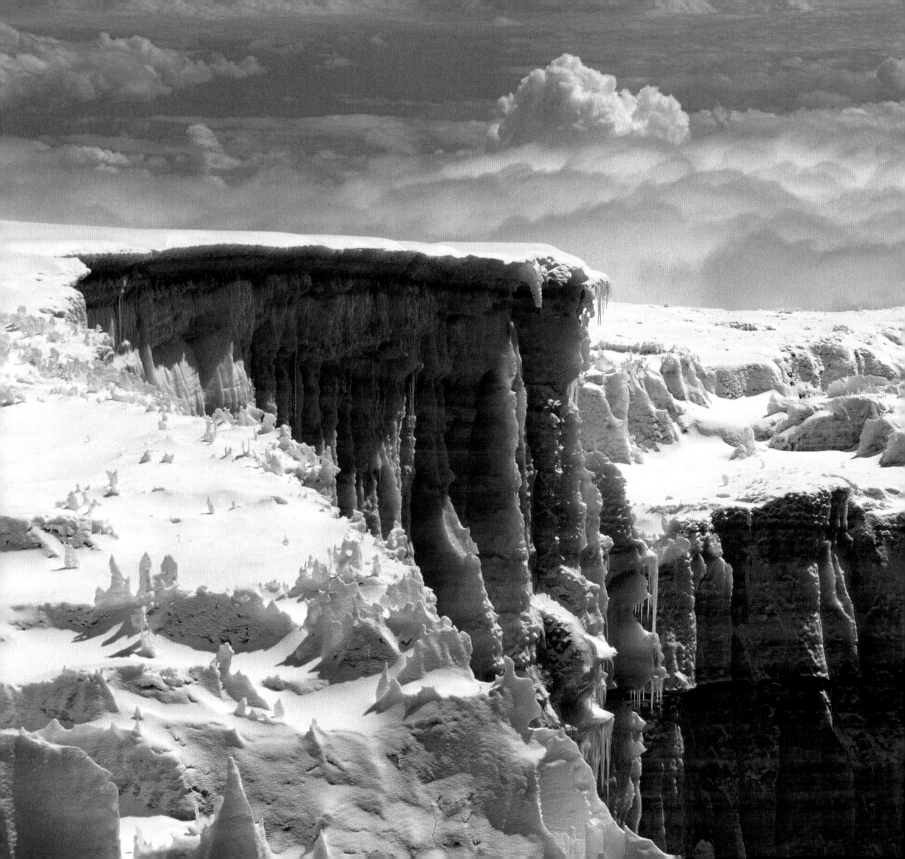

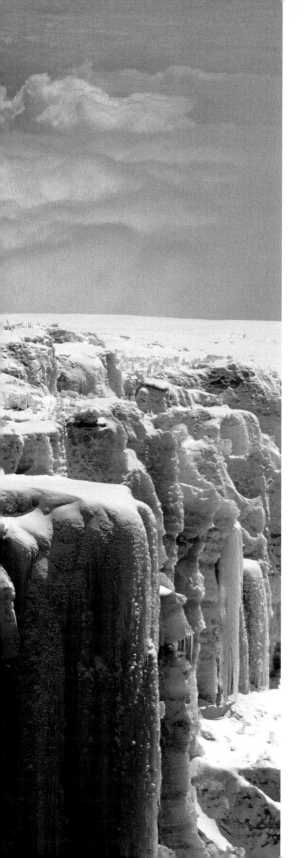

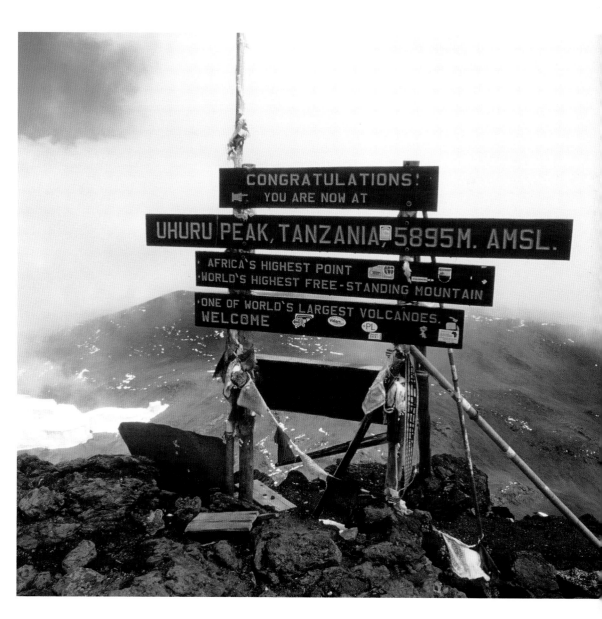

HANG GLIDING ATOP THE APPALACHIANS

A running jump-start to escape gravity's imprisonment culminates in a dramatic leap of faith. As your feet leave the ground, your body is encased by a pod harness that's suspended by an aluminum airframe. With hands on the base tube, shifting your weight from the hips helps you pivot from the wing's center of gravity, altering both direction and subtle contours in the airfoil's delta design. Cautious beginners will often find, as did the Wright Brothers when they undertook their initial short stabs at flight, that the softer sand dunes of Kitty Hawk provide a more reassuring margin of safety upon reconnecting with the land below them. However, after learning to interpret winds, extend glide ratio, and seek out thermal updrafts and those mountain-created lee waves, determined pilots are ensured a more stable skyward trail than Icarus ever experienced. Hurling themselves off the precipice at Pennsylvania's Hyner View, they'll join hawks reigning supreme above Appalachian ranges, where a meandering Susquehanna River way beneath helps point the direction toward an eventual landing zone.

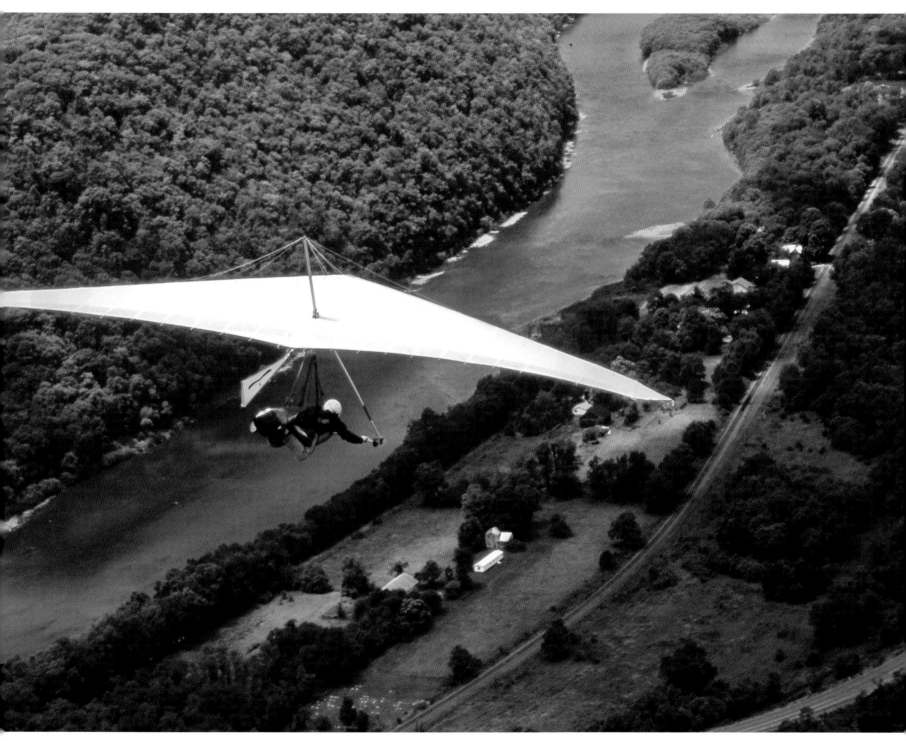

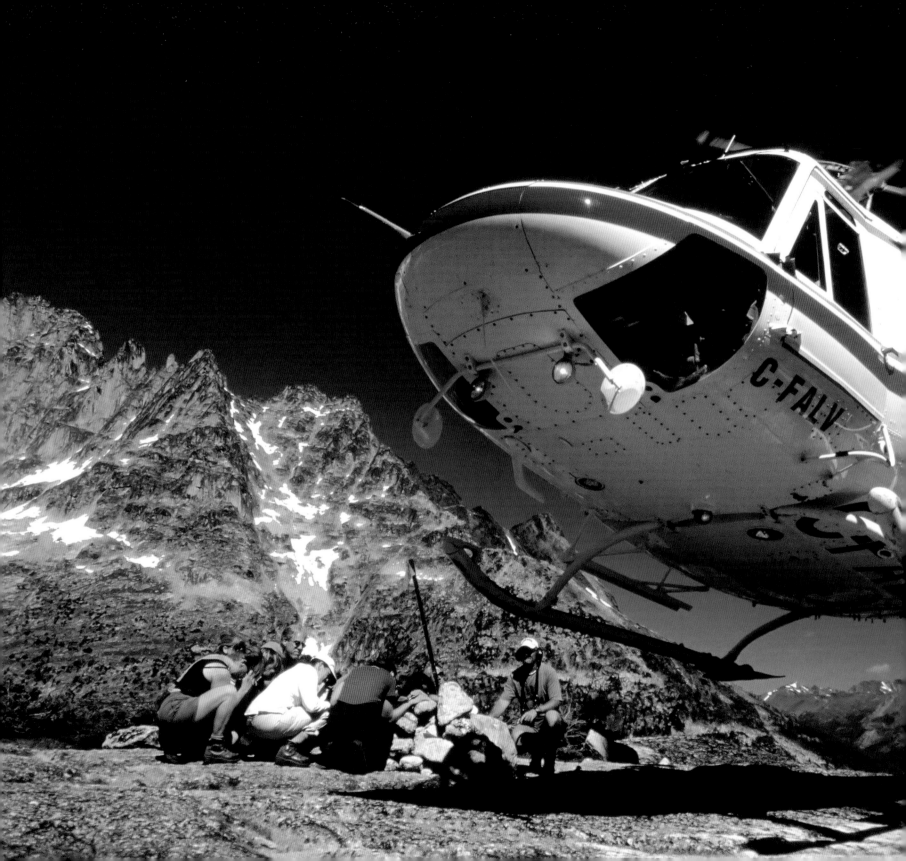

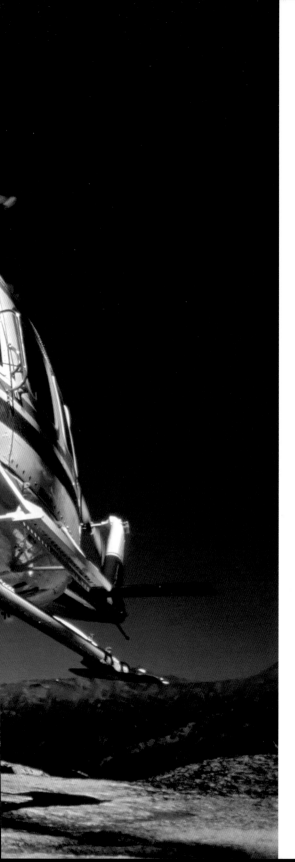

HELI-HIKING THROUGH THE PURCELL RANGE

The tympanic crescendo of distant avalanches echoes across the granite walls of the Canadian Rockies. Plunked by helicopter near a nine-thousand-foot summit, you bushwhack down a steep slope to Anemone Lakes, passing moose-trimmed greenery and waves of orange Indian paintbrush. Milky, silt-laden streams leak into sun-dappled glacial tarns, as marmots scurry through deposits of tinkling scree. As crushed slate slides beneath your feet, try avoiding holes engineered by grizzly bears sniffing for a pika meal. With whirring blades dancing peak to peak, your aerial limousine drops you off onto Conrad Glacier, where care is taken to sidestep pools sculpted by spinning rocks and treacherous fissures that slice 150 feet into the icy bowels. High above, the jet-powered whirlybird buzzes across the moraine and, with Swiss efficiency, returns for weary human cargo. The intense suction of swirling rotors seems to vacuum the wet paint from your legs. Hunkering down in a tight heli-huddle, the entire group crouches into an earthbound anchor. Returning to the roadless lodge, you prepare for another exhilarating day of cheating gravity.

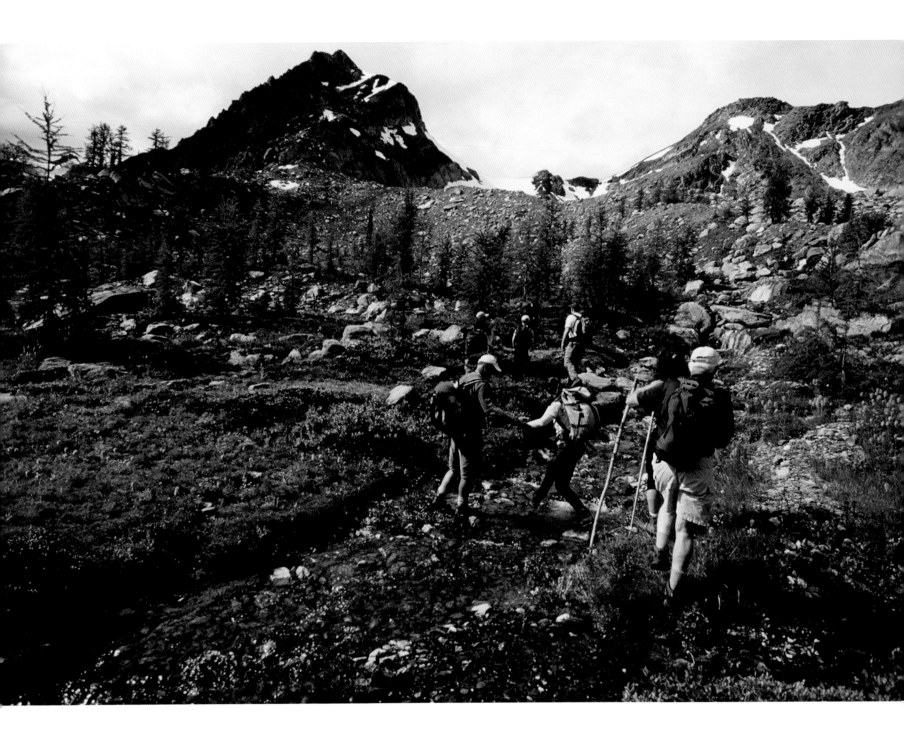

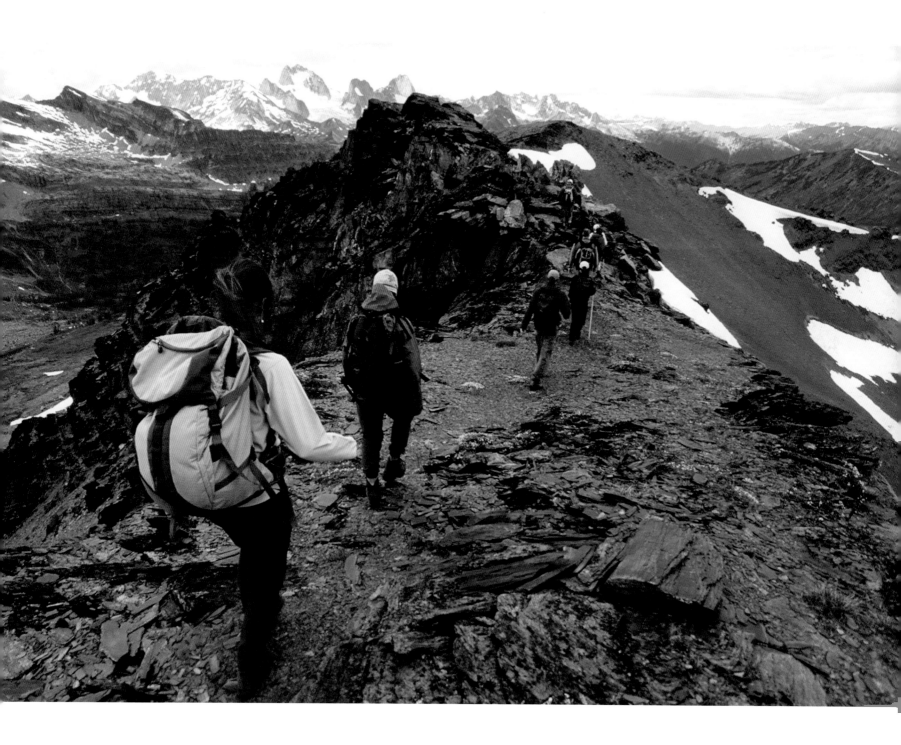

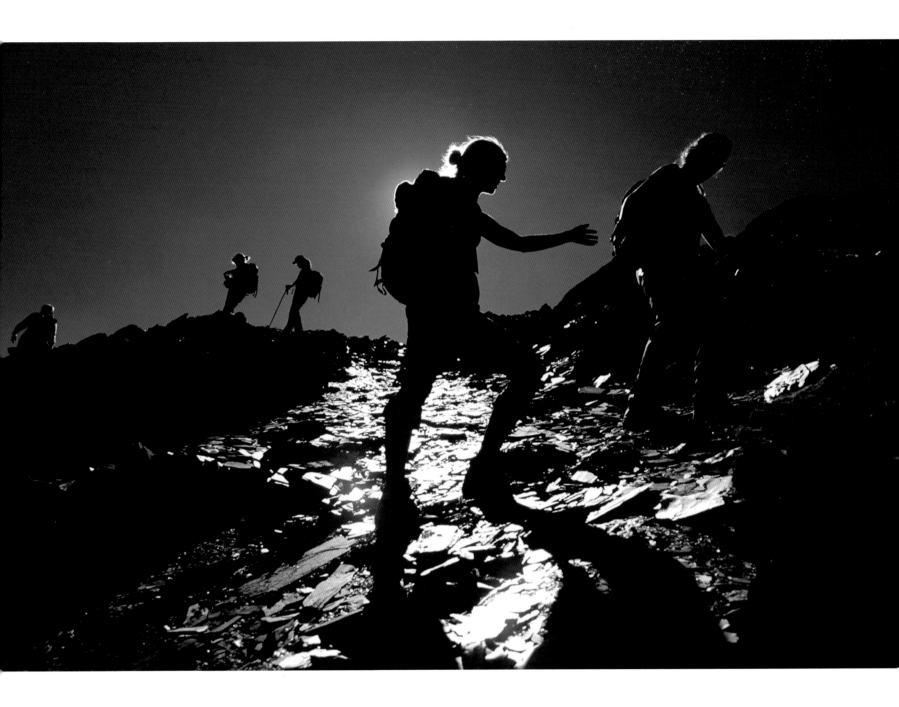

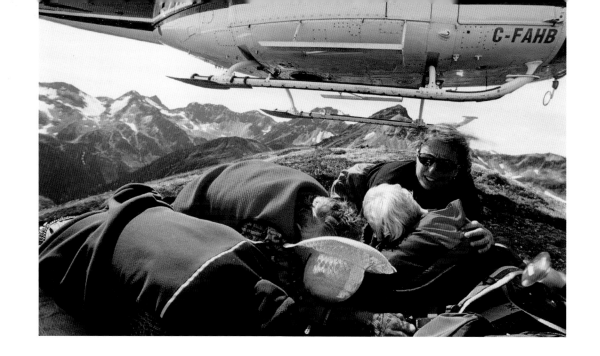

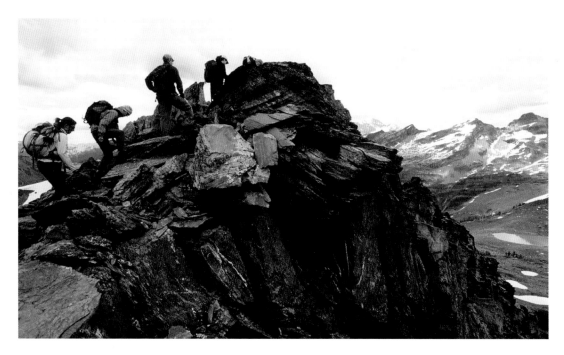

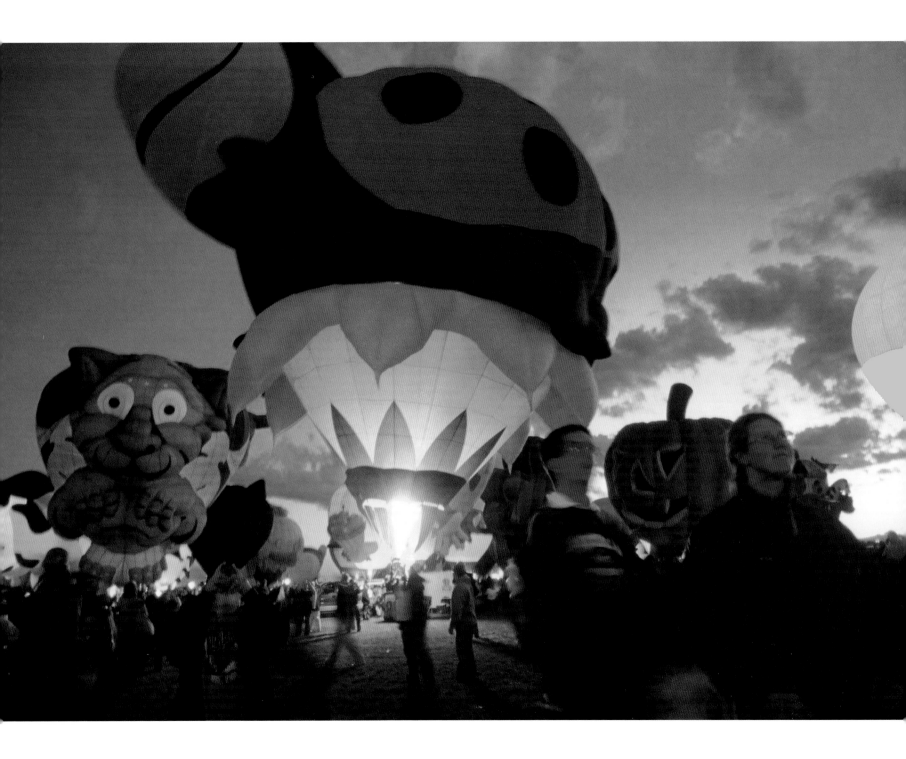

HOT AIR BALLOONING AT ALBUQUERQUE'S MASS ASCENSION

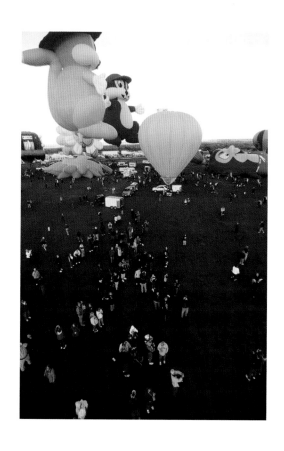

Sandwiched between the Rio Grande Valley and the West Mesa, Albuquerque's unique topography along the Rio Grande Valley provides a rotating hamster wheel of gusts in its early morning skies. Taking advantage of that boxed wind pattern, enthusiastic pilots from around the world converge here each autumn to experience an unusual aerial phenomenon's competitive joys. Rolls of vibrant, synthetic fabric are tugged, yanked, and made to blossom with air as seven hundred hot air balloons prepare for the globe's largest mass ascension. You hurdle a suede-edged basket brimming with stainless steel propane tanks, an instrument panel, and the high hopes of eager passengers.

A jerk on the blast handle ignites a series of deafening, fiery jets that shoot buoyant warmth into a colossal nylon envelope, bulging overhead with almost one hundred thousand cubic feet of air. As tethers are released, your wicker container eases you up, up, and away into cerulean skies and over the heads of waving spectators, who turn increasingly Lilliputian. Neighborhoods and roads appear as a model railroad's miniature landscape while the curving horizon fills with suspended Christmas ornaments. Hissing flames are judiciously doled out as you eye the altimeter, enabling the craft to hitch a ride with currents headed in your desired direction. At one with the wind, you float like a bubble in stunning silence. Upon descent, avoid power lines and livestock, then prepare for the evening's communal celebration of incandescent glow.

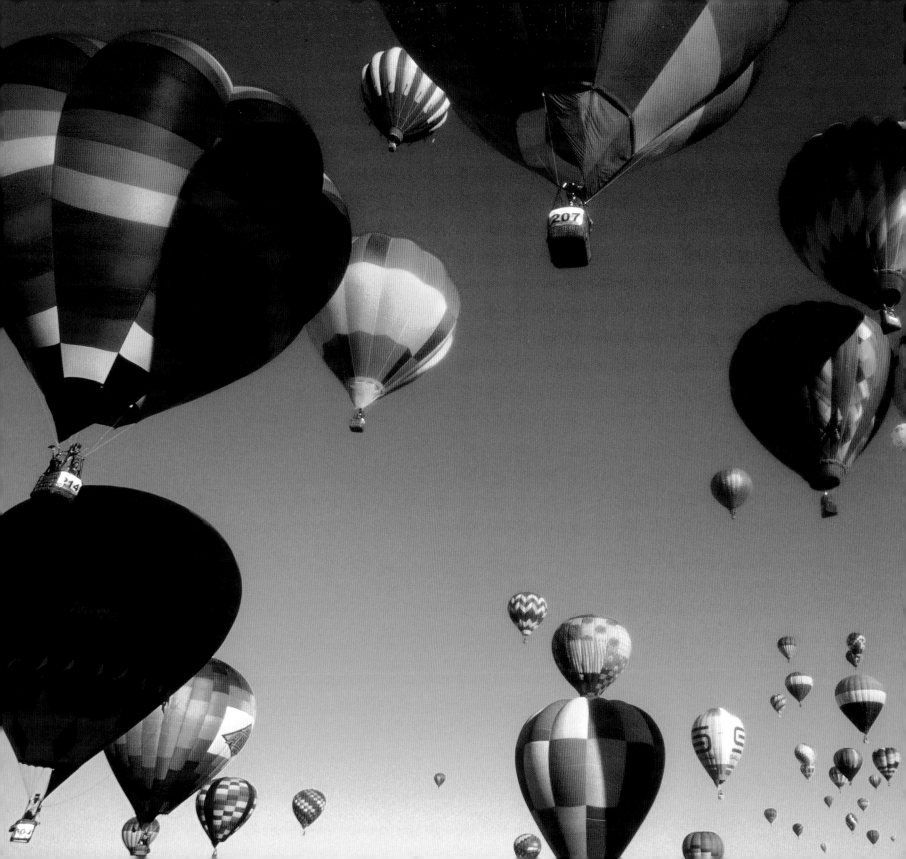

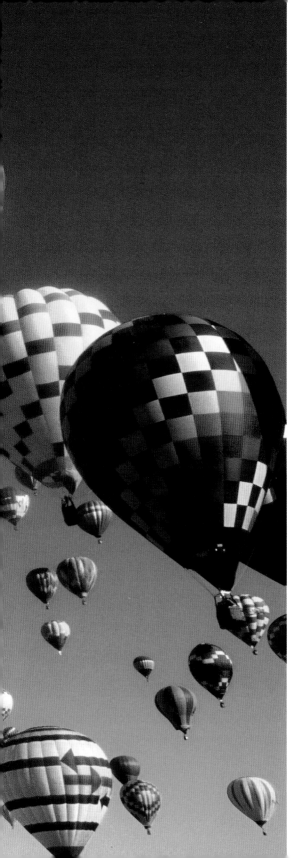
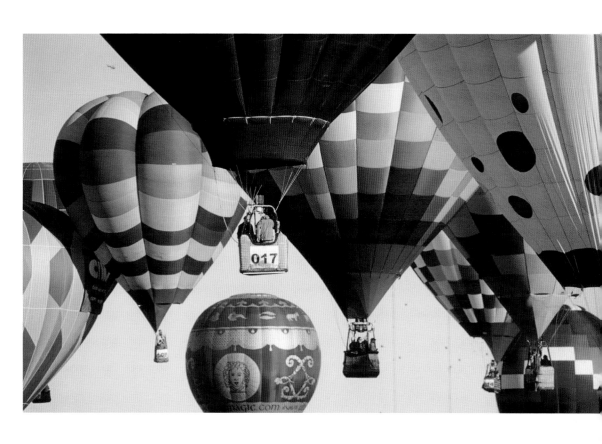

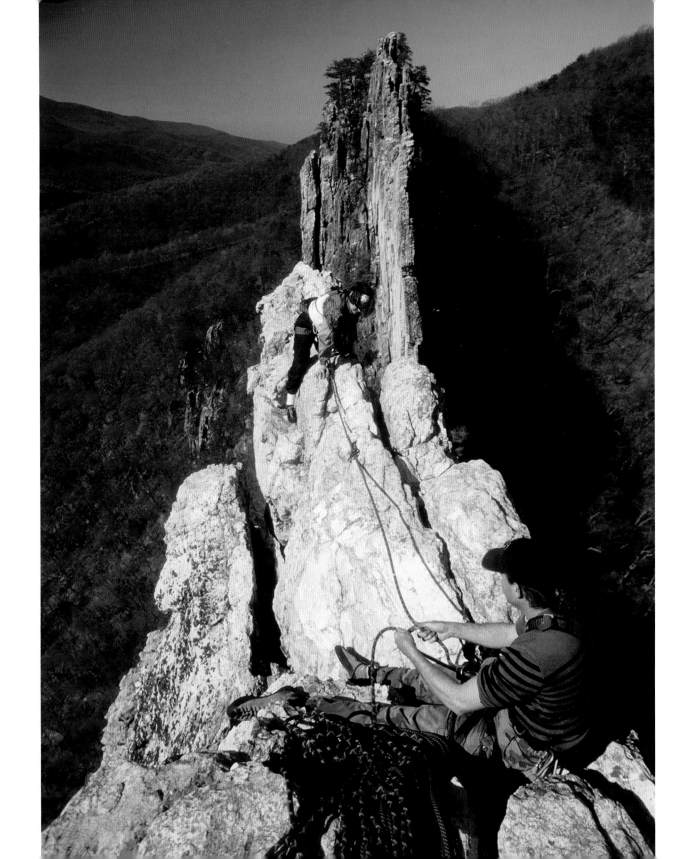

CLIMBING ONTO THE SOUTH
PEAK OF SENECA ROCKS

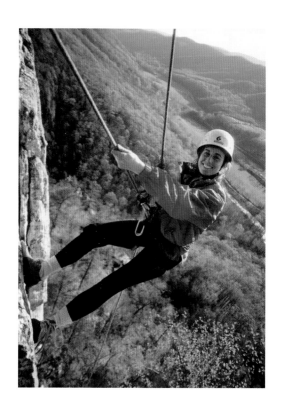

Threatening to slash the sky with its Tuscarora Sandstone knife edge, Seneca Rocks is a nine-hundred-foot magnet for rock jockeys seeking the sheerest walls east of the Mississippi River. Primed to defy gravitational forces and a skeptical nervous system, you adjust your sticky-soled climbing shoes and begin the search for dime-thick ledges on which to support yourself. While tied in by aluminum snap-link anchors, wedging nuts, and odd widgets, the leader grapples to slip a life-supporting chock into a tiny crevice. With your body contorted into improbable angles, you struggle to maintain equilibrium as well as a relaxed positive attitude while jamming fingernails into slivers of cracks, all the while denying the sweeping abyss below. Tiptoeing up a precipice is simply a matter of crystallized will shuffled into chess-like strategy. Finally, perched high atop God's antenna, you savor the exhilaration, collect your wits, and prepare for a summit plummet. Rappelling off the edge in a smoothly controlled descent allows your slow walk backward down the cliff, and eventually into an ecstatic embrace with terra firma.

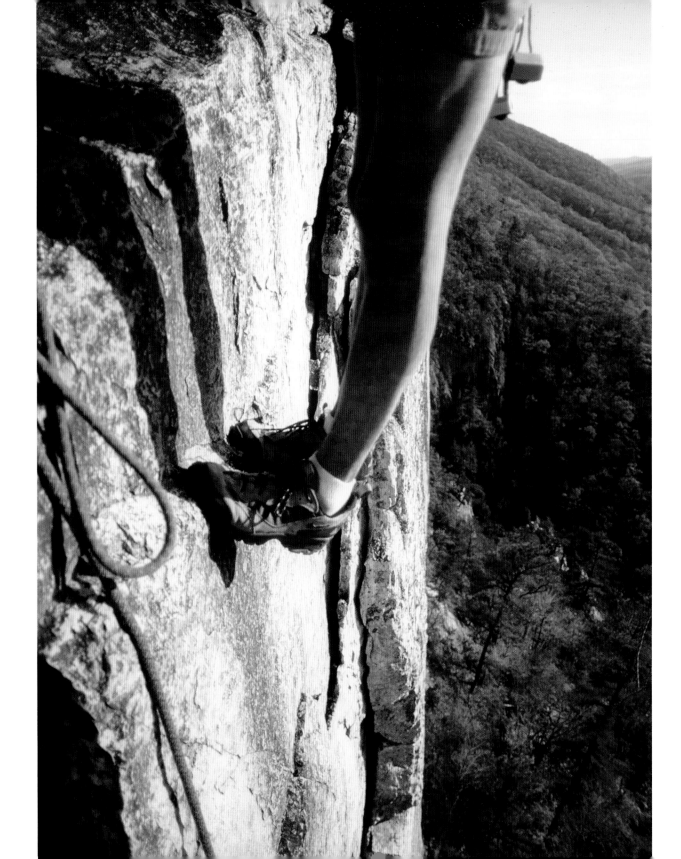

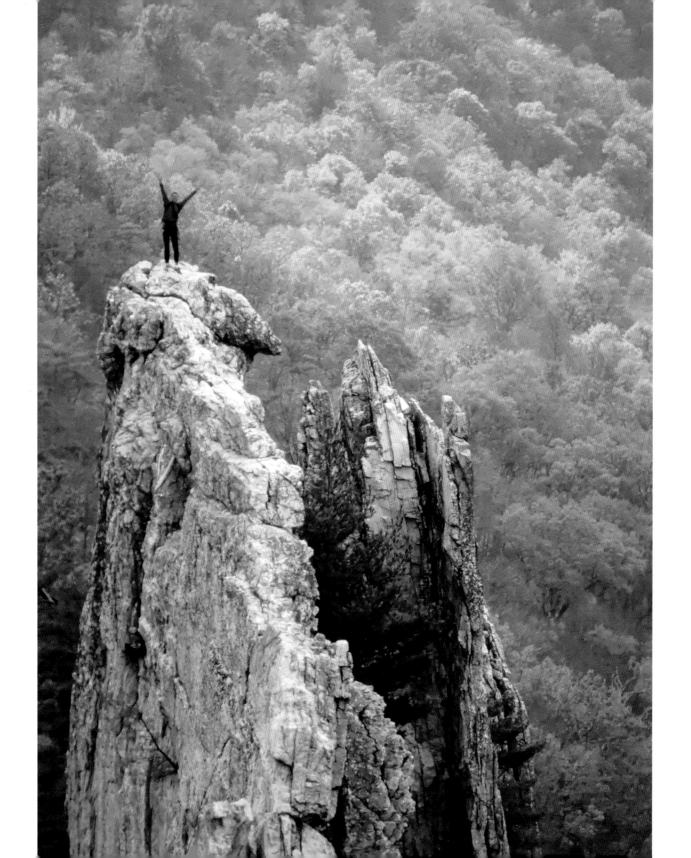

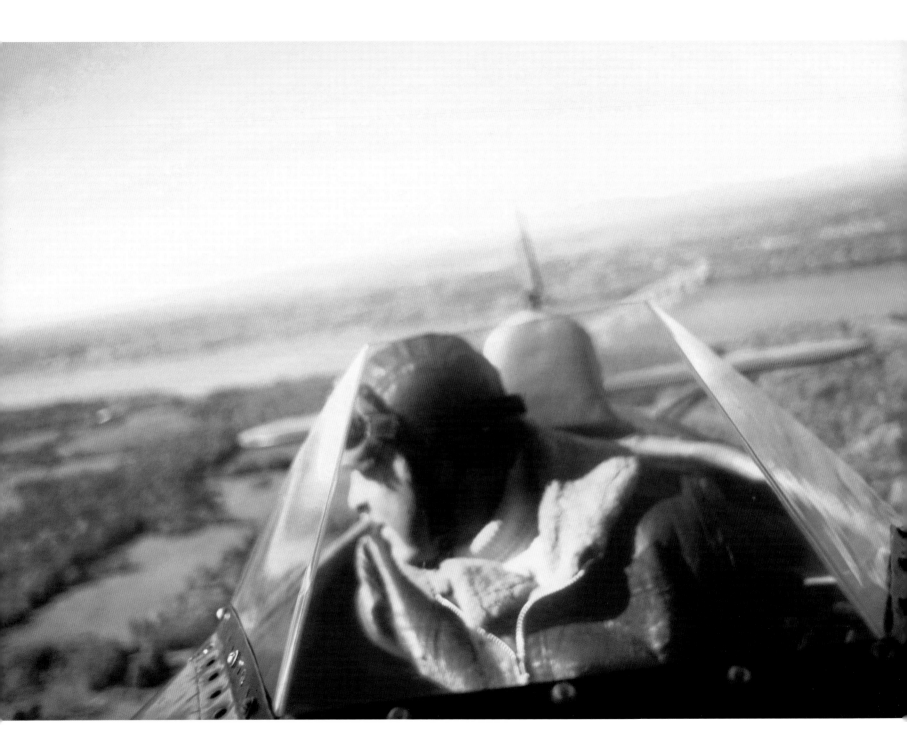

OPEN-COCKPIT BARNSTORMING ABOVE DUTCHESS COUNTY

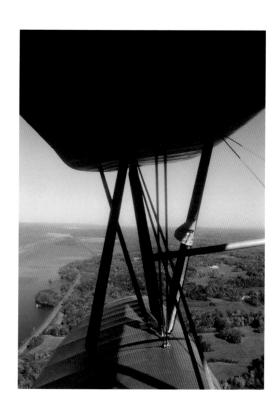

High above the aerodrome, the atmosphere whines with the growling vibrations of tiny airborne motors. Under cirrus-streaked skies, witness the aerial gymnastics of barnstorming antique planes. Wearing leather helmets, goggles, and counterintuitive confidence, strap yourself onto the worn cushions of a 1929 New Standard biplane. Throttling down a short grassy runway, your plane rapidly approaches an imposing stand of trees, the wheezing propellers barely outrunning a trailing haze of exhaust and smoky castor oil. Just in time, wings finally grab the winds and climb reluctantly above the woods. With unchecked optimism, you entrust your very safety to a pilot steeped in World War I dogfighting skills. Like a mosquito caught in a gale, this small craft's canvas and wire framework skitters precariously on the airstream. The vintage bird suddenly vaults into tailsliding loops and wingovers, the deafening engine roar muffling screams of fellow passengers who clutch the doors of this trackless roller coaster. An earthbound plunge toward the Hudson Valley's peach orchards way below is a spiraling flight of fancy that your shaking legs won't soon forget.

MOUNTAINEERING ON GRANITE SPIRES IN THE BUGABOOS

Amongst the legendary Bugaboos, relatively young one-hundred-million-year-old clusters of alluring batholith spires and granite peaks crown the Purcell Mountains. Here, the Quintets are sharp, black outcrops offering the backdrop of a mountaineering climb up Pyramid Peak. Begin a helmeted and roped ascent near islands of rock that poke through glacial fields at Phacelia Pass, named by the profusion of purple scorpion weed blooming during this short, monthlong window of snow-free meadows. Amongst a highly glaciated world of dazzling tarns and roaring creeks, the valley floor recedes during scrambles up scalloped ice fields soaring toward a forbidding series of deckled cliffs. As friction-grabbing belaying devices and carabiners are clipped in for anchored protection, ice axe transforms from walking stick and claws at lopsided topography as alpine knee leverage assists your hair-raising, cramponed ascent along perilous knife edges. A mixture of intense concentration, strategic balance, and emotional detachment enables your rise toward the summit. Bolted trails facilitate sideways momentum across exposed ridges and buoys a rappelling return to safer ground.

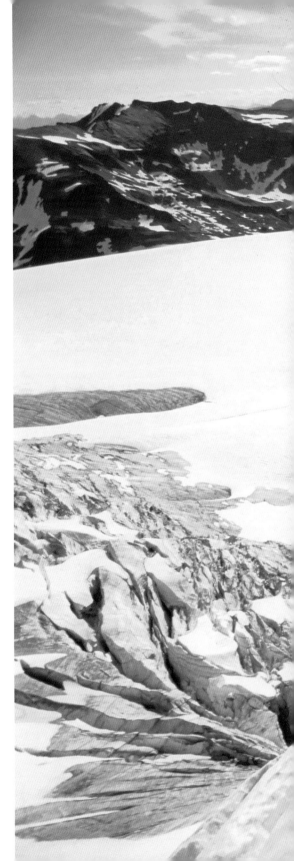

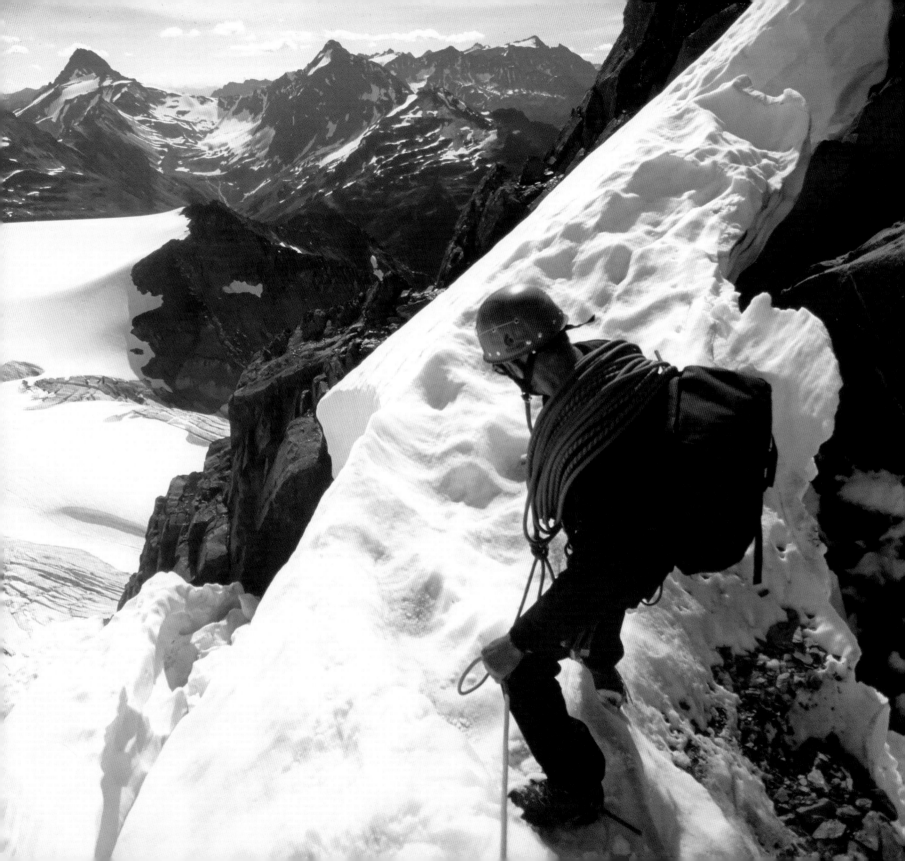

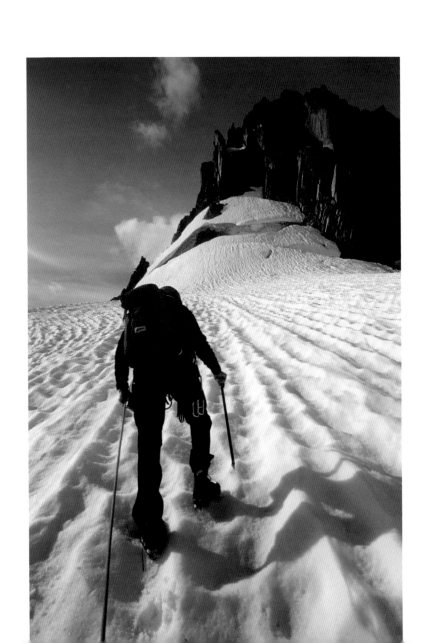
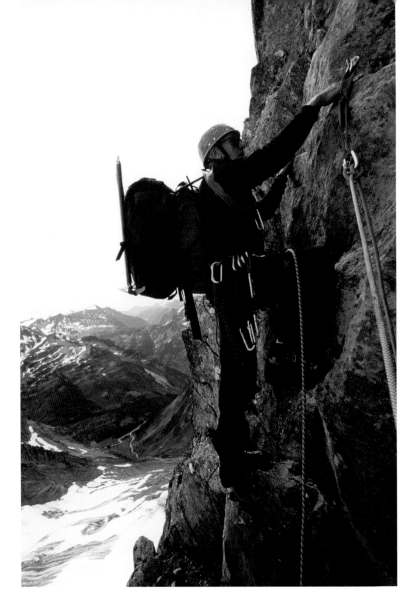

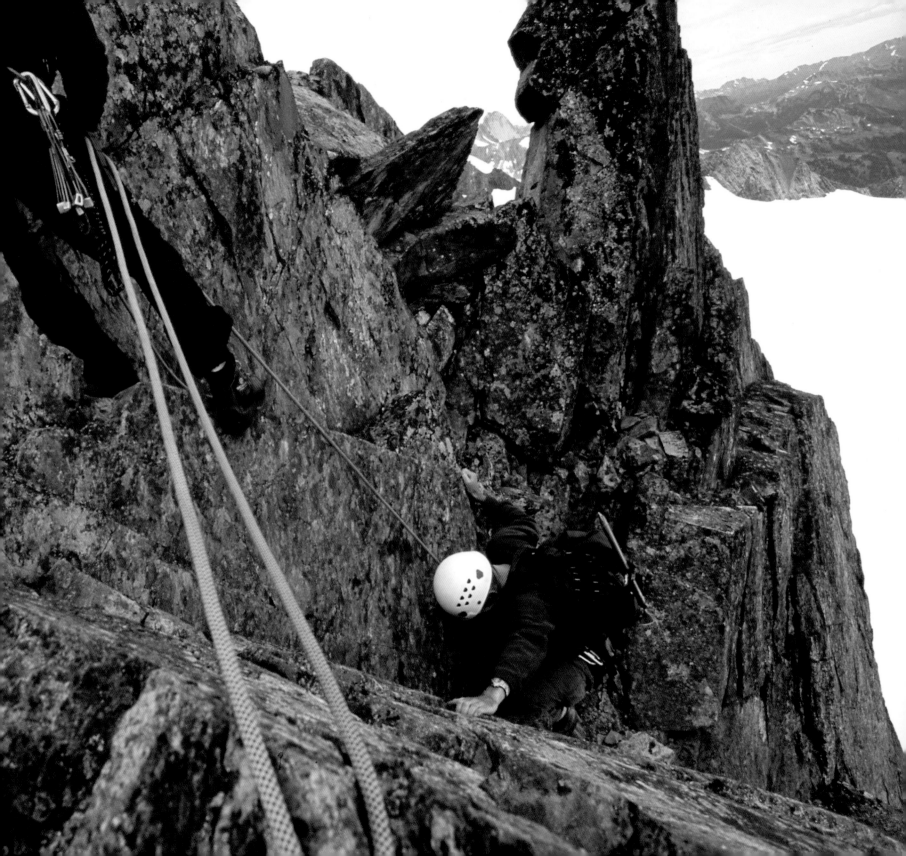

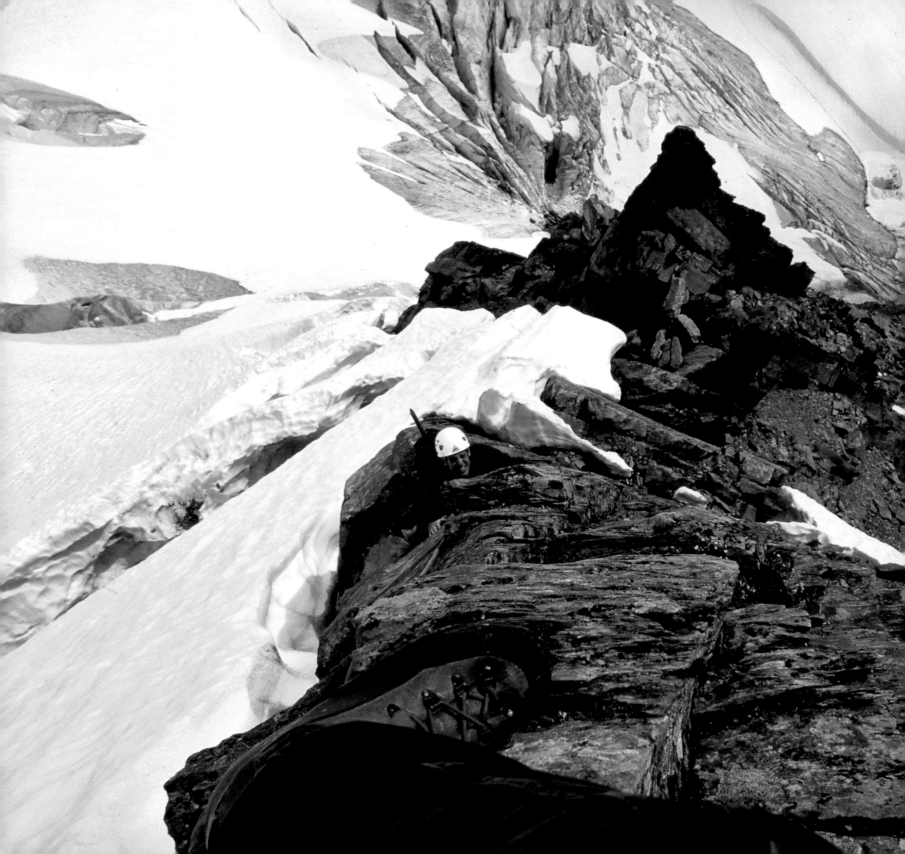

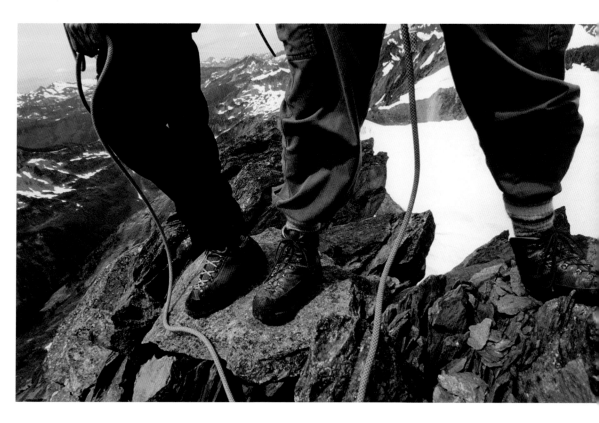

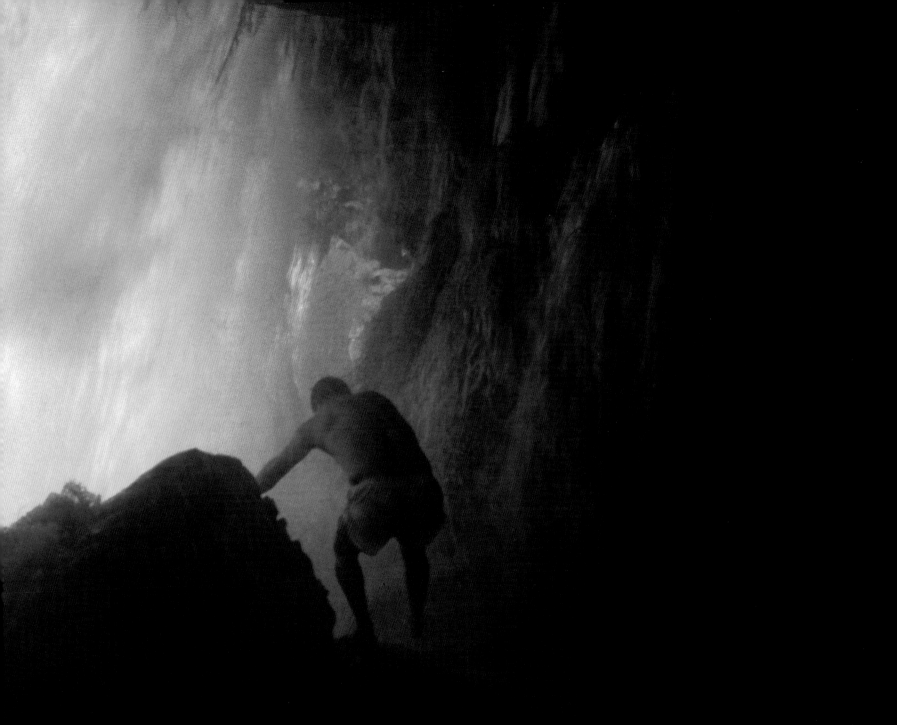

SOAKING WATERS

PADDLING A DUGOUT TO VENEZUELA'S ANGEL FALLS

Infiltrating the jungly heart of the Orinoco basin is a minimum requirement for laying eyes on the world's highest waterfall. From deep within the fabled shadows of Arthur Conan Doyle's *The Lost World*, towering shafts of rain-soaked limestone stretch into the clouds, creating evolutionary islands of time. Below one tepui, an encircling wall of pounding cascades rings the frothy Canaima Lagoon, a base for exploration into faraway stretches of rain forest wilderness. At nearby Sapo cataracts, duck behind deafening curtains of tangerine-dyed currents, stained by tree bark tannin upstream. Then, launching a curira into Rio Carrao, your loaded dugout is paddled upriver.

The hand-carved log furiously strains to match the velocity of insistent riffles and taunting chutes. Distant thunderstorms drown out chattering monkeys and scatter flocks of macaws, adding resistance to the upstream struggle. Hang a right at the next confluence up Churira's tumultuous hydraulics to reach an improvised campsite at

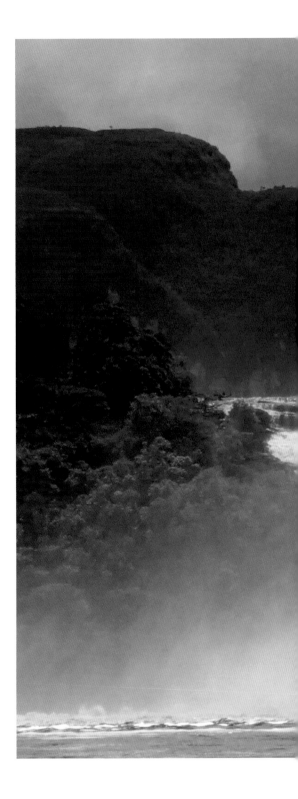

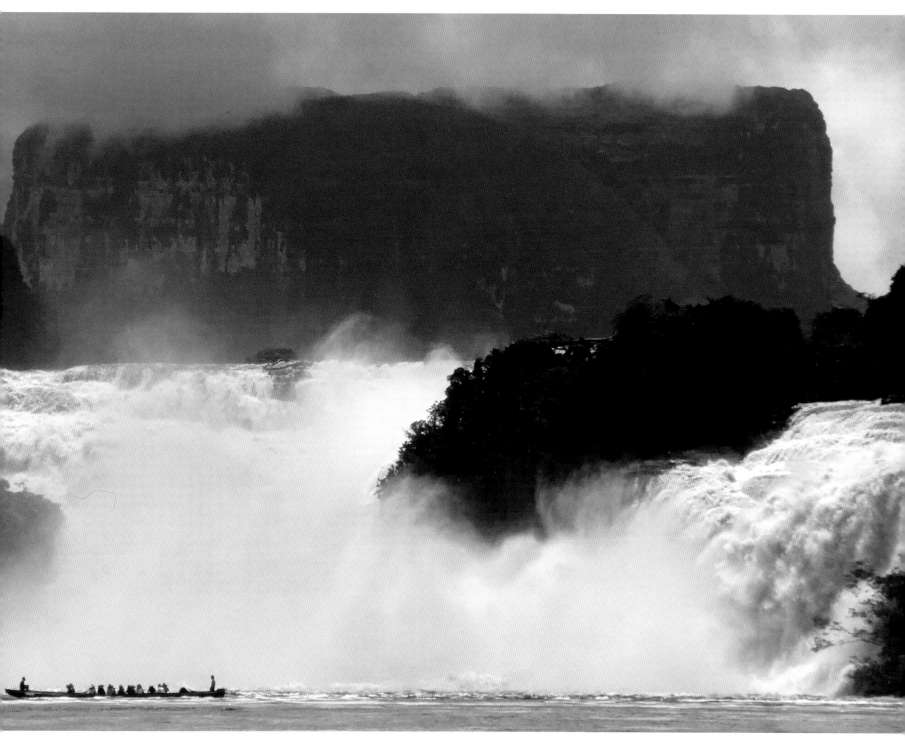

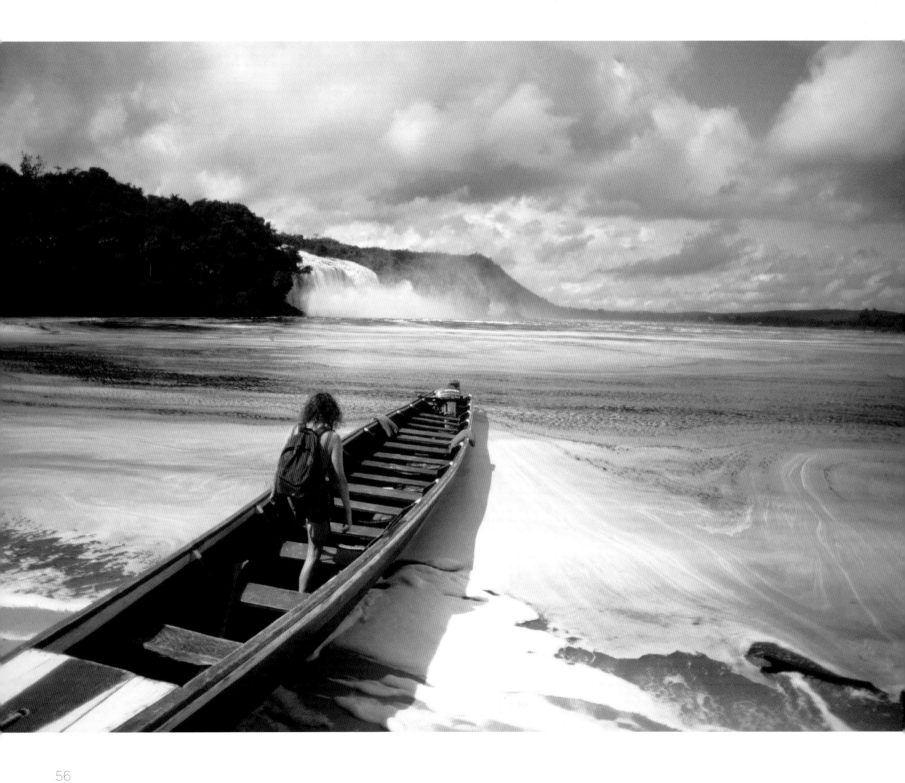

Ratoncita Island, where strung hammocks and a roaring fire slow roast water-soaked skin. As day breaks, hop the rattling bridge of rocks to the base of a soaring stone citadel, shrouded by persistent mist. Suddenly, the morning sun melts away retreating nimbus clouds, revealing a chiseled copper castle shielding a three-thousand-foot bridal veil gushing out of the firmament. Only discovered by outsiders in 1937, Angel Falls is a cascading kilometer of free fall—a heavenly spirit in the sky.

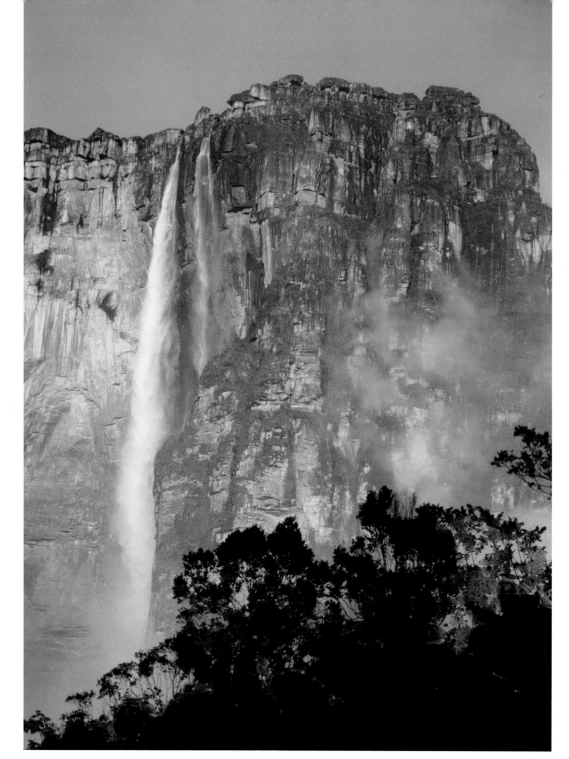

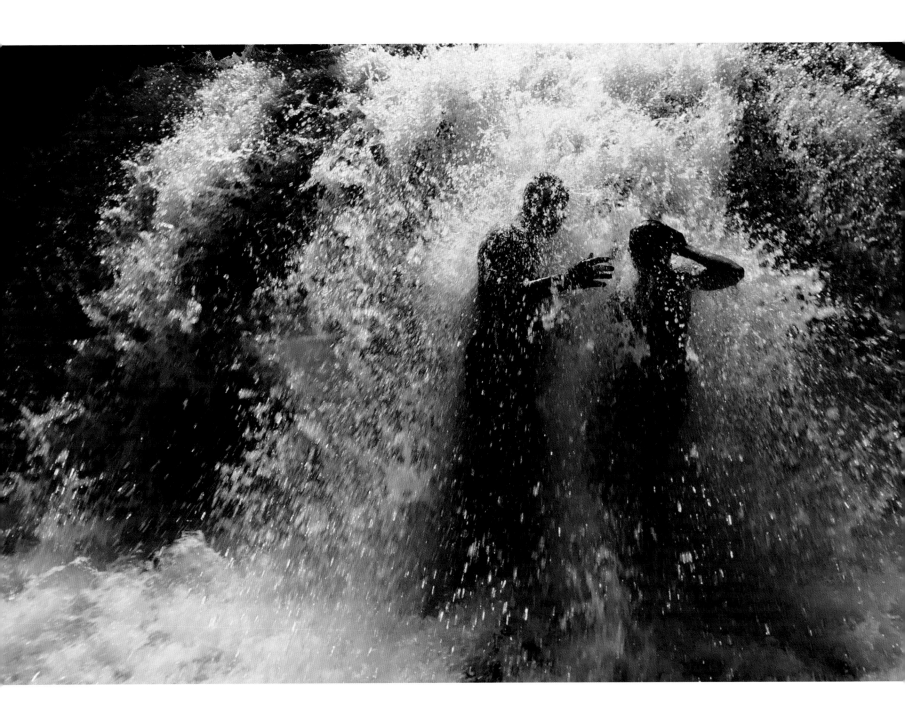

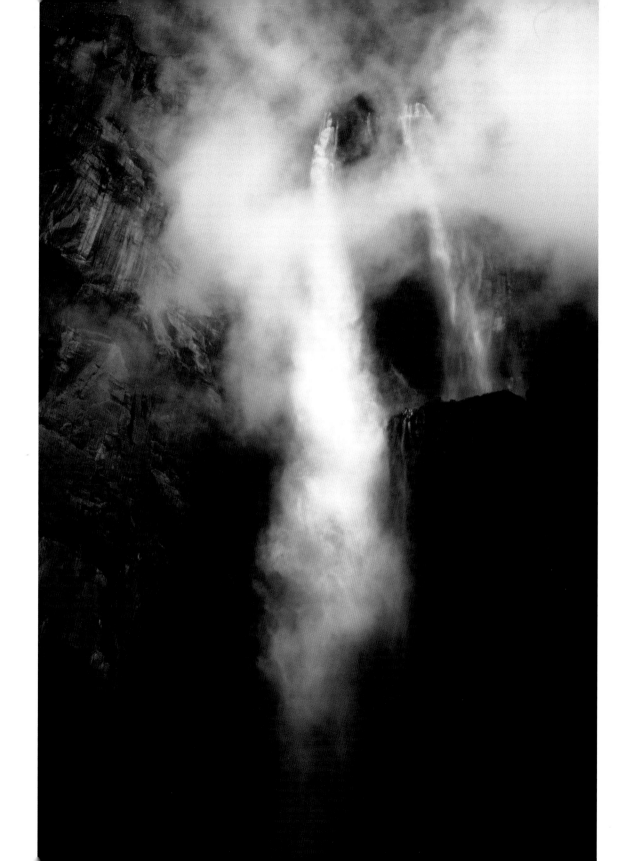

SNORKELING BETWEEN SPAWNING SALMON ON THE CAMPBELL RIVER

On Vancouver Island, the largest on the western American coast, five species of salmon flourish in the Campbell River. They are a crucial keystone in the complex ecosystem of bears, eagles, and whales, all depicted on totem poles of the region's Tlingit people. On the riverbank, after you cram into neoprene wetsuits, snorkels are adjusted and arms projected Superman-style to launch into a downstream rapid transit on an effortlessly streamlined six-mile glide. Sunlit gravel beds blur into the riverbed whirl below, while you weave through parting schools of glistening pink and steelhead salmon, all struggling to swim upstream against a powerful current. Having spent years out at sea, they are completing their lifespan and round-trip imperative. The salmons' livers deteriorate in fresh water as they determinedly return to spawn at the very spot of their own conception. In your downstream, out-of-body exhilaration, the irony is lost that at the very zenith of feeling alive, you're crossing paths with an aquatic death march of creatures spending their last hours of existence. Overhead, eagles circle impatiently, anxiously awaiting their all-you-can-eat salmon buffet.

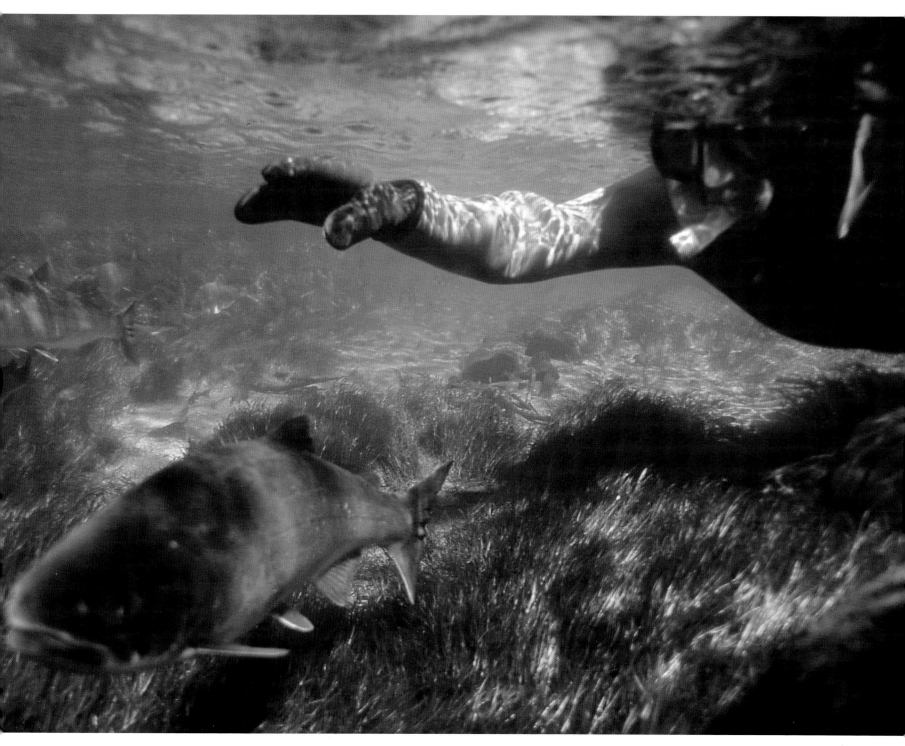

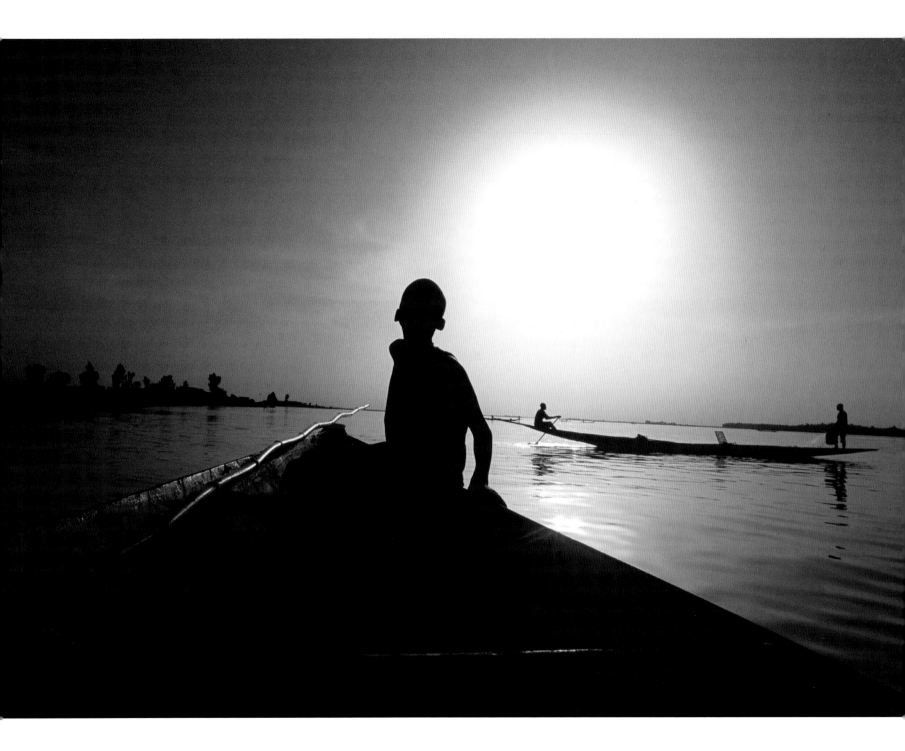

PILOTING A PINASSE DOWN THE NIGER RIVER TO TIMBUKTU

Setting a course toward legendary Timbuktu requires adept piloting skills through the Niger's restlessly shifting sandbars. The continent's third-longest river traces the improbable U-turning course of a sable antelope's horn.
As you gingerly walk a narrow wooden slat serving as a plank, boarding a local pinasse feels like stepping onto an elongated wicker basket. Embarking from the noisy hubbub of Mopti, poling Fulani boatmen clog the harbor and will soon throw fishing nets from drifting pirogues, slowly falling behind your motorized pace. Settling onto bulging bags of millet, you peer out onto a biblical scene where all traces of the present day vanish at timeless mud-baked villages. At their hearts, mosques that were sculpted with the bank's Play-Doh-like clay etch the skyline with spiritual presence.

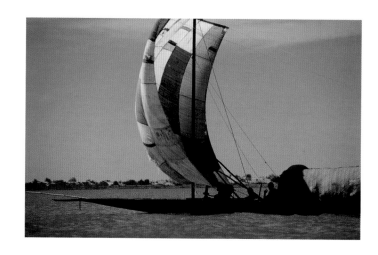

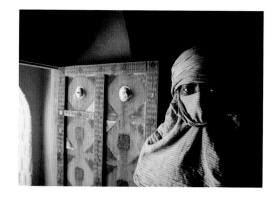

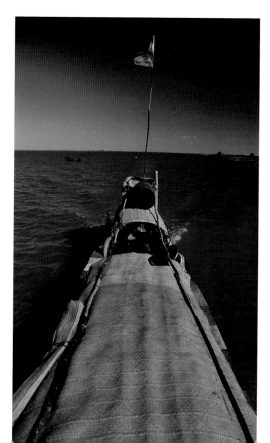

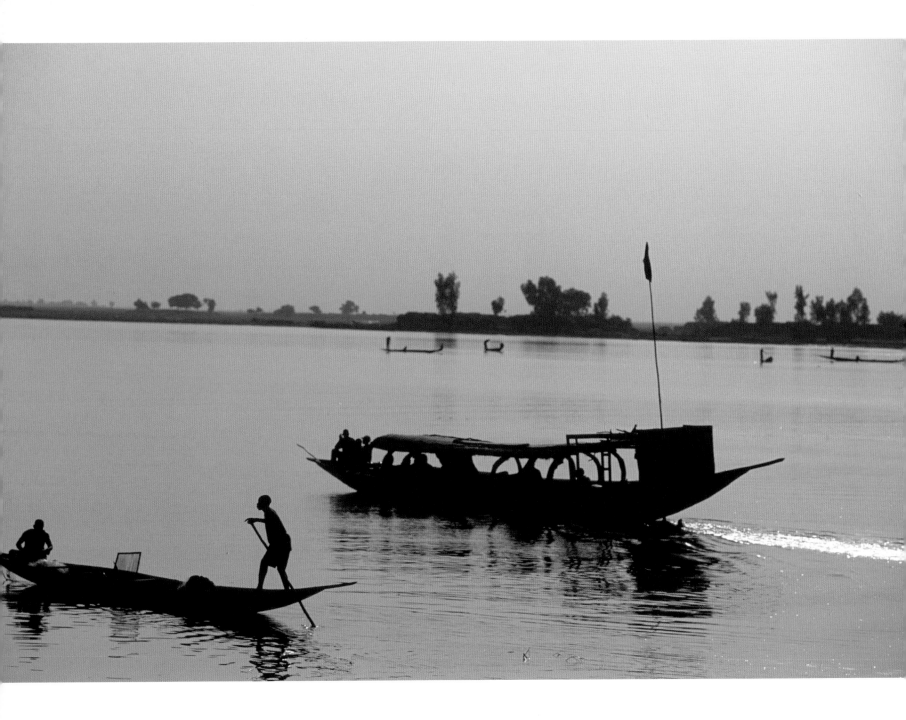

As you near the next dusty settlement, herdsmen lead a bellowing chorus of livestock to the riverbank for a bovine car wash. At the crowded village landing, waves of noisy children swarm your arrival, escorting you through narrow donkey-clogged lanes where Bozo women halt their backbreaking, grain-threshing chores to await their husbands' haul of freshly caught *capitaine*. Upstream, catch the evening's flailing black magic incantations performed to the hypnotic rhythms of beating drums. Awakening beneath two-story termite mounds, you resume the journey, passing rice sack flotillas whose improvised patchwork sails do an admirable job propelling cargo upstream to market. Shorelines will shortly disappear amidst immense, five-mile-wide flows, swollen by rainy floods.

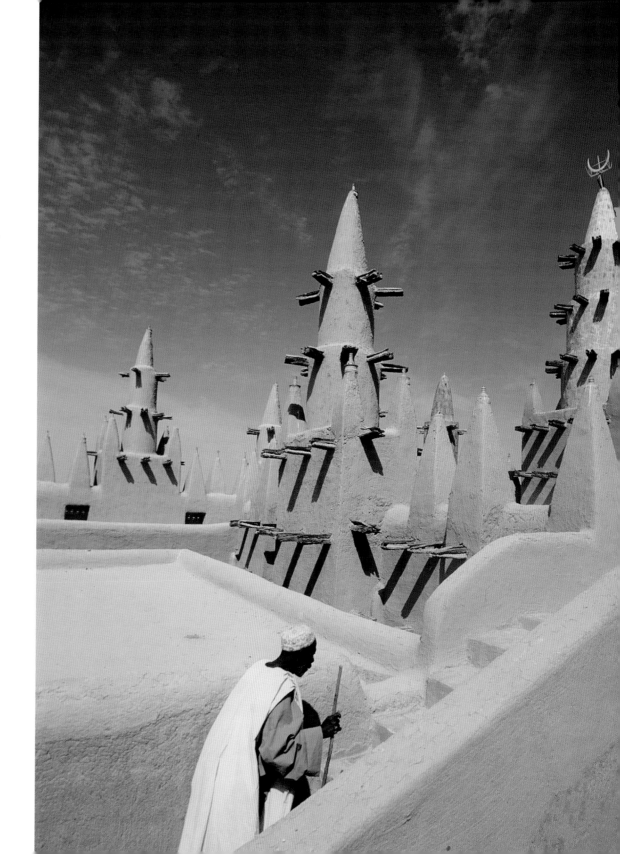

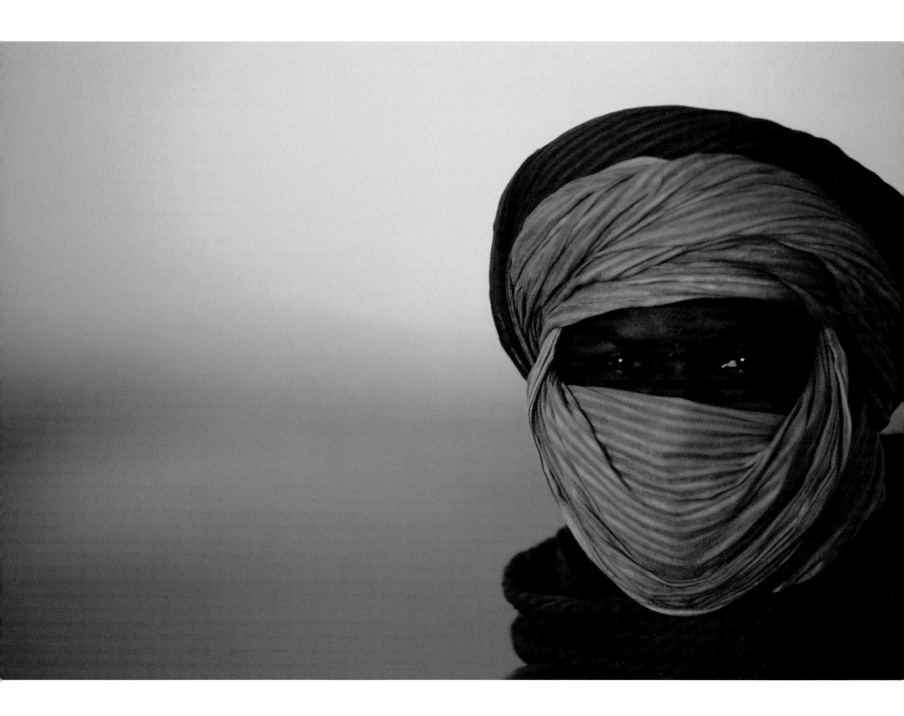

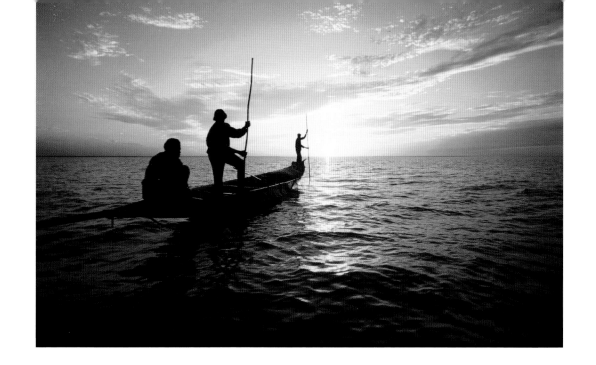

Days away, your fabled destination swarms with veiled men, wrapped in mysterious three-foot-long cheches of indigo fabric. Affording protection from the cruel gusts of the harmattan sandstorm season, the Tuaregs' facial cloaks barely reveal more than eyeballs peering out from blue-tinted skin. Ornate doors hint at faded grandeur. Once an eighteenth-century seat of African intellectuality, this famous settlement occupies a pivotal position between a waterway thoroughfare and precious trading avenues of historic desert caravans, enabling months-long journeys to exchange gold and salt. This windblown outpost of camel parking lots and adobe streetscapes teeters on the edge of being swallowed up by a growing Sahara, luring adventurous outsiders to its storied past.

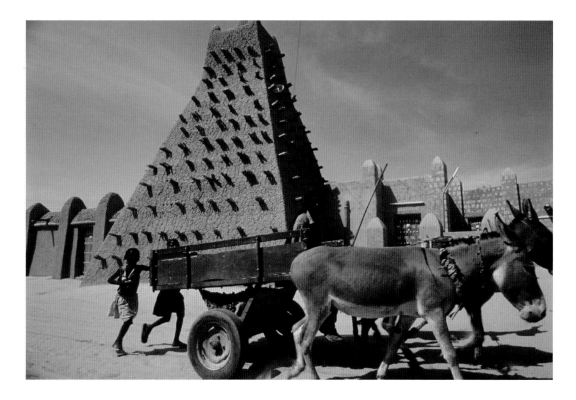

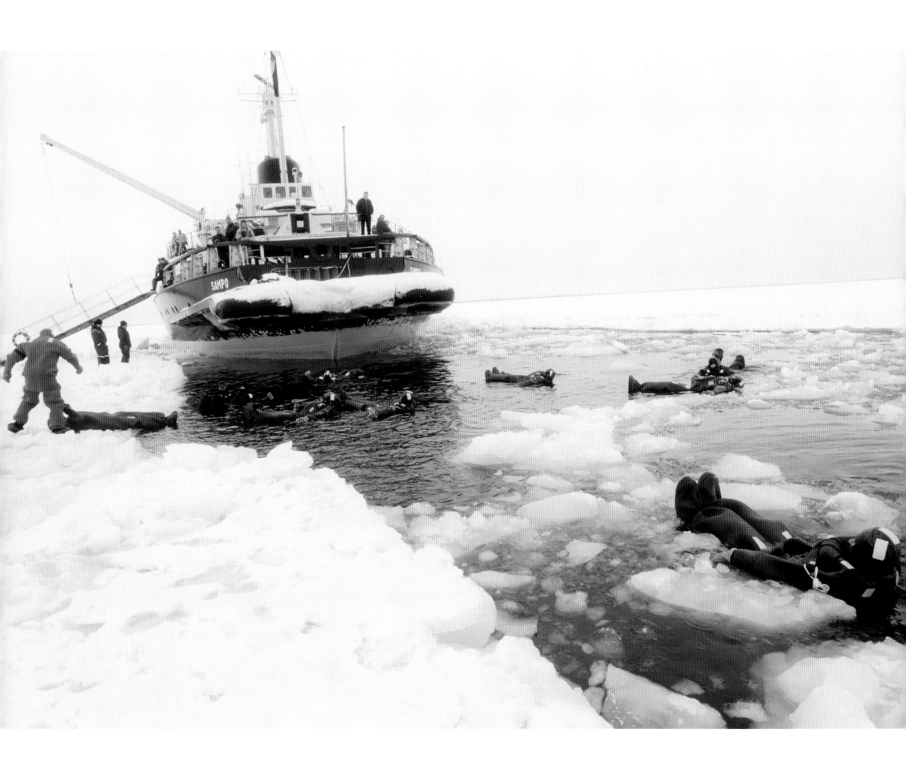

FLOATING IN A SURVIVAL SUIT ON THE FROZEN GULF OF BOTHNIA

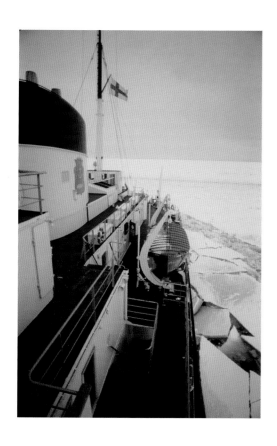

The Finnish ports lining the northernmost arm of the Baltic Sea find themselves blocked by ice five months of the year. Shipping lanes are forcefully pried open by the 3,500 tons of icebreaker steel that rides up onto the frozen surface. As the ship crushes the obstinate, three-foot-thick sheet underneath, the banging snap, crackle, and pop heard at the rounded bow continue unabated until the ship comes to a halt in the middle of an infinite horizon. A fleet of snowmobiles convoy onto the Gulf of Bothnia, pursuing rendezvous with the Sampo, a distant peripheral speck getting larger every few seconds. Approaching the ship, visitors are cherry-picked by crane and deposited safely aboard. After a hearty meal of reindeer and salmon stew, it's time to replace your overcoat with oversized gloves and the neoprene coziness of an insulated survival suit. Waddling down the gangway by the stern, ease into the newly created pond, making certain to float only on your back to prevent leakage into the face-lining seams. Armored in a wardrobe designed to thwart maritime hypothermia for three hours, buoyancy feels surreal, reclining in your imaginary lounge chair.

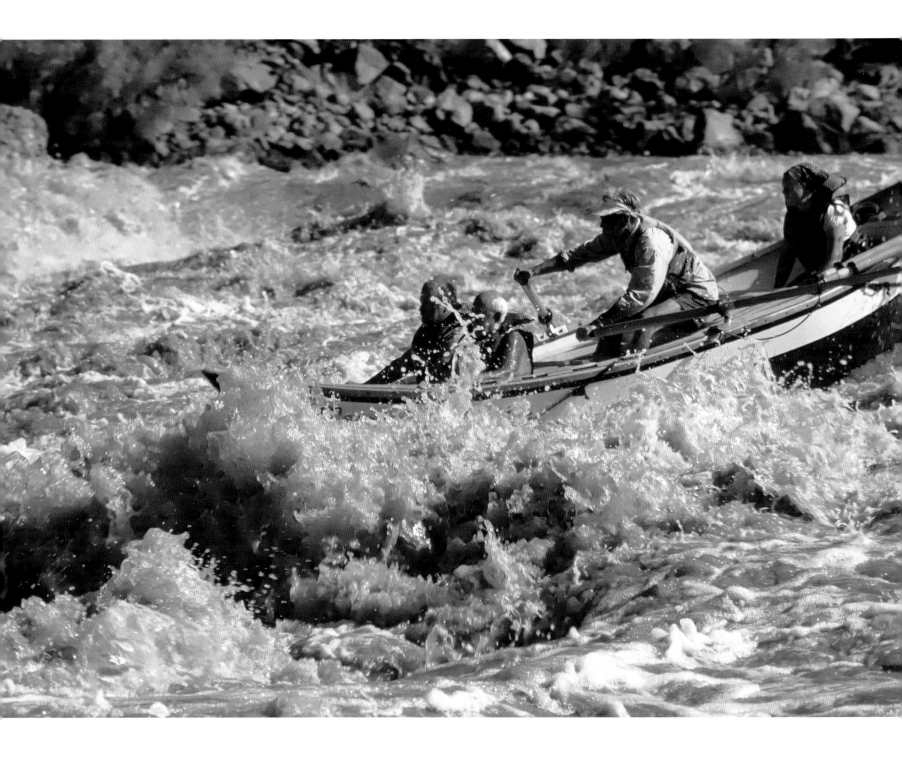

TRAVERSING THE GRAND CANYON BY DORY

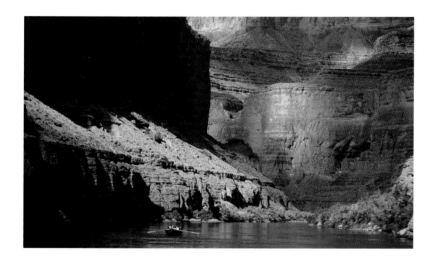 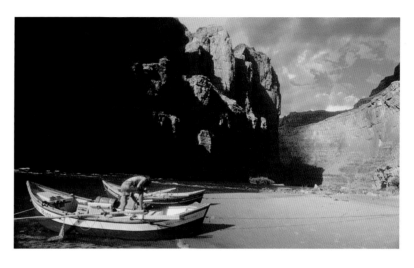

Drilling through earth's most renowned cavity requires filling a weeks-long adventure with adrenaline-soaked determination. Arm yourself with the confident knowledge that 277 miles of rollicking, wave-smashing obstacle course lie ahead of your wooden boat's chilly initiation at the ramp put in by Lee's Ferry. The elegant, hard-shelled craft is an eighteen-foot-long tweaked version of its ancestral European fishing dory, fine-tuned with raised square stern to slash into waves and slice through mid-current shoals. Expert rowing techniques chauffeur the vessel through explosions of pounding spray that spill over the gunwales as the river's four-miles-an-hour descent cuts through an animated picture book depicting billions of years of Earth's geologic growth rings. Cutting deeply into an uplifted Colorado Plateau, the striking, sun-torched immensity of Marble Canyon wallpapers its sides in colorful bands of Kaibab, Toroweap, and Coconino sandstone.

A midday pullover finds Redwall Cavern, whose gargantuan entrance could host a shaded softball game. Back afloat, rocky walls soar a mile overhead and point toward golden eagles gliding over bighorn sheep, cliff-clinging temptations for prowling coyotes. Before long, sandy coves beckon alluringly toward a late afternoon encampment where Dutch-oven cooking precedes a welcome dive into deep slumber beneath a blanket of dazzling stars. At daybreak, you realize the soothing melody of cascades will envelop most of your onward journey as the pulsing, continual series of descending rapids begins to synchronize with a tension-shedding reduction in your own blood pressure. At Nankoweap, a climb up sheer escarpments leads to windswept,

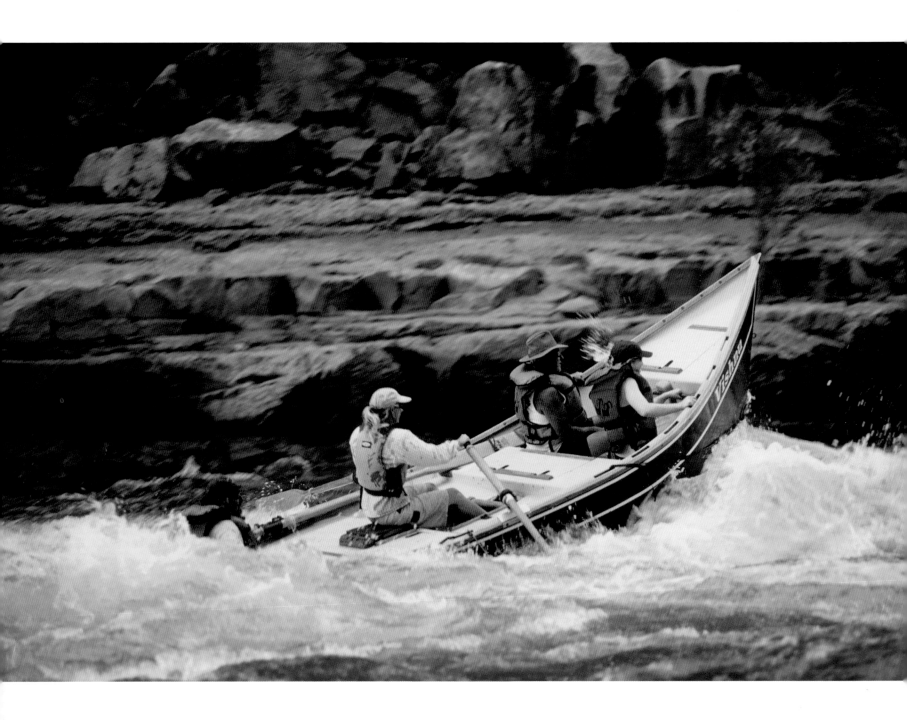

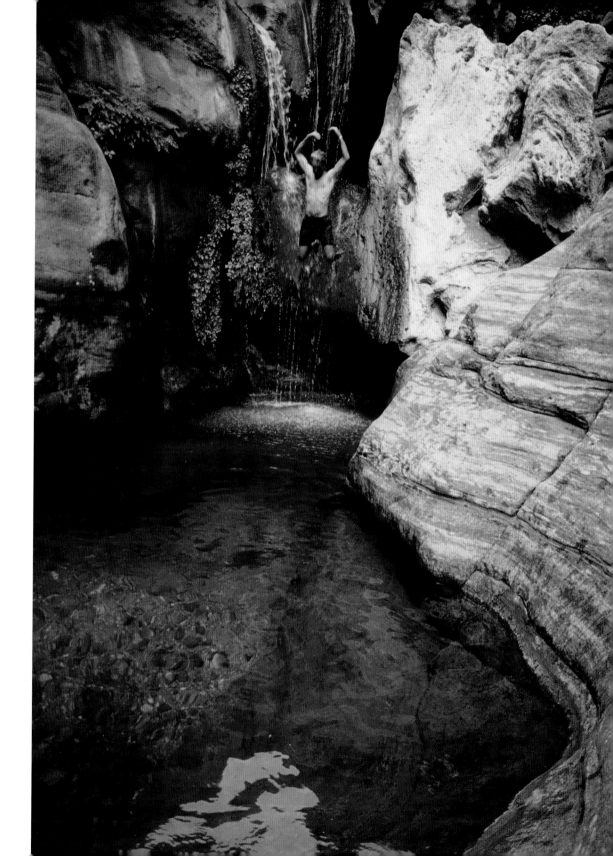

gravity-defying, eleventh-century Anasazi squash granaries that survey the slender silver thread deep below that just delivered you to this astonishing spot.

Water-drenched days quickly fill with wide-eyed explorations of narrow gorges, intriguingly sculpted by pounding torrents at Deer Creek Falls or leading mysteriously into ferny, moss-carpeted glens like Elves Chasm. At Little Colorado's confluence, turquoise currents race through limestone chutes and travertine pools, yielding facial cream sediments that are slathered liberally by joyful explorers. Approaching the dismaying menace of Lava Falls, boatmen turn somber for a prayerful meeting and scout session before running the violent maelstroms. After lurching frighteningly into a demolition derby of apocalyptic, scow-crunching chaos, intact emergence on the other side of hell's gate almost feels like an undeserved heaven-sent gift. Settling in at your encampment, the sighs of relief turn short-lived as blossoming cloudbursts turn dramatic bluffs into dangerous wraparound curtains of torrential, flash-flooding monsters. At that point, it becomes forever apparent that the Grand Canyon's proud nomenclature is actually an extreme understatement.

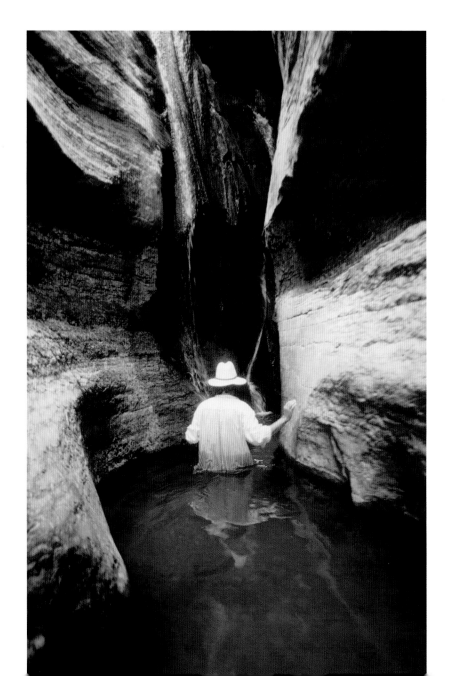
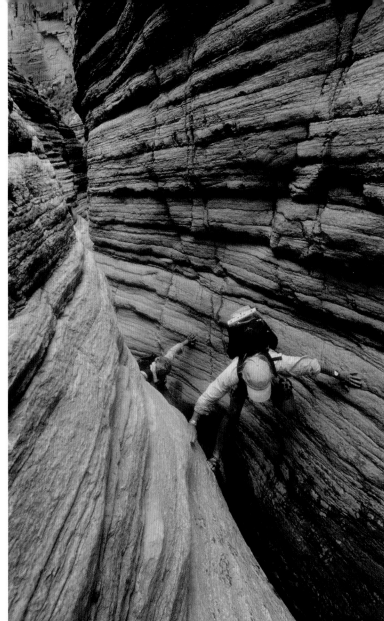

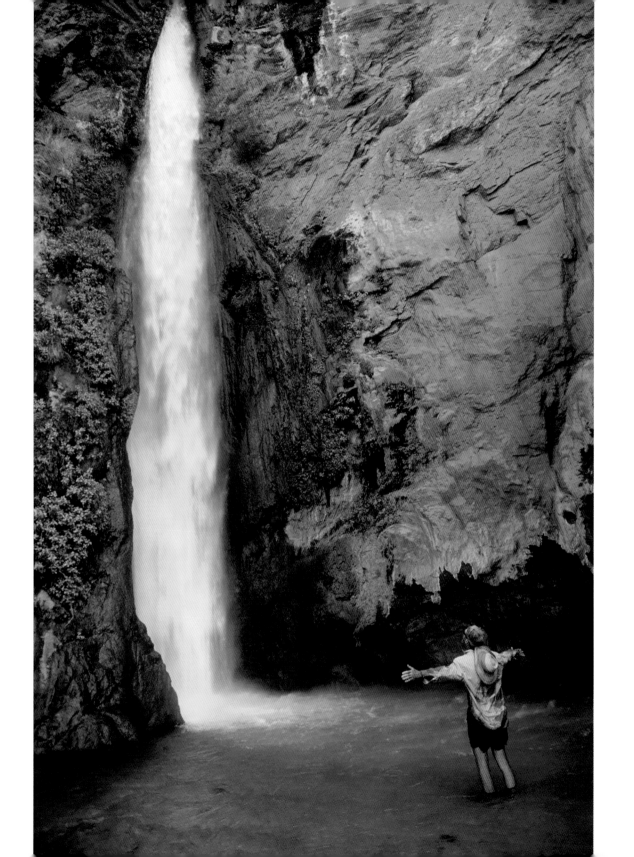

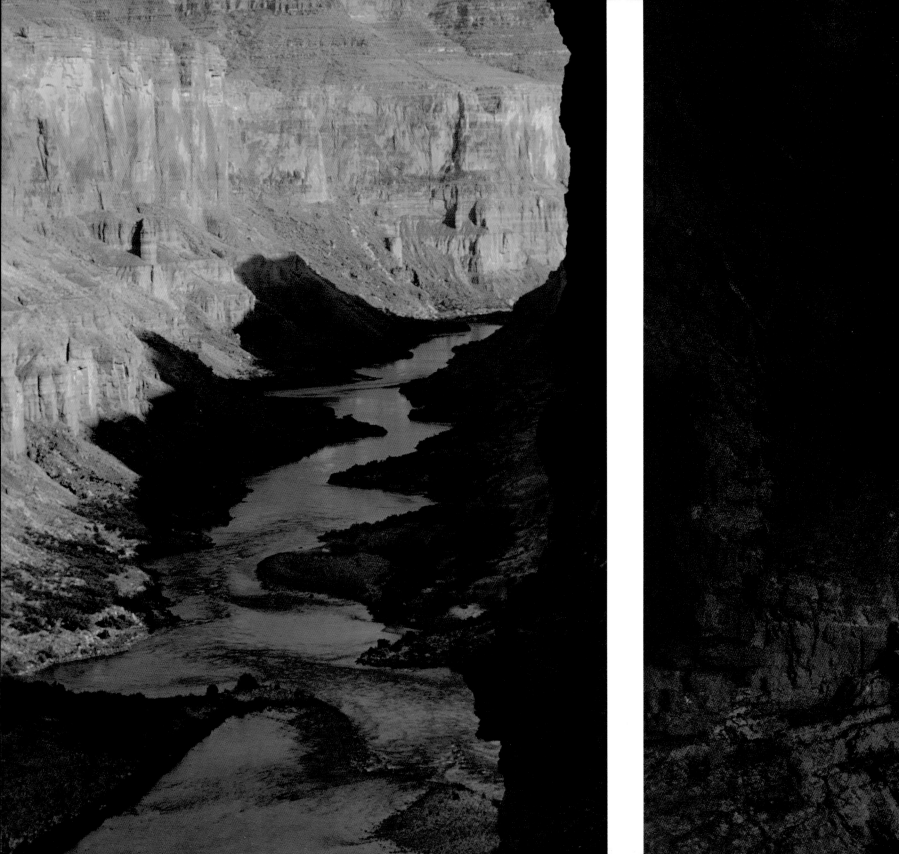

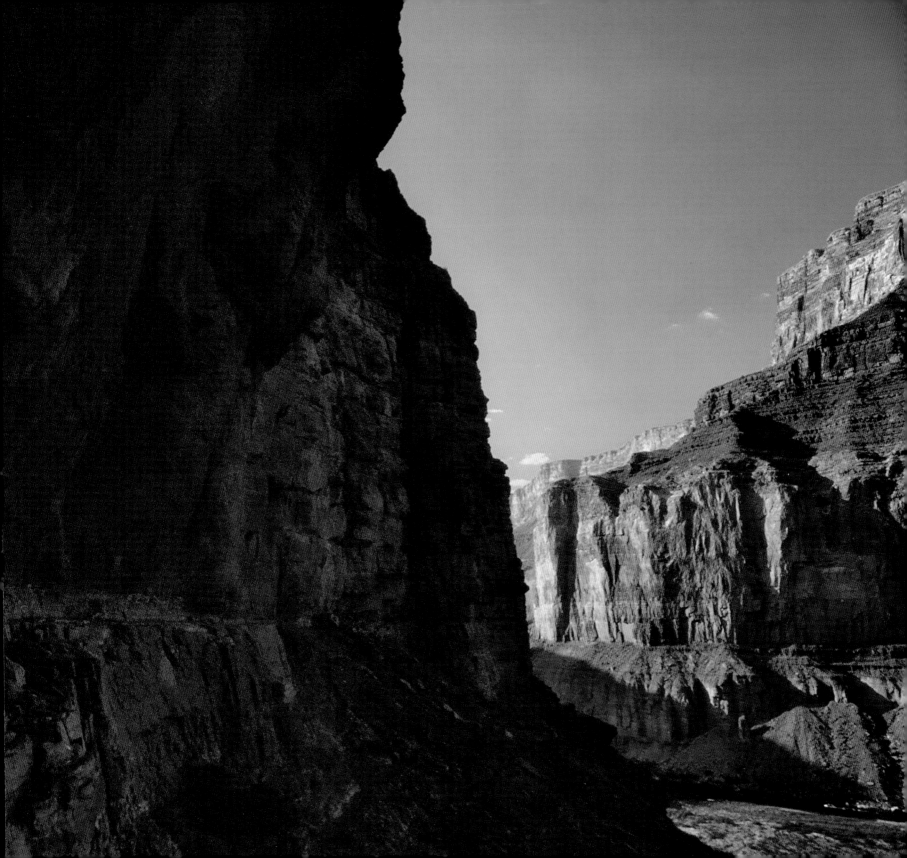

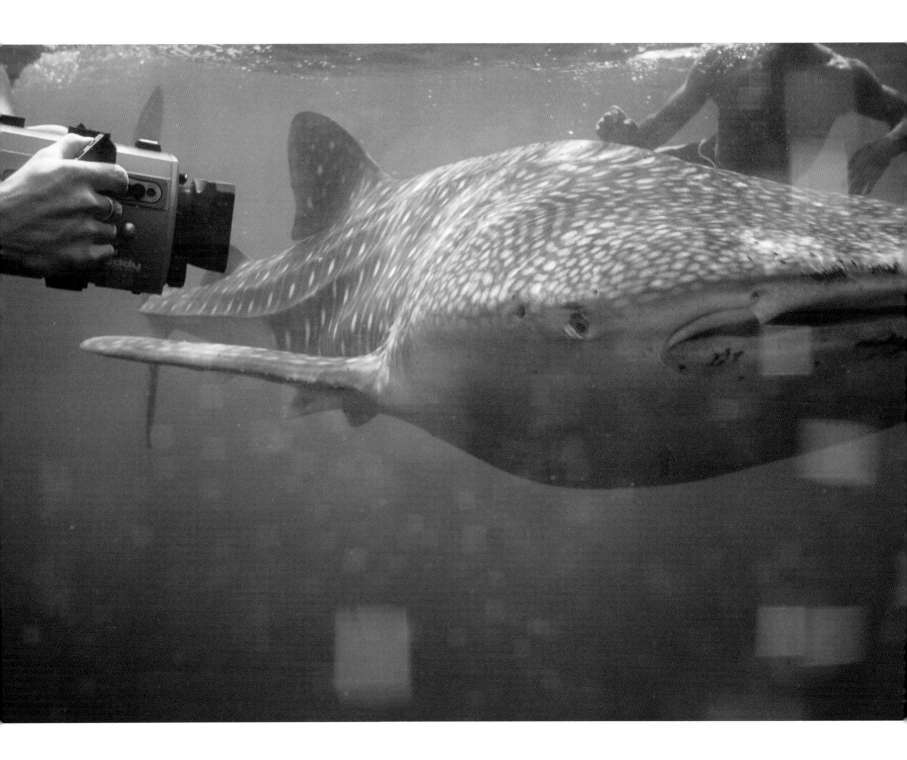

SWIMMING WITH WHALE SHARKS
IN THE INDIAN OCEAN

Basking in the remote precincts of the Indian Ocean, the Maldives are a series of ring-shaped coral reefs that comprise the world's lowest-lying nation. Off the western side of the Baa Atoll, the largest fish that inhabits our world gracefully plies the tropical currents at about three miles an hour. Swimming with whale sharks requires little more than a snorkel, life jacket, and jump-start from the local boat's deck. An effervescence of bubbles is released by jumping swimmers as a buoyant forty-seven-thousand-pound, polka-dotted gentle giant glides straight in your direction. At the very front of this forty-foot-long nautical behemoth, an astonishing five-foot-wide gaping mouth acts as an aquatic vacuum cleaner, its 350 tiny teeth and ten filter pads straining algae, plankton, and krill from the warmest oceanic waters on the planet. Jonah and the whale flash through your mind as you take care not to let the swishing tail smack you. Though its graceful and decorated fins have designs as individual as a fingerprint, the abrasive sandpaper texture can provide even more reason to feel a profound sense of vulnerable insignificance amidst the greatness of nature.

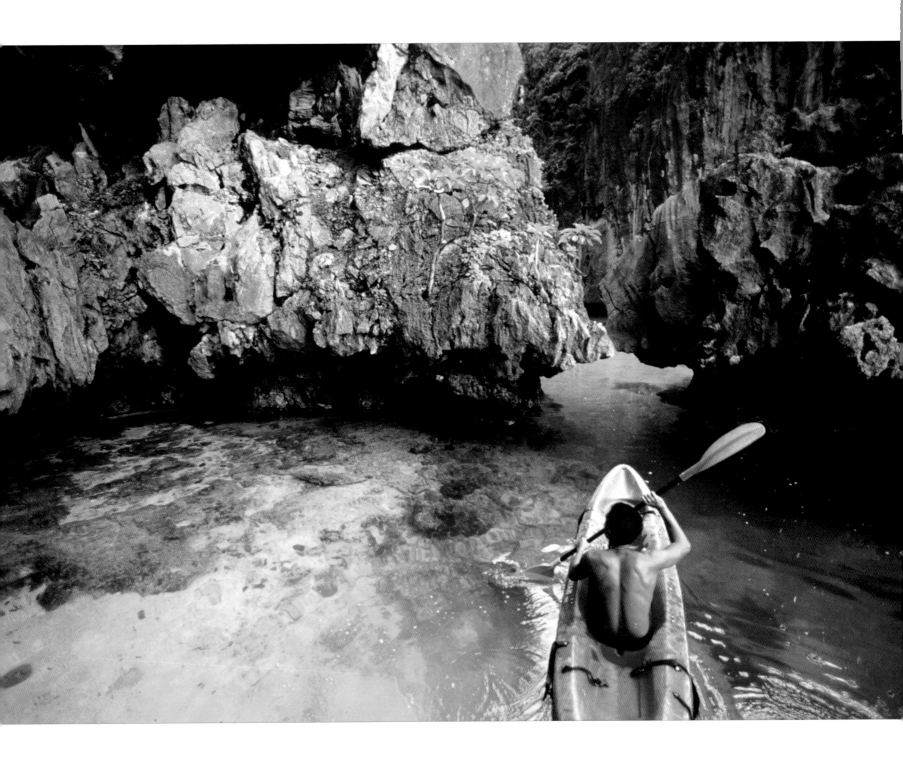

SEA CAVE KAYAKING THROUGH
THE PALAWAN ARCHIPELAGO

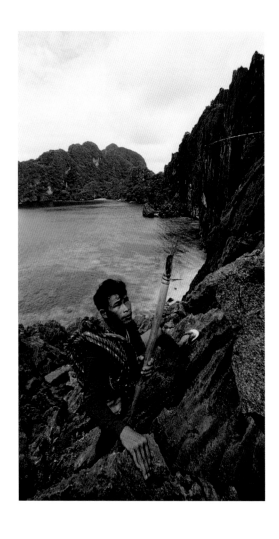

The seven thousand islands of the Philippines comprise the world's second largest archipelago. In the Palawan region, dramatic karst topography hoists its ancient Permian-period limestone to a neck-craning six hundred feet above the South China Sea's swim-through emerald aquarium. Below these sheltered coves, humped bannerfish and zebra moray eels glide past blue-lipped giant clams blowing kisses to two-hundred-year-old volcano sponges. Glide toward severely undercut mushroom outcrops amongst a tortuous network of grottoes, then paddle your nimble sea kayak, needle-nosing into narrow cavern portals that invite a single-file drift through a geologic tunnel of love. To guarantee safe return, be certain to time your entrance to coincide with ocean tides. Exercise care pushing off the corridor walls' razor-sharp fins. You'll finally emerge into immense, flooded cathedrals whose spooky, dehydrated corridors invite flashlit exploration. Those knife-edged surfaces also laminate the outside on steepled, cliff-edged walls, where local profit-motivated collectors bravely seek out the saliva-spun nests of swiftlets, a prime ingredient for haute cuisine soups served in distant cities.

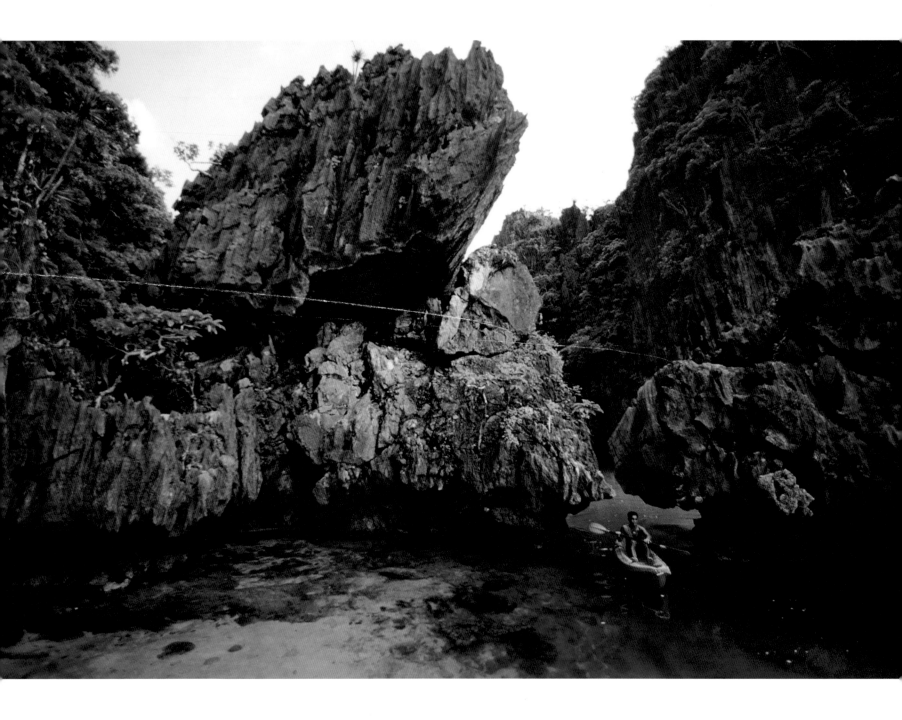

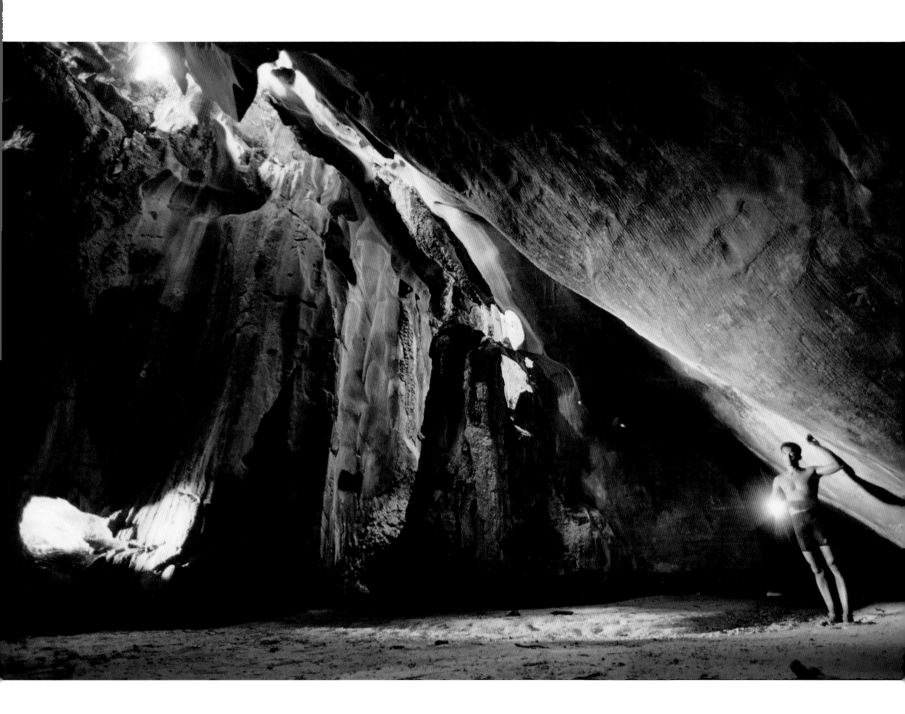

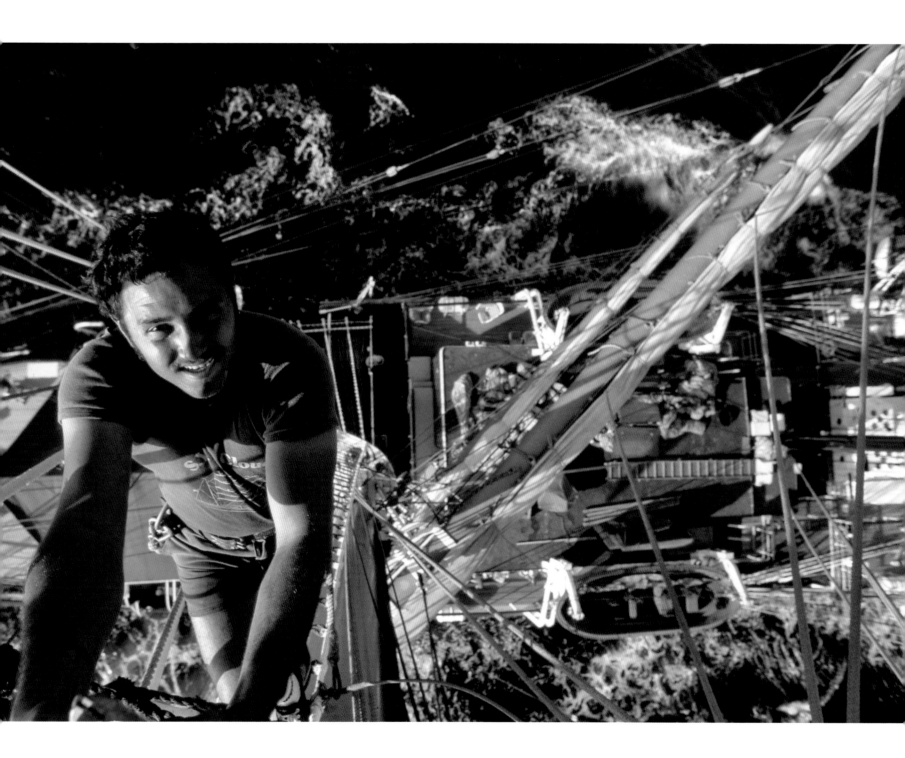

TALL SHIP SAILING ALONG THE TRADE WINDS OF THE CARIBBEAN

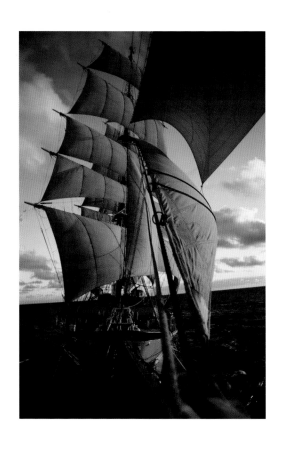

Windswept out of an earlier gilded age, the *SY Sea Cloud* slashes through churning waves and salt spray toward the next exotic port of call. Out of a frame from *Mutiny on the Bounty*, acres of taut canvas scoop gusts and billow, stretching four masts soaring higher than church steeples. On the world's tallest mainmast, a band of deckhands scramble high above teak and mahogany decks, wrestling on the yardarms with a reluctant immensity of bulging fabric. Sails are nimbly adjusted by muscular, tattooed arms working in choreography as ropes are smartly coiled around shiny brass belays. With an officer's assent, you assist with some of the lines, and perhaps ascend the swaying mizzenmast, making certain to fasten your safety harness onto a jackstay. As the ship pitches beneath you, it feels like you're holding on to the wrong side of a wildly swinging pendulum. Later, slump into netting at the far end of a sixty-foot bowsprit and feel the mighty windjammer buck beneath creaking rigging. Below, a pod of dolphins rides the ship's currents, seemingly racing the vessel's figurehead and straining to catch the sea chanteys wafting from crew quarters.

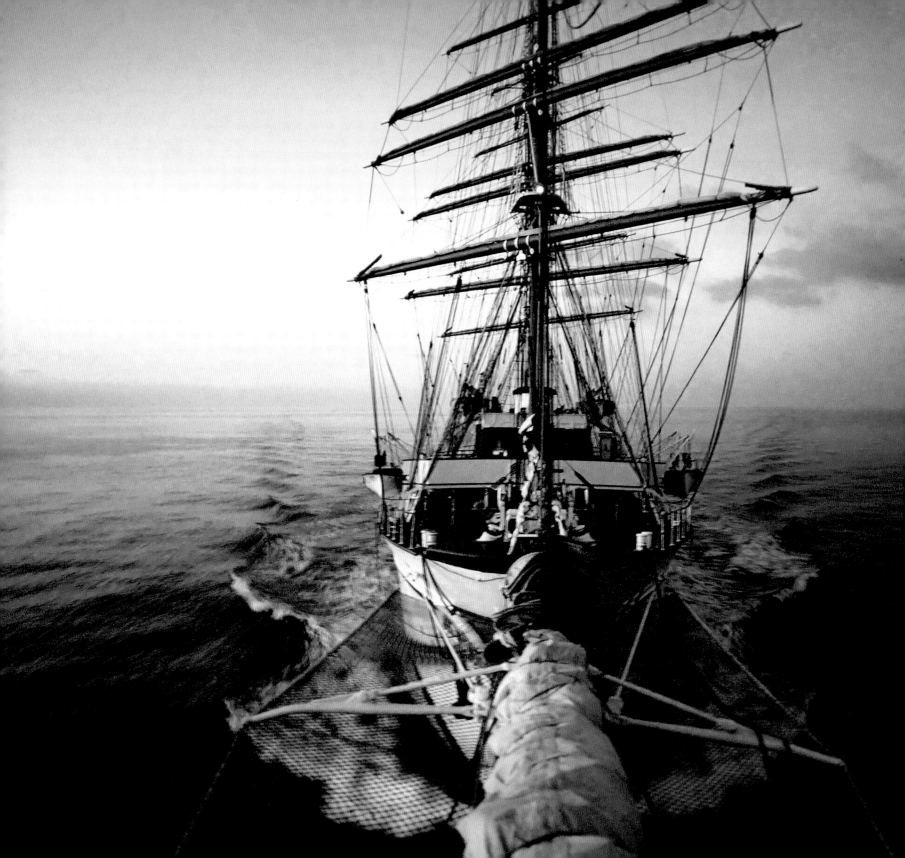

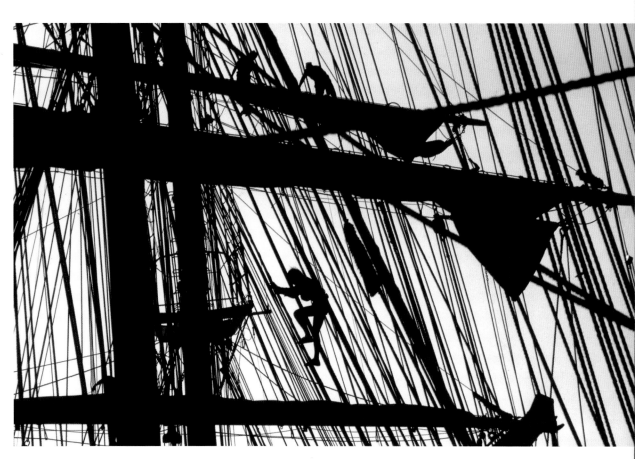

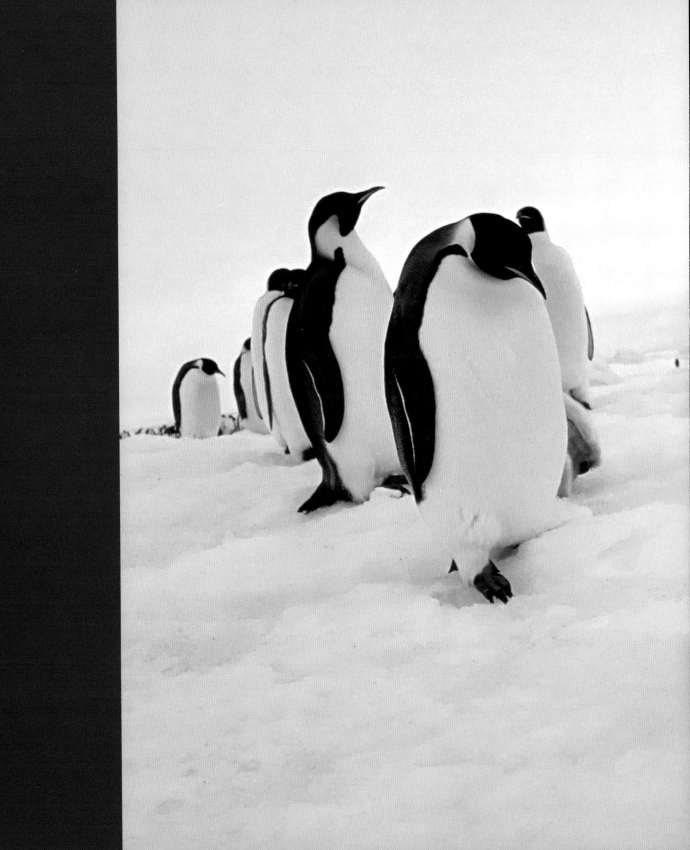

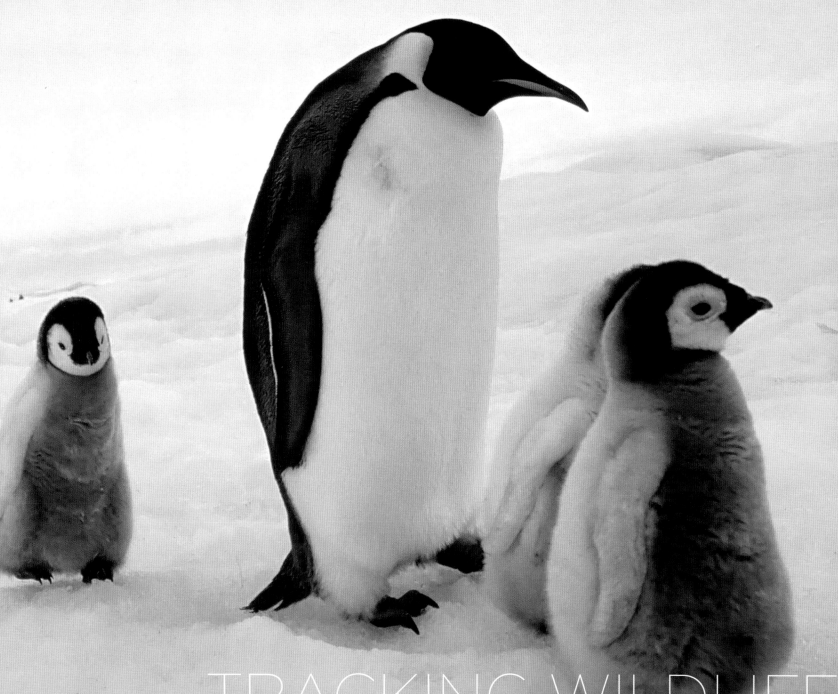

TRACKING WILDLIFE

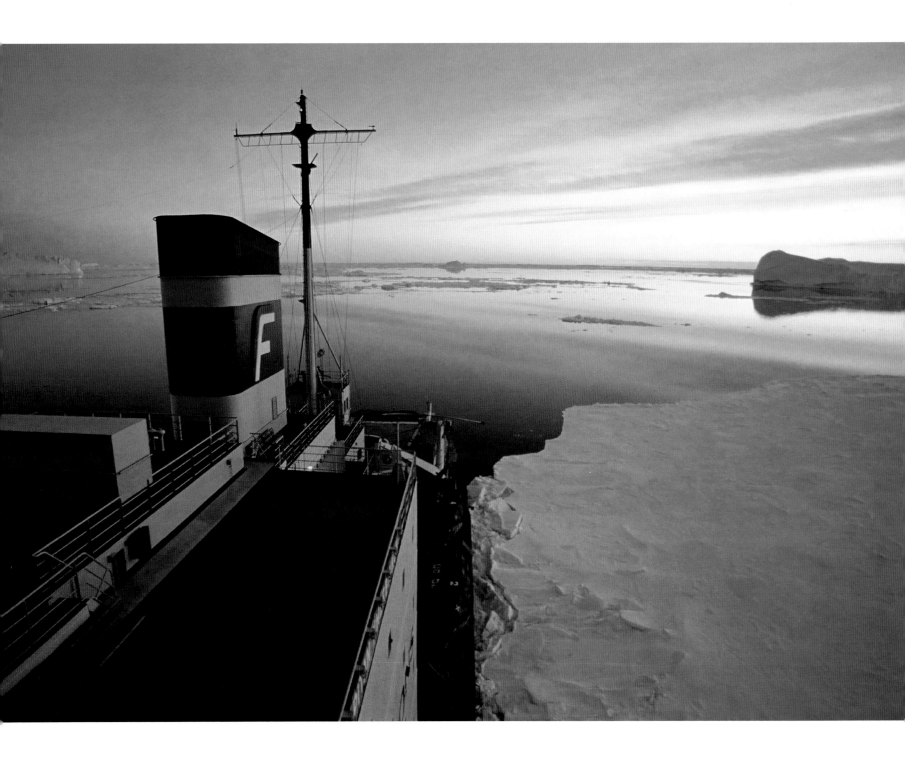

ICEBREAKING TO ANTARCTICA'S REMOTE EMPEROR PENGUIN COLONY

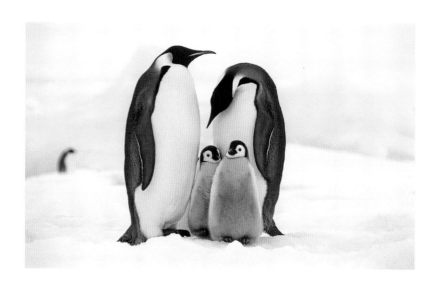 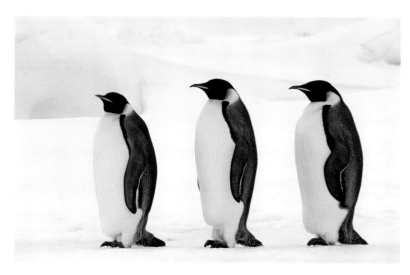

Cracking the inaccessible Weddell Sea sometimes requires the deployed assets of a behemoth icebreaker, as its hull can nudge aside countless miles of stubborn polar cap with the brute force of twenty-five-thousand horsepower engines. On its top deck, helicopter pilots scurry, readying their crafts for the subzero Fahrenheit taxi ride toward Snow Hill Island. Scruffy tents double as a makeshift airport terminal. Bundled deep inside synthetic layers, arriving visitors grab their ski poles to begin an inland trek. In adjacent lanes, the hikers pass numerous avian single-file processions headed the opposite way. In a determined march to the sea, the world's deepest divers will attempt fast food delivery, eventually relieving their feathered monogamous spouses who are now offering a body-heated nest for their squawking offspring. When the birds finally arrive back at the crowded emperor penguin colony, fuzzy chicks gorge on their parents' regurgitated meal of silverfish purée, gathered at depths of a thousand feet, swallowed, stored, and returned fifty miles through blizzard conditions. As storms worsen, adults form a protective corral against howling wind in this harsh, southernmost corner of the planet.

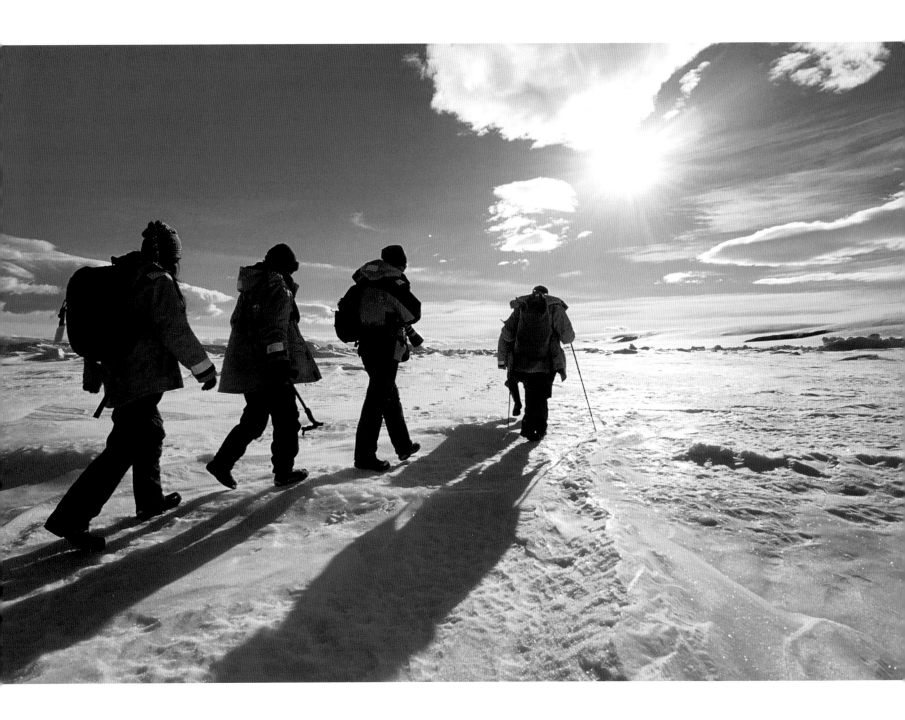

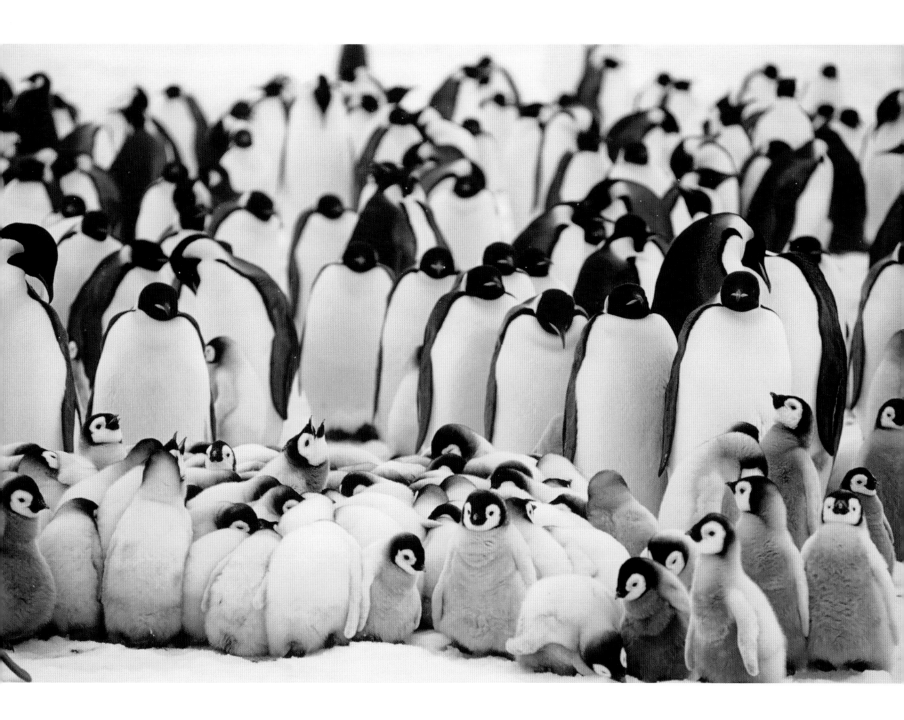

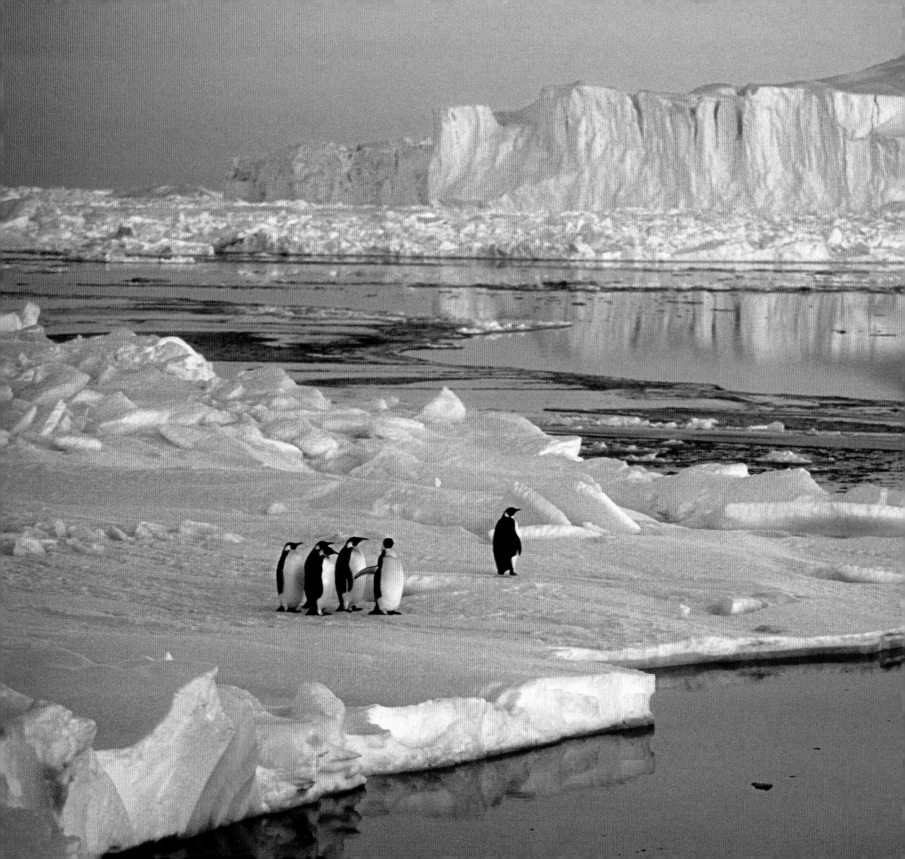

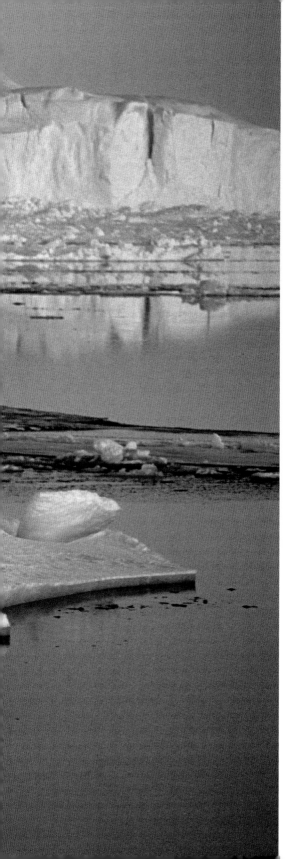
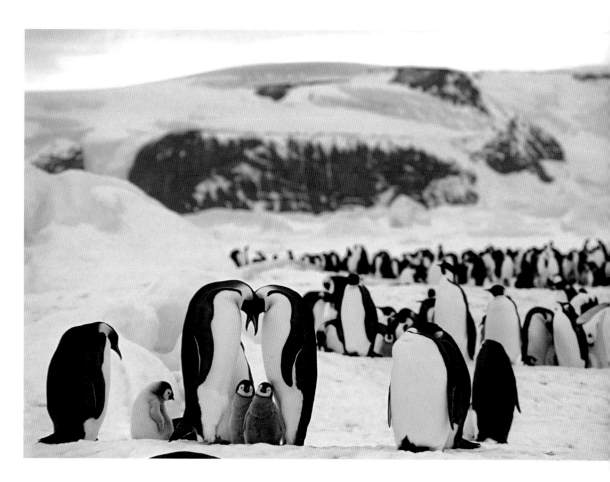

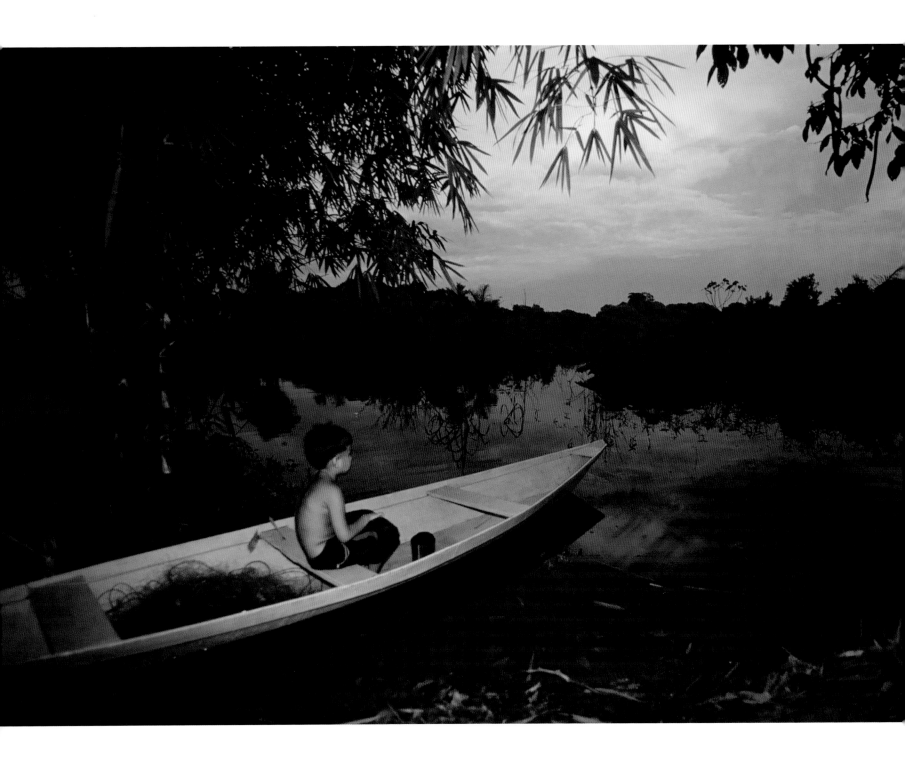

SPOTTING THE AMAZON'S MYSTICAL PINK DOLPHIN

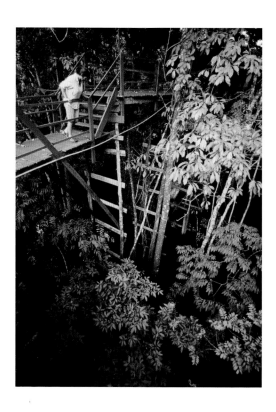

With howler monkeys serving alarm clock duty, arise amongst the misty treetop canopy at Ariau, where six miles of wooden boardwalk lace the dense Amazon. In the heart of the Anavilhanas, the world's largest freshwater archipelago, the massive floodplain swallows a bromeliad-decked jungle where the local Tucana hunt for crocodiles and fish for flesh-eating piranhas. Board a small boat to locate the indigenous people's magical healing totem. The pink dolphin weaves improbably through the forests as swollen rivers allow dispersal of their prey amongst a flooded thicket floor. Their contortion-friendly spines allow tweezer-beaked access through submerged snarls of branched vegetation. Feeding beneath the dark, murky waters is aided by clicking sounds they emit, echolocating sonar that's received through an antennae-like jawbone. Where the Rio Negro's darkened sediments abut the main channel's clearer currents, the legendary boto emerges. Appearing as a huge, rubbery pastel hummingbird, this mammal hoists its three hundred pounds in the air, showing off an astonishing hue painted by a thick concentration of capillaries just beneath the skin's surface.

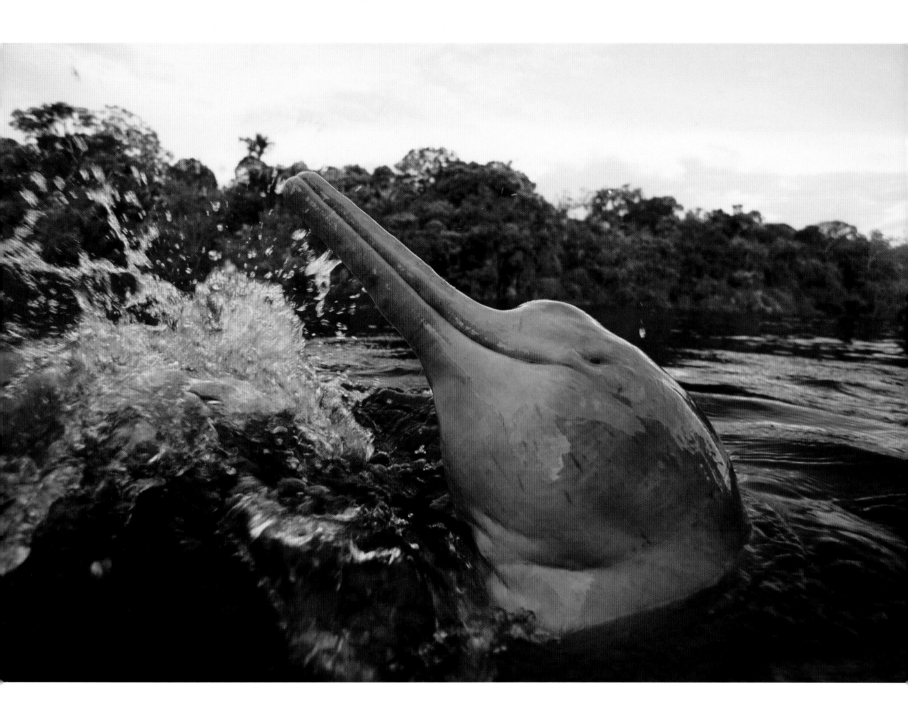

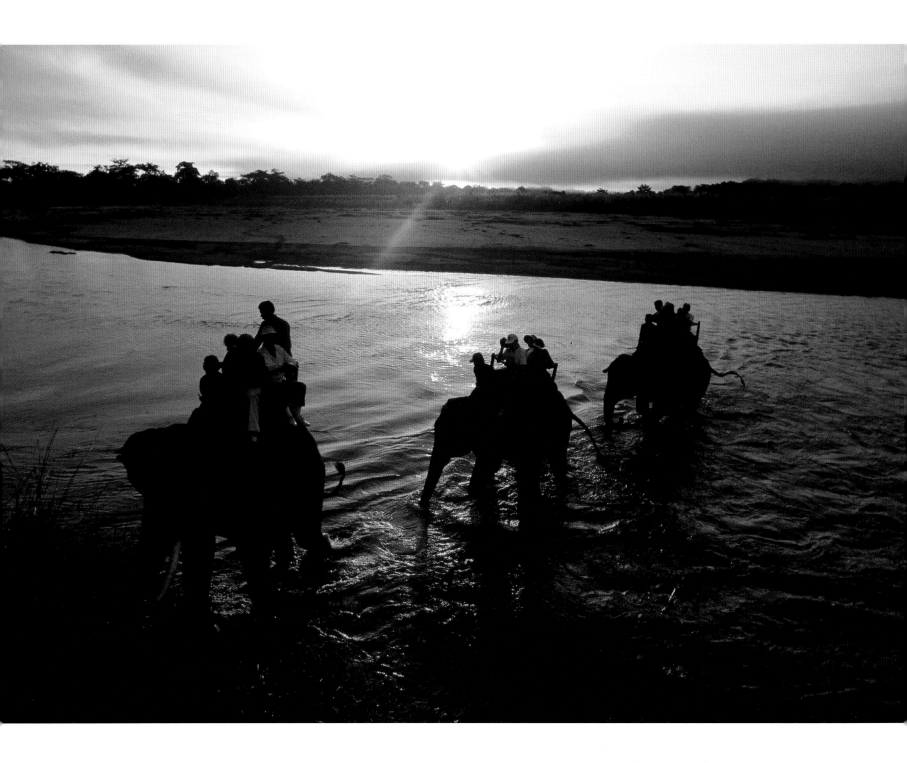

ENCOUNTERING TIGERS
ON ELEPHANT BACK
IN CHITWAN NATIONAL PARK

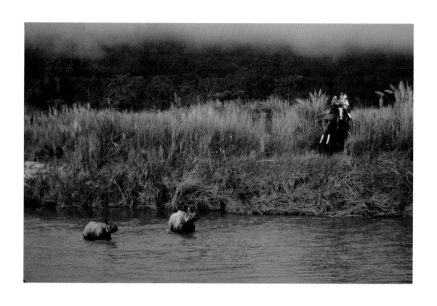

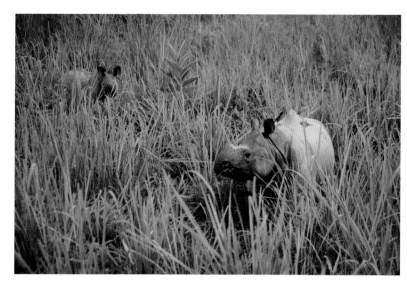

Striking out at dawn, you catch the amber glow on the misty grasslands by the Rapti River as it silhouettes a lumbering parade of ivory-tusked pachyderms. They wade through languid waters bound for heavily wooded forests across the shore. In a page torn from Rudyard Kipling's *The Jungle Book*, kingfishers flit above fish-eating gharial crocodiles while honey badgers and sloth bears keep an alert eye for prowling tigers. Atop a rhythmically swaying platform, you brace your legs around the bamboo howdah post. This elevated view over the plains reveals a snorting, mud-caked one-horned rhinoceros emerging from a favored watering hole. The mahout driver utilizes his *cheru kol* elephant brake to pinpoint the fleeting sight of a distant tiger, largest of all feline species. The cat's orange- and black-striped pattern is designed to provide confusing camouflage amongst the scraggly brush. The muscular, eleven-foot carnivorous predator marks his territory amongst a stand of shala trees with a roar, accompanied by a squirt of urine. The resulting silence elicits a spine-tingling fear, mitigated only by the awareness that you're high atop earth's biggest land mammal.

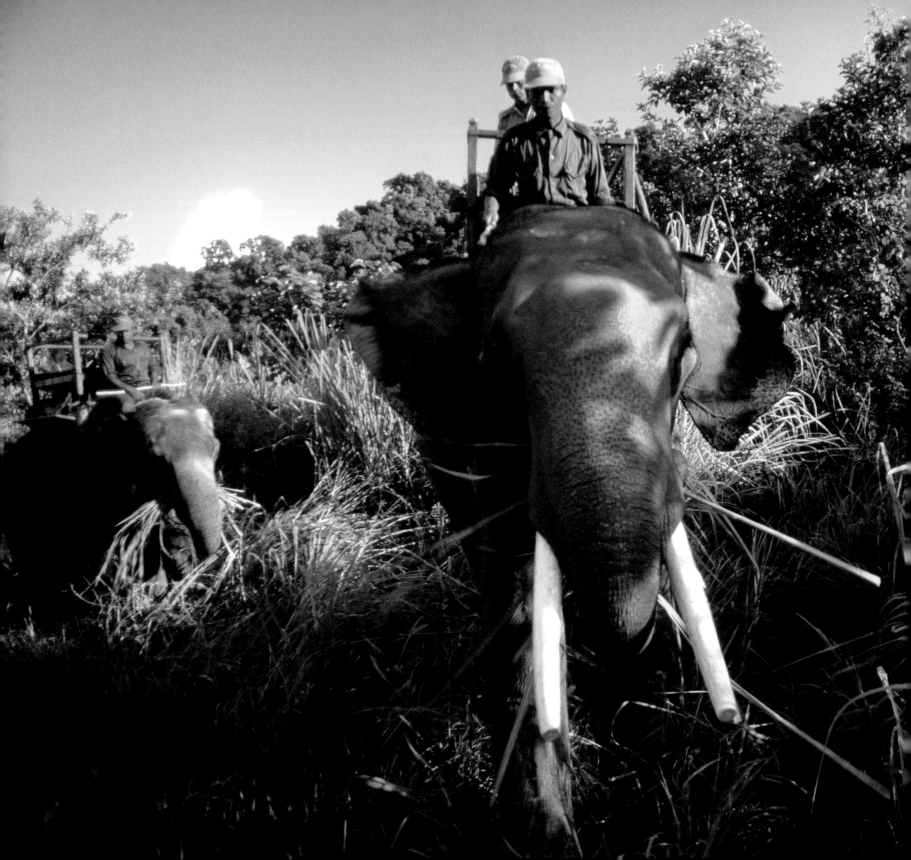

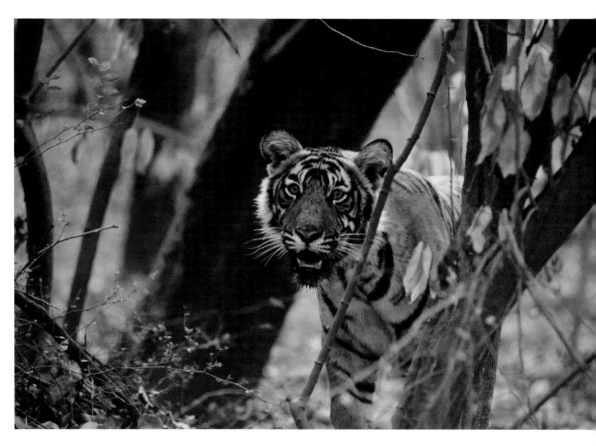

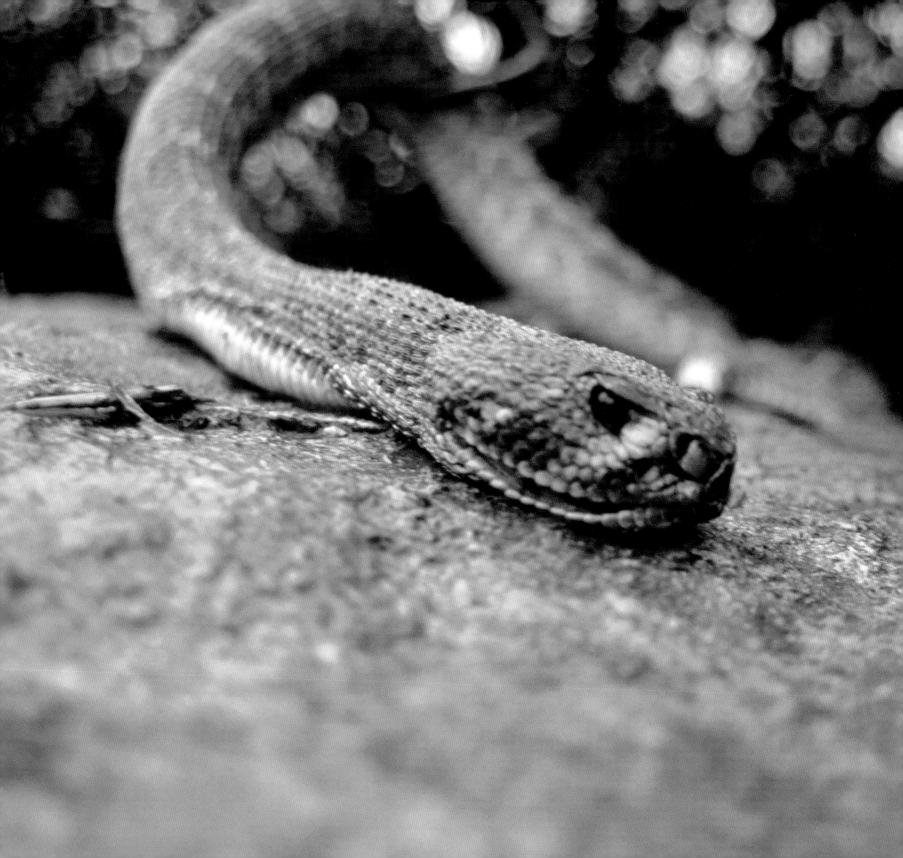

RATTLESNAKE HUNTING
IN WEST TEXAS

Dust and tumbleweed sweep across the desolate, windblown West Texas prairie, a favorite habitat of the western diamondback. The overpopulation of these serpentine pit vipers, more aggressive than other rattlesnake species, is a major concern for local ranchers fearing for the safety of unsuspecting children and livestock. Out amongst the cactus and sagebrush, only sure-footed Kevlar-legged wranglers dare attempt the gathering of one of Earth's most deadly predators. Despite its poor vision, the six-foot slithering reptile can track its prey with heat-sensing facial pits and a flicking tongue that enables olfactory detection. Hidden, limestone rock-protected dens may signal a horde of coiled snakes, unveiled by steady-nerved hunters with small handheld mirrors to reflect the searing sun into subterranean passages. When disturbed, the hissing, maraca-pitched tail-shaker can rattle up to ninety times per second, the fastest firing muscle in the world. Wielding a pinner with adept hooking finesse, rattlers are flung into wooden boxes, eventually supplying a milking-delivered antidote from their fang's concentrated, tissue-destroying, hemorrhage-inducing venom.

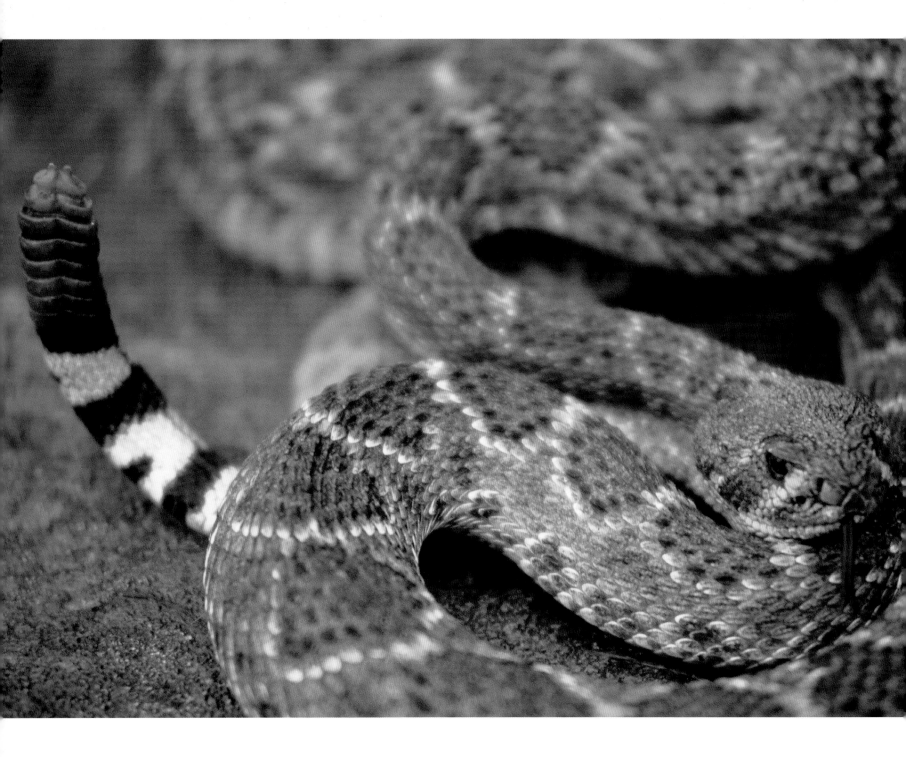

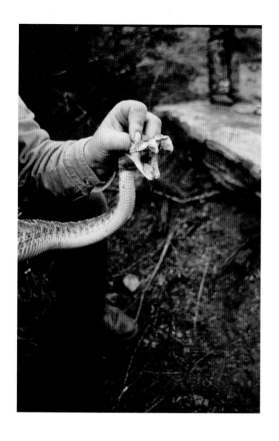

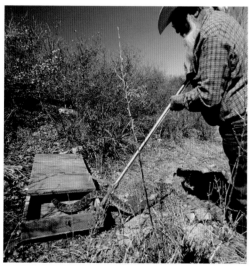

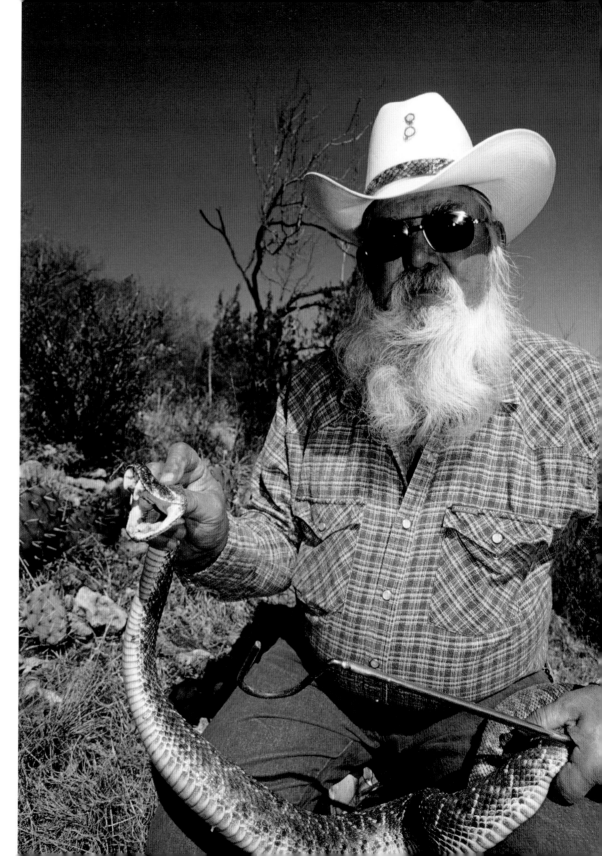

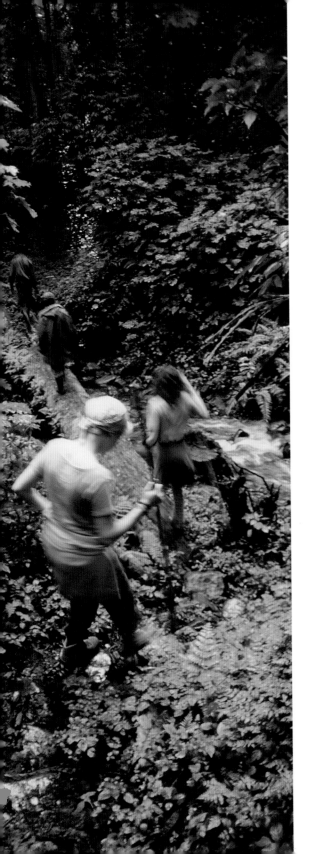

GORILLA TRACKING INTO THE RAIN FORESTS OF UGANDA

In the heart of Africa's equatorial belt, Bwindi Impenetrable National Park is a moisture-laden carpet of crinkled topography. Clinging to their dwindling cloud-soaked living quarters, mountain gorillas, now measured only in the hundreds, are threatened by extinction, yet were completely unknown to Westerners until the twentieth century. A nearly unfathomable snarl of scrambled vegetation conceals the pathways of these nomadic great apes whose mobile homes are created anew each evening—nests resembling temporary sleeping bags of leaves and branches. At daybreak, head out from camp with a sharp-eyed jungle sleuth who carves a bushwhacked swath with rhythmical slashes of his machete. Howling chimpanzees trapeze across the jungle canopy as butterflies trace a scattershot trajectory, splashing iridescence into dimly lit, moss-carpeted recesses. Ahead, steep, taunting ridges hide slippery valleys where bronze pools are forged. Careful footing sidesteps determined streams of hungry army ants. Wearing heavy gloves to thwart stinging nettles, you grasp at handrails of vine, enabling a climb down the ladder of primate evolution.

Telltale dung and squashed vegetation hint at an approaching rendezvous. To avoid human transmission of disease, there is careful monitoring of both distance and time spent with one of our genetically closest zoological relatives. Peering through dense brush, you first spot the patent leather complexion of a thickly haired silverback, who snacks on bitter wild celery. Crouch submissively and avert your eyes. Soon his knuckle-walking harem and offspring emerge from camouflaged cover to resume their meal at the salad bar.

When finally satisfied, the graying patriarch begins a King Kong-style ascent, heaving his astonishing six-hundred-pound weight into the treetops. Here, the world's heaviest climbing animal signals to the rest of his troop that naptime has begun, loudly announced with a belching grunt of contentment.

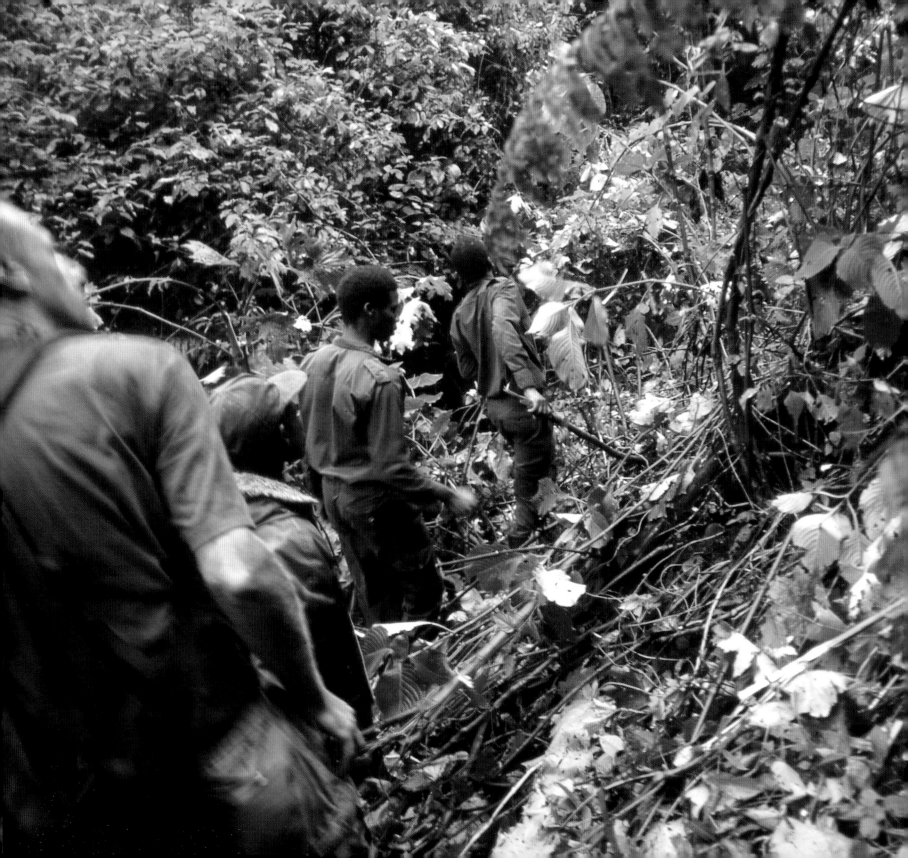

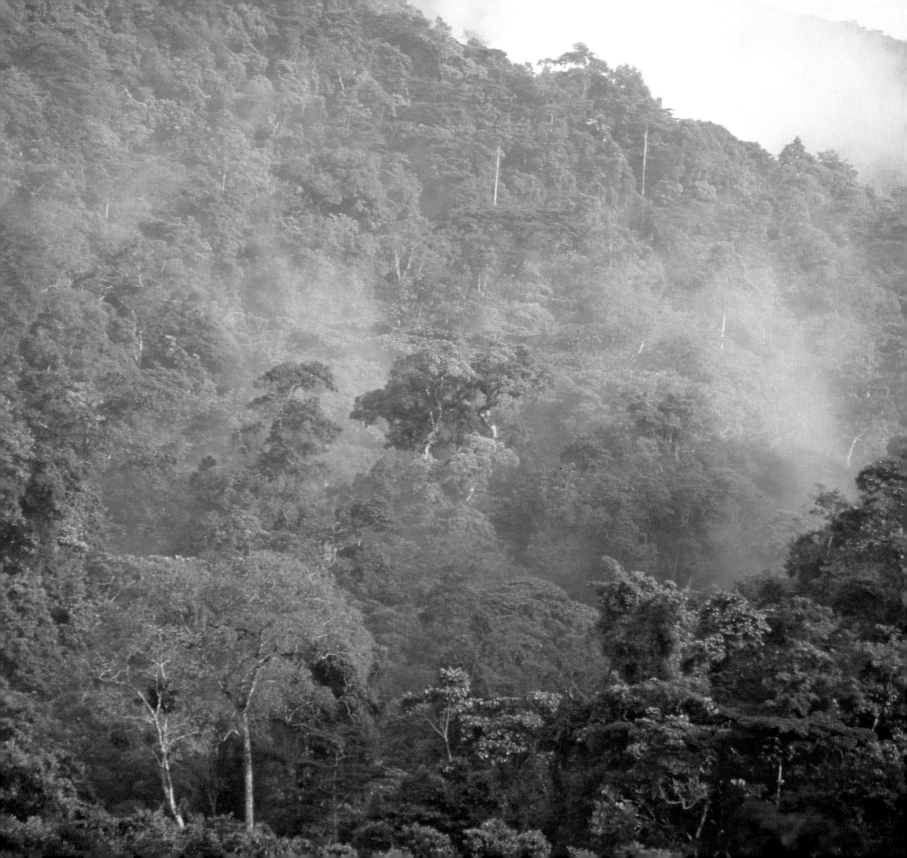

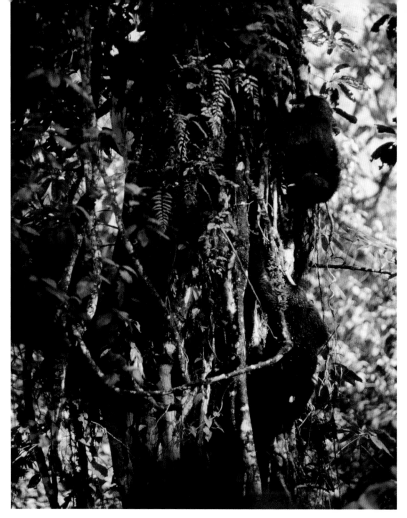
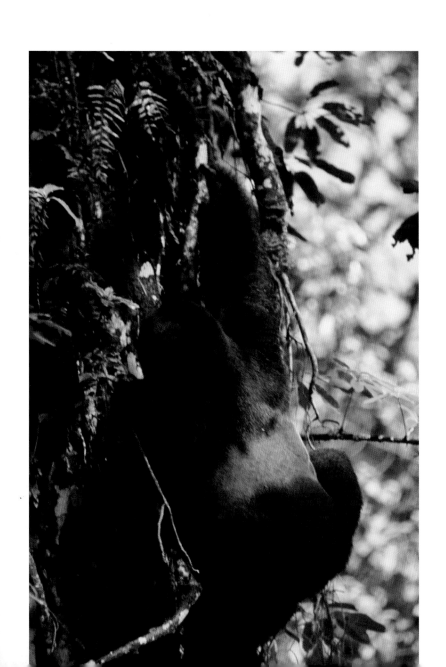
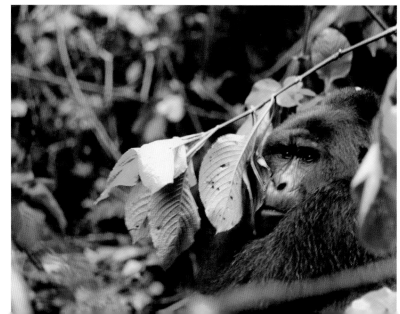

CARESSING GRAY WHALES
INSIDE SAN IGNACIO LAGOON

The ten-thousand-mile round-trip commute of the gray whale is the greatest migratory marathon of any mammal. After a summer spent munching on amphipods in the nippy Bering Sea, these leviathans find their way down into the bathtub-warm safety of the Baja California peninsula's hidden lagoons, their liquid maternity ward. Above, a tightly formed squadron of pelicans glides toward sculpted shoreline dunes, while distant grays hoist their 150 tons of blubber into a spyhopping telescope formation. Having been sighted, the friendly whales maneuver closer to your bobbing craft and signal their interest in a meeting with their pungent exhalations. A startling rainbow of mucus and salt water spray across your bow as the panga's idling engines lure nursing newborns with riveting vibrations. Easily the mass of ten elephants, the protective mama emerges from the emerald depths, bumping the fishing vessel with some playful swats of her powerful flipper. Gazing into the intelligent soul cradling those baseball-sized eyes, it seems difficult to resist the temptation to plant a kiss on that beautiful barnacle-encrusted jowl.

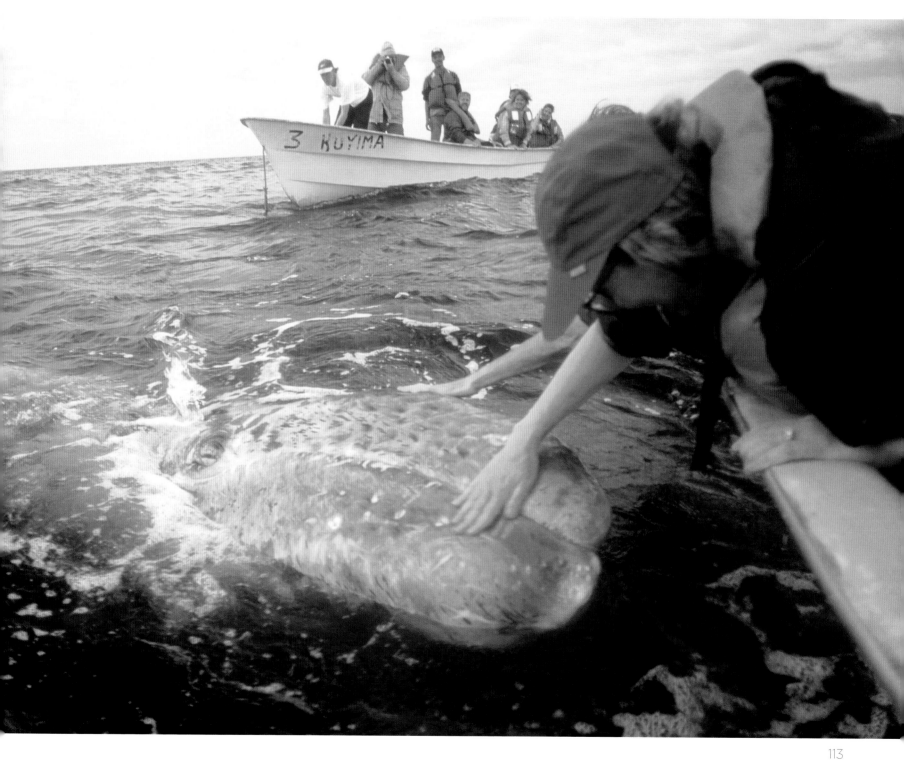

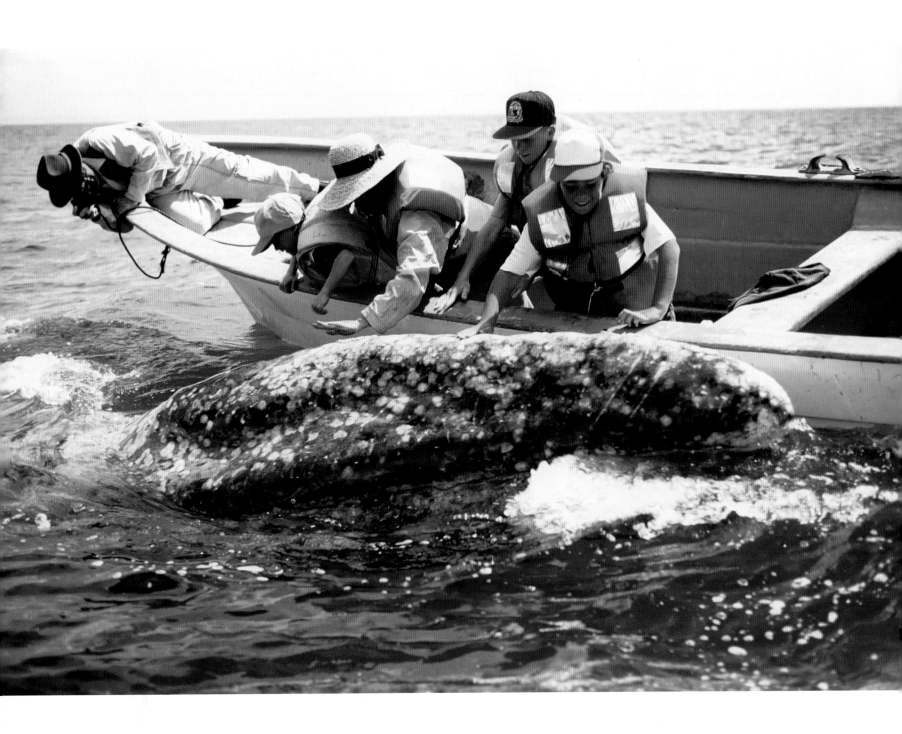

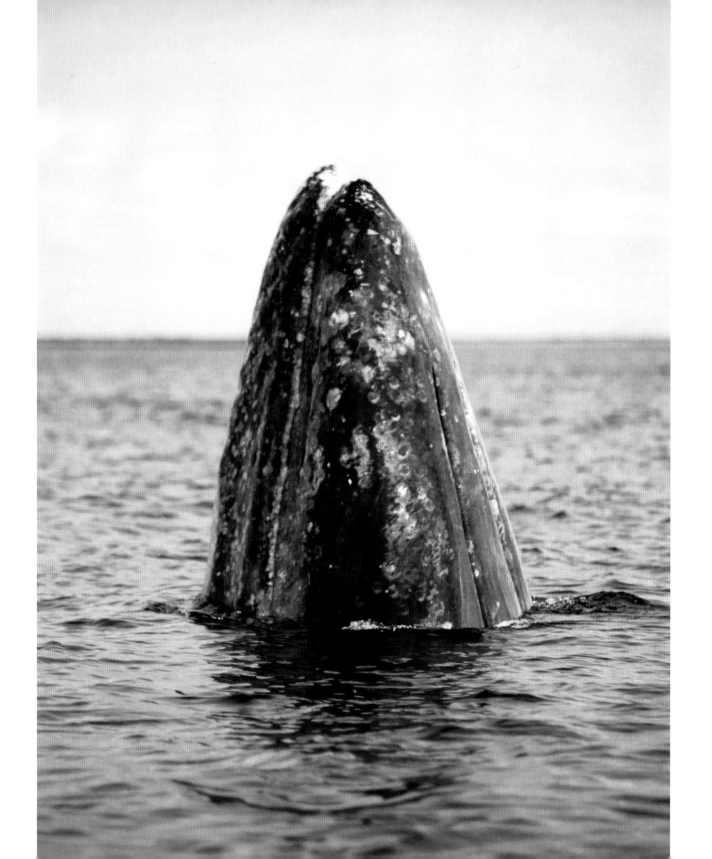

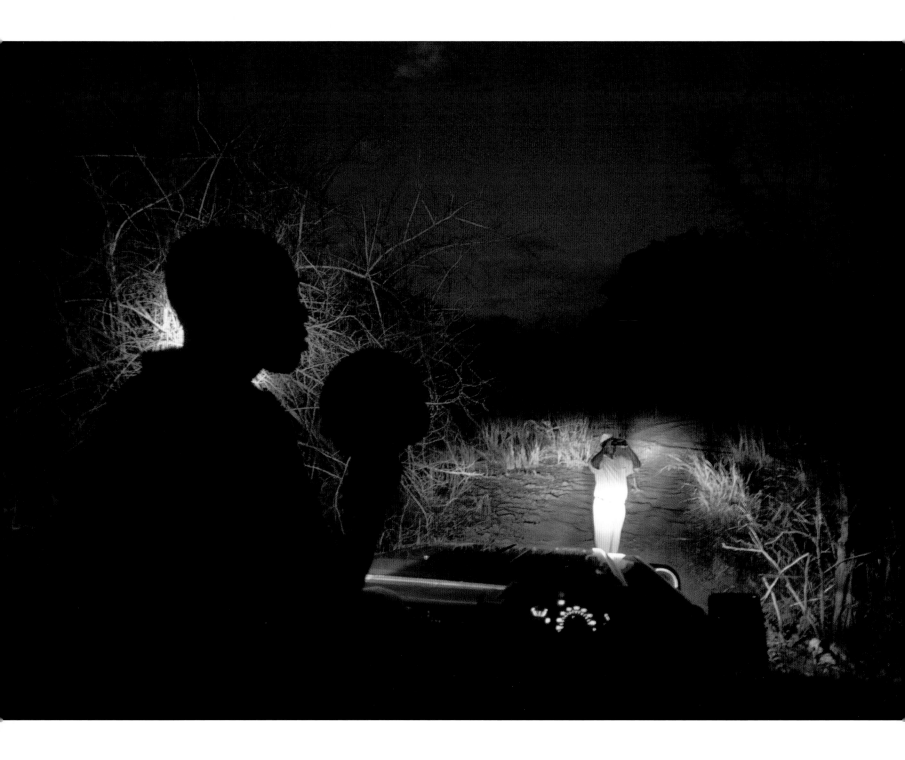

NIGHT SAFARIING WITHIN ZAMBIA'S LUANGWA SAVANNAH

 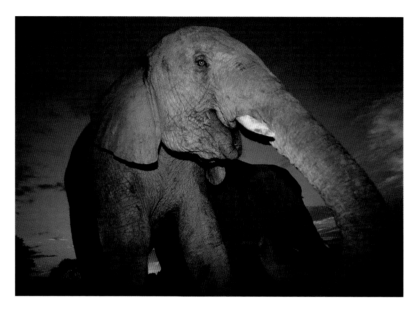

When David Livingstone first stumbled upon Victoria Falls in the nineteenth century, the world's attention turned to this landlocked African nation. The undulating high plateaus that dominate Zambia are deeply scratched by river valleys pouring their liquid cargo downstream toward that majestic waterfall. In the dry season, large populations of wildlife crowd the dwindling watering holes and riverbanks. To access the zoological heart of the savannah, a paddle-pulled cable ferry rafts your 4WD across the murky Luangwa River and past mud bathing hippos. As the equatorial sun swiftly lowers beneath clusters of acacia trees, the ambient volume of wildlife sounds quickly rises, announcing the animals' most active time of day. Amplifying the acoustics, a choir of chirping crickets crescendo as drivers train handheld spotlights on the darkening scene, quickly spotting the highly reflective crystals imbedded at the rear of most mammalian eyeballs. Leopards prowl for prey, and as cheetahs gnaw on their victims, impatient hyenas maneuver for leftovers. On the edge of the nocturnal drama, lumbering elephants vie for a moonlight stroll during the coolest hours on the tropical clock.

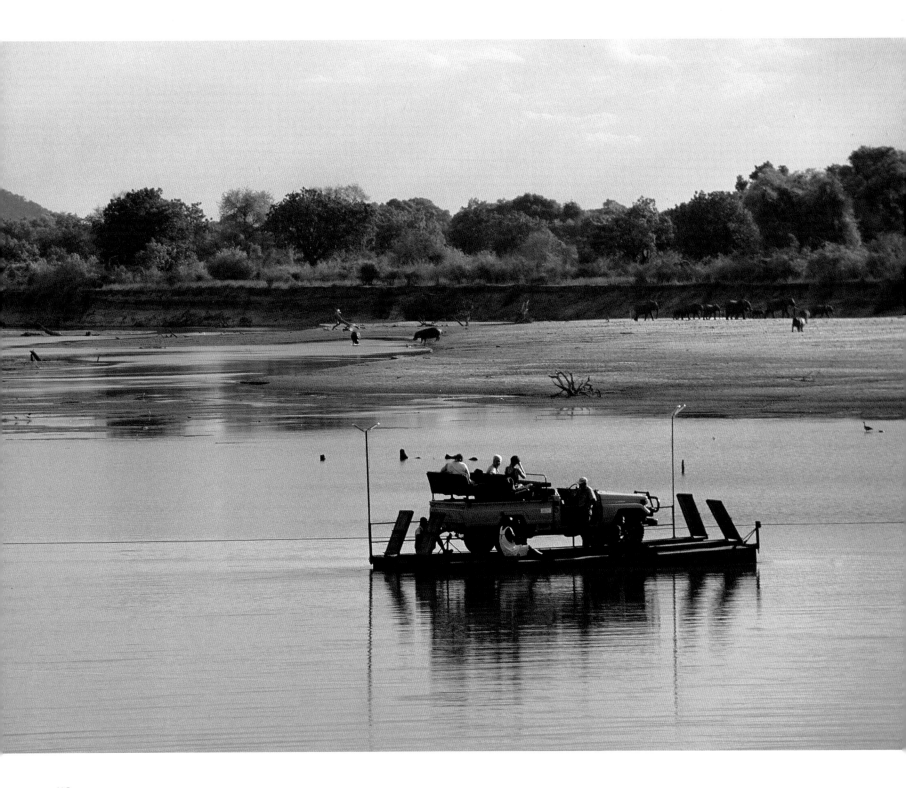

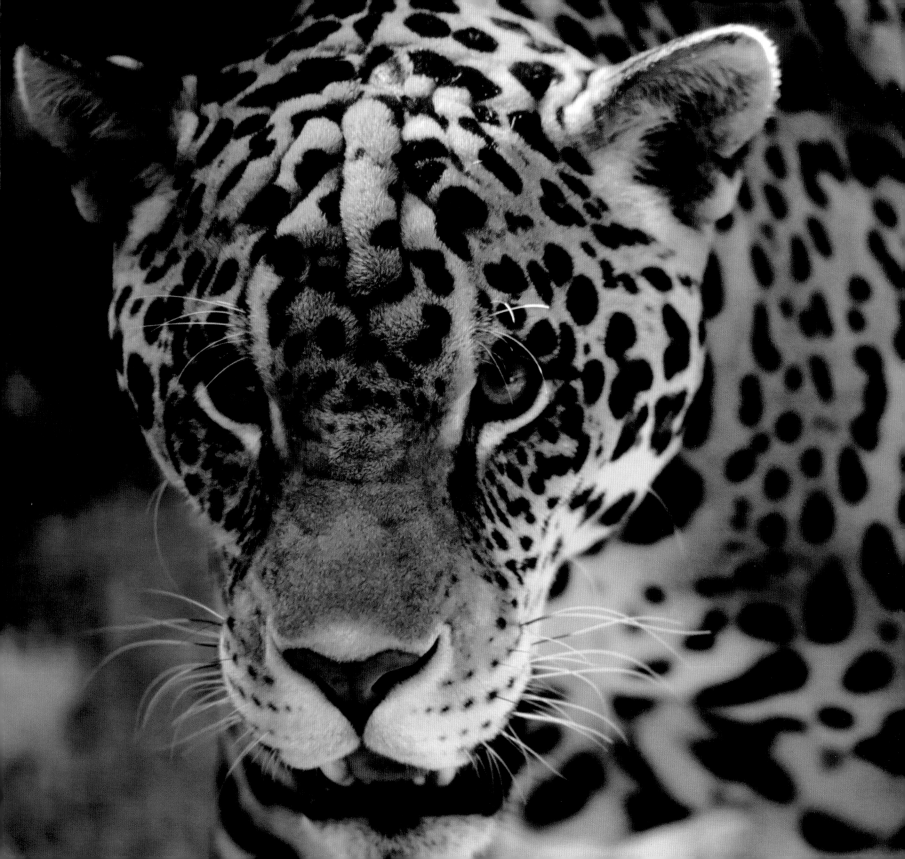

STALKING JAGUARS ALONG THE GOLDEN STREAM IN BELIZE

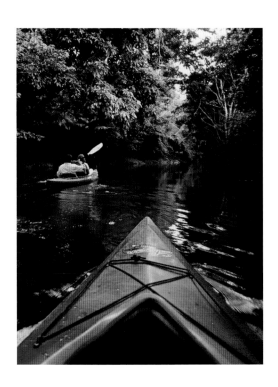

The least populated nation in Central America houses its largest jaguar count. Belize is bisected by the aptly named Golden Stream, which sweeps tannin-stained flows scraped from adjoining jungle vegetation. A crucial trans-habitat corridor for the solitary *panthera orca*, the river strings together the mountainous headwaters where trickles emerge from cave-riddled mountains and gurgles through rain forests of red-eyed tree frogs, picking up a wider current on its way toward the bay's saltwater mangroves. While kayaking down the languid, ceiba-shaded river, where tapirs clumsily rummage for fruit with their prehensile noses, Mayan jungle guides eyeball promising riverbank trails that feature fresh paw prints and territorial scratches on the orchid-scented trunks of fig trees. Quietly spying on the action below, the largest cats in the Western Hemisphere maintain an inactive daytime calendar. Yet, as darkness advances during a rapid equatorial sunset, baritone grunting from treetops alerts surrounding wildlife to prepare for the fierce, record-breaking nature of this nocturnal hunter's pressure-per-inch bite.

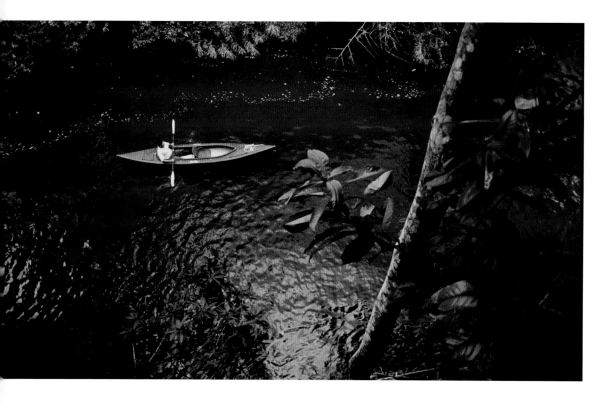

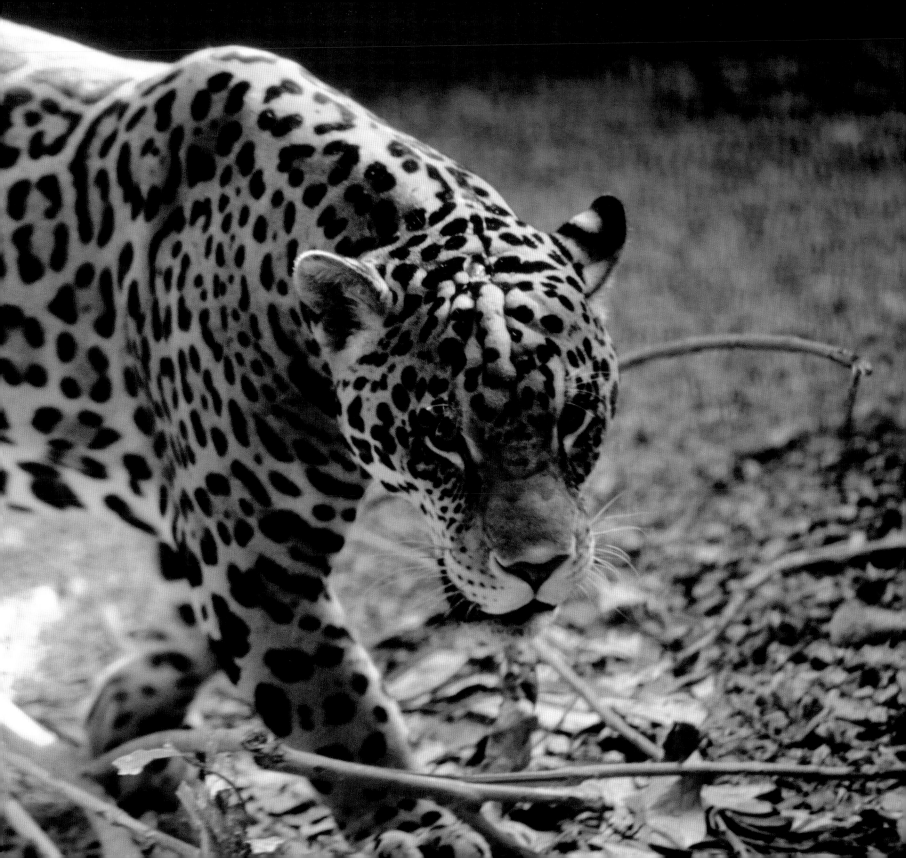

SUBMERGING UNDER PALAU'S JELLYFISH LAKE

Out in the North Pacific, Micronesia harbors an inordinate bounty of exotic cultures and natural history. Palau's Rock Islands are a scattered cluster of pristine coral jigsaw pieces, sculpted fancifully into green-bearded mushrooms and rimmed by ivory slivers of sandy beach. On Eil Malk, hold-ropes assist climbs up a steep trail to a hidden, bewitching pocket of aquatic wonder. Dipping gently into Jellyfish Lake, you soon encounter a scattering of stingless golden jellyfish. Through evolution, their nematocystic stinging cells lost their potency, sieved through three Miocene era limestone fissures that connect with the sea. A swim to the marine loch's sun-dappled core finds you submerged amongst thirteen million gently pulsating orbs, busy with their twice-daily, nitrogen-seeking horizontal migration across waters where shoreline shadows warn of anemone predators. Nearing the surface, they'll spin rotisserie-style in slow, counterclockwise movements, evenly exposing the sugar-converting algae they host to the sun. Avoid dangerous clouds of hydrogen sulfide floating below this meromictic, liquid layer cake, eerily topped by a throbbing ballet of drifting aliens.

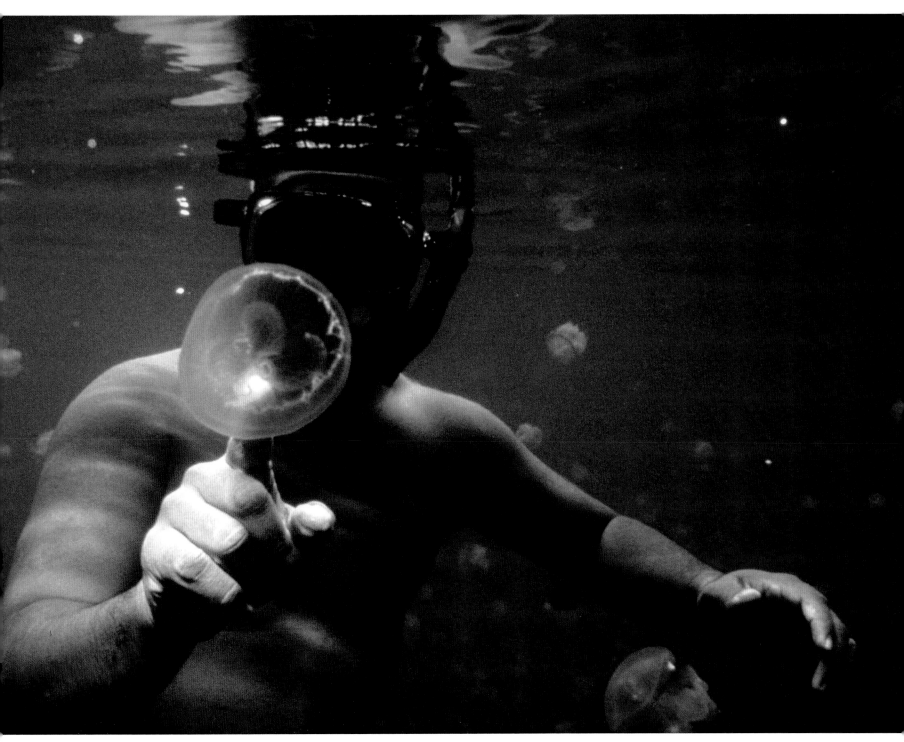

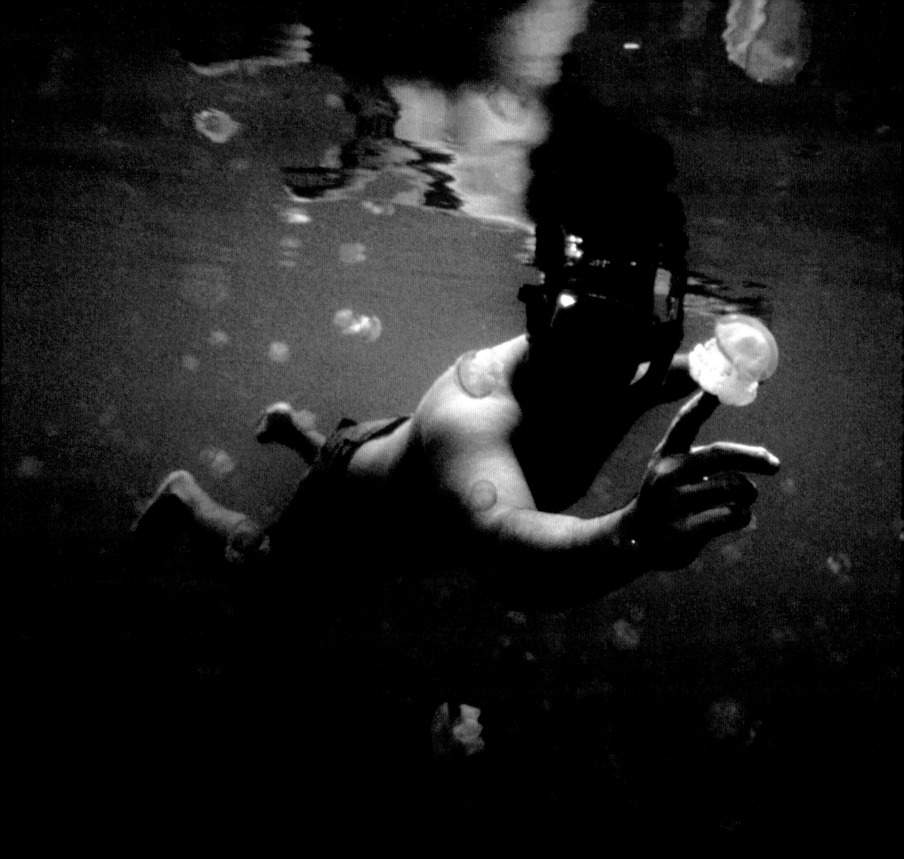

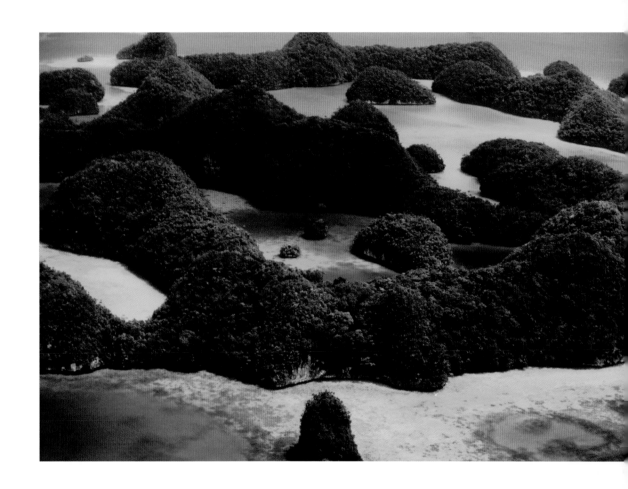

VERIFYING THE EXISTENCE OF THE SPIRIT BEAR

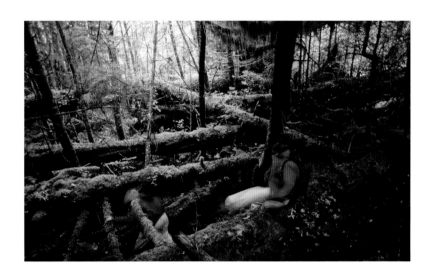 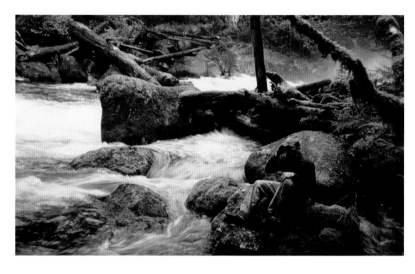

Anchoring fog-kissed fjords, the temperate Great Bear Rainforest is the largest in the world. To access the gloomy interior of moist Gribbell Island, wade past barnacle-crusted boulders guarding the grassy estuary and weave between a rotting tangle of dank, moss-coated pick-up sticks. By a gurgling stream and under a continuous drizzle, grab the nearest waterlogged seat. Come equipped with a generous supply of patience and be rewarded through binocular lenses only when timely appetites find autumn's salmon-choked creeks irresistible. Mostly found on this particular island, the elusive Kermode bear eventually lumbers haltingly toward his all-you-can-eat seafood buffet. This ursine subspecies, revered by the local Gitga'a community and studied intensely by scientists, bears a hereditary concentration of double recessive genes that gift the mystical creature with a shaggy, vanilla carpet of fur. Amidst a spooky riverine world of fishing wolves and swimming ungulates, the ghostly mirage of this adept, sharp-clawed fisherman quickly disappears into the slippery mists with its meal, leaving you shivering with both wonder and sogginess.

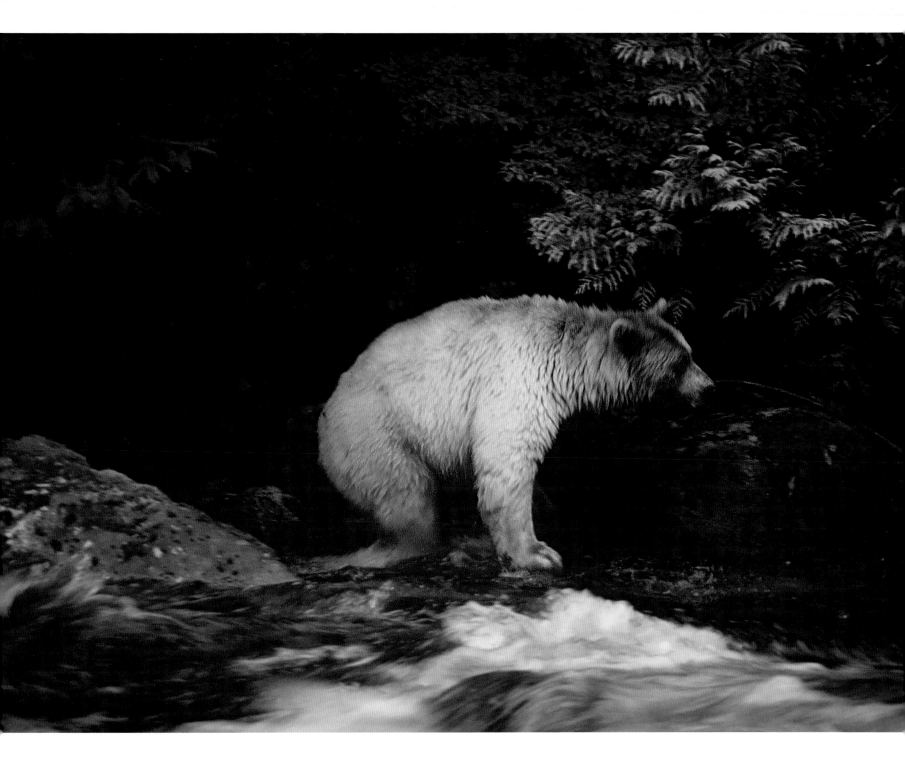

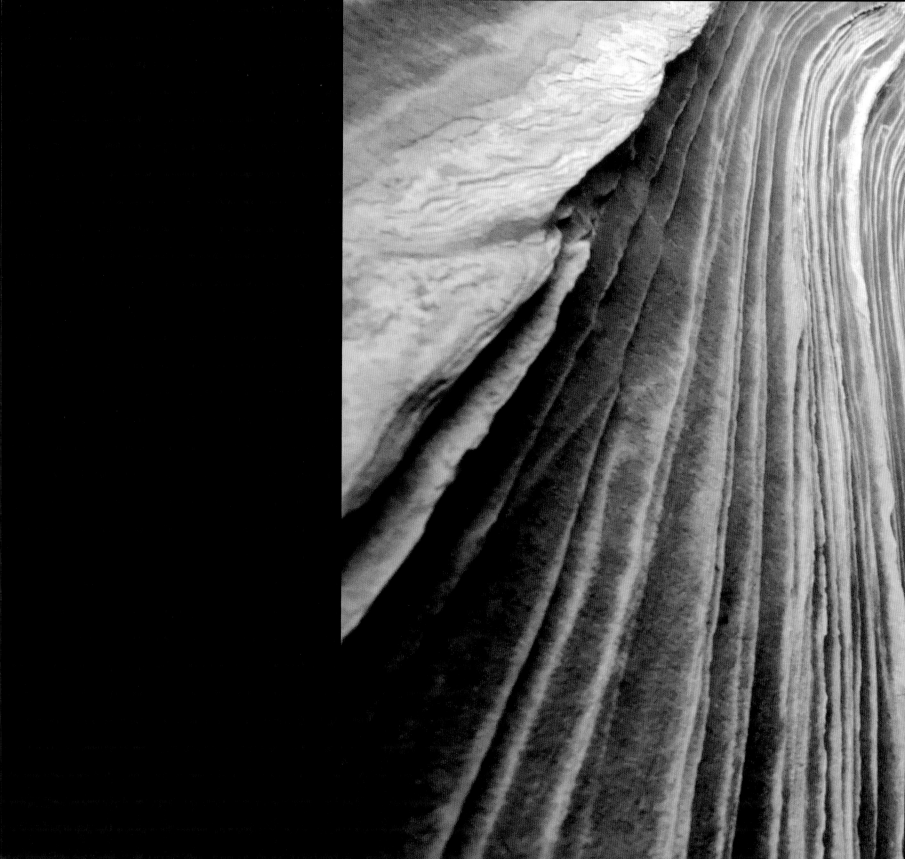

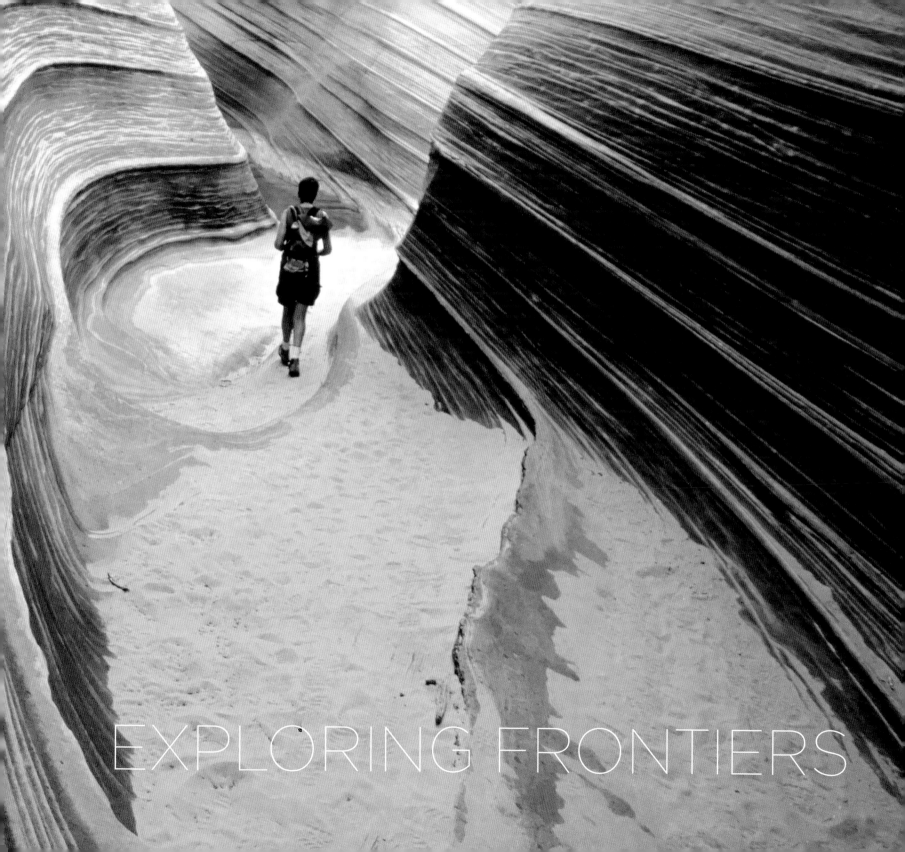

EXPLORING FRONTIERS

ORIENTEERING TOWARD THE WAVE AT COYOTE BUTTES

Victory in a four-month advance lottery provides an assured gateway to the Vermilion Cliffs' most spectacular treasure. The Wave is an astonishing undulation of candy-striped sandstone fins, delicately sculpted from petrified sand dunes still nurturing a dinosaur dance floor. Thankfully, only twenty people a day receive permits to explore this Early Jurassic sanctuary, unscathed by trails of any sort. With ample water, begin at a Utah ranger station, crossing the wash, ascending slickrock and heading south through landscapes ablaze in both rusty hues and shadeless furnace-like heat reflected off a desert bakery. Orienteering with the help of charts and images, search for landmarks east of the saddle and dutifully memorize the scene behind you to ensure a safe return. Hiking into Arizona, keep alert for the black crack on the southern cliff face pointing to intimidating sandy hills and the secret passageway into a magical destination. Roller-coastering swirls of layer-caked geology dip into vernal pools brimming with tadpoles and soar amidst parched scoops of stone swimming with lizards. The privilege of experiencing this dreamy wonderland will probably summon prayerful thanks.

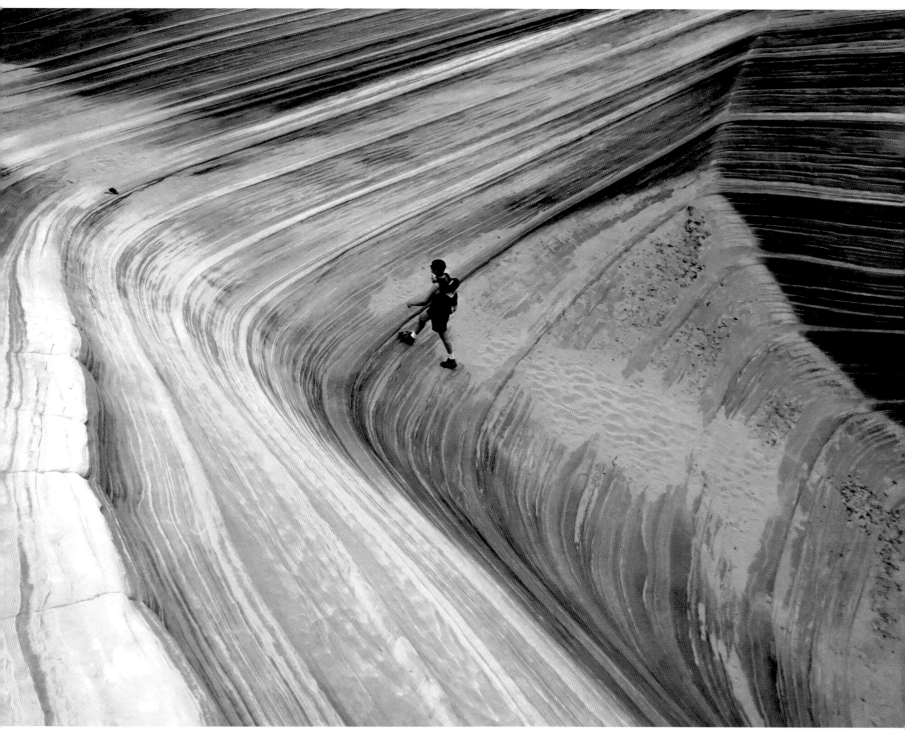

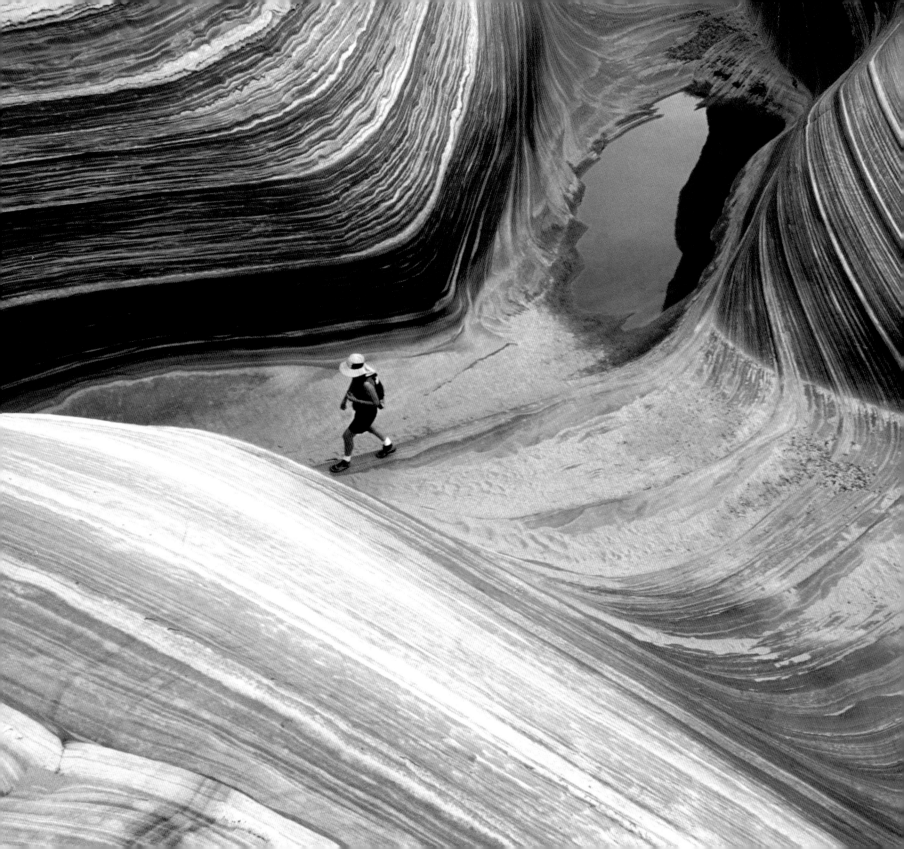

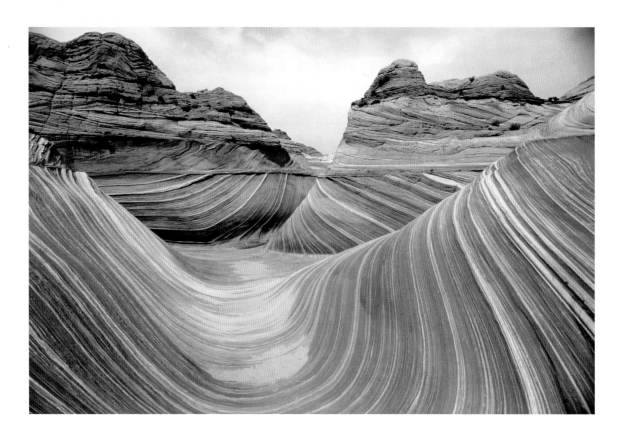

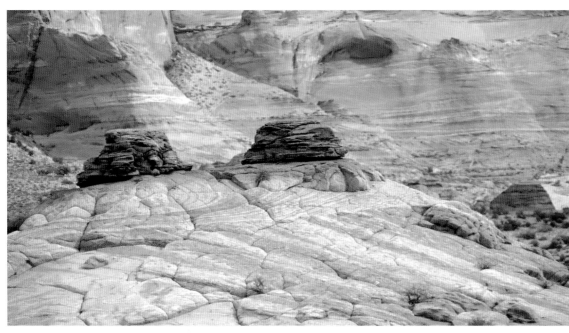

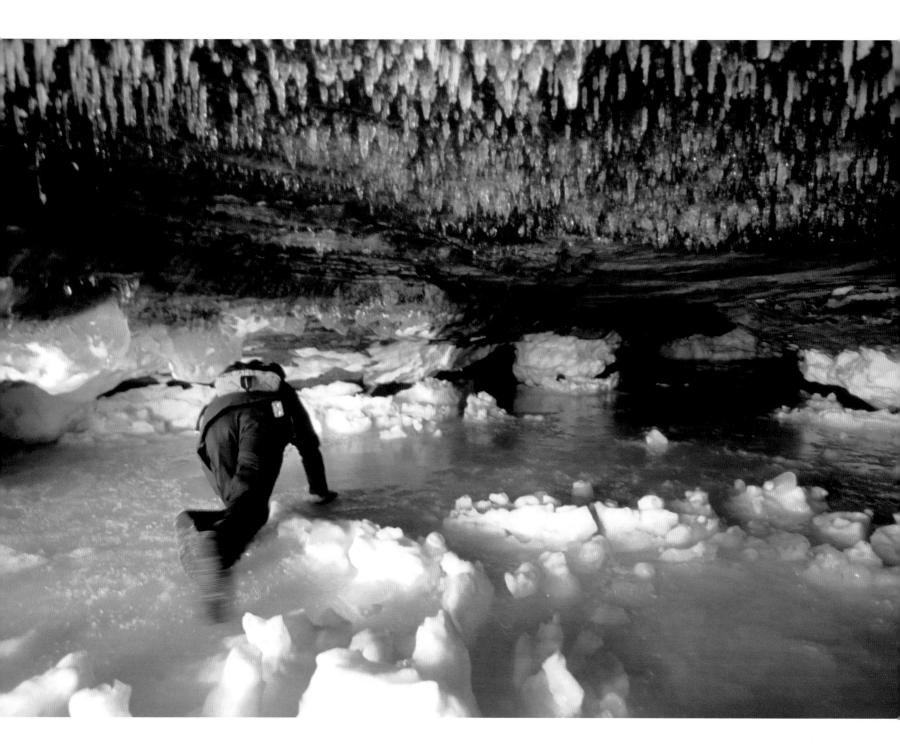

ICE CAVING THE APOSTLE ISLANDS

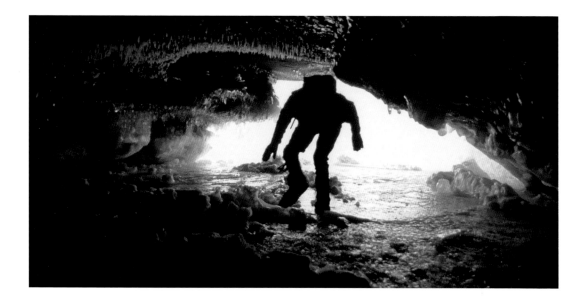

When the temperature plunges, a gingerly walk on water provides access to the immense frozen expanses of the world's largest freshwater lake. Underfoot, foreboding cracks creak and groan with a disconcerting orchestration as you stabilize your traction in the howling winds. On Lake Superior's horizon, rusty sandstone pillars invite entrance into a seldom-seen fairyland of honeycombed tunnels and vaulted chambers dripping with glazed mounds of slippery, mineral-tinted orbs. Brandishing a flashlight, you penetrate the inner sanctums by crawling beneath an inverted forest of translucent soda straw formations, a chilled souvenir of summer's incessant seepage. A millennium of lakeshore wave action, engaged in an alternating dance of freezing and thawing, has sculpted these exquisitely delicate ice palaces. Visible only during particularly frigid years when nature paves a pathway by the western shores of the Apostle Islands, this remote corner along the Great Lakes receives a rare treasure trove of winter's capricious artistry. As the sun hangs low on the horizon, it paints the icicles a dazzling vermillion, offering a harbinger of their forthcoming seasonal disappearance.

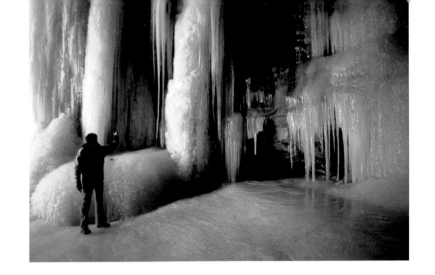

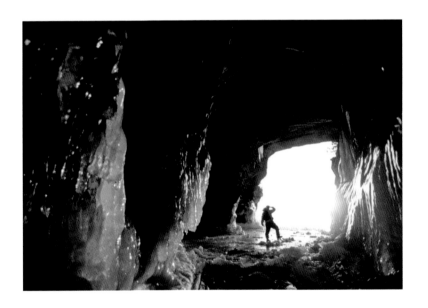

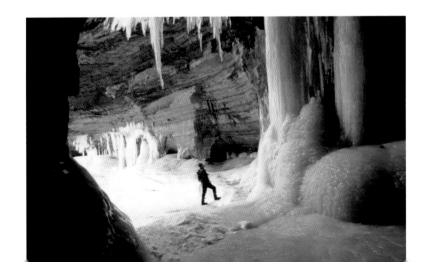

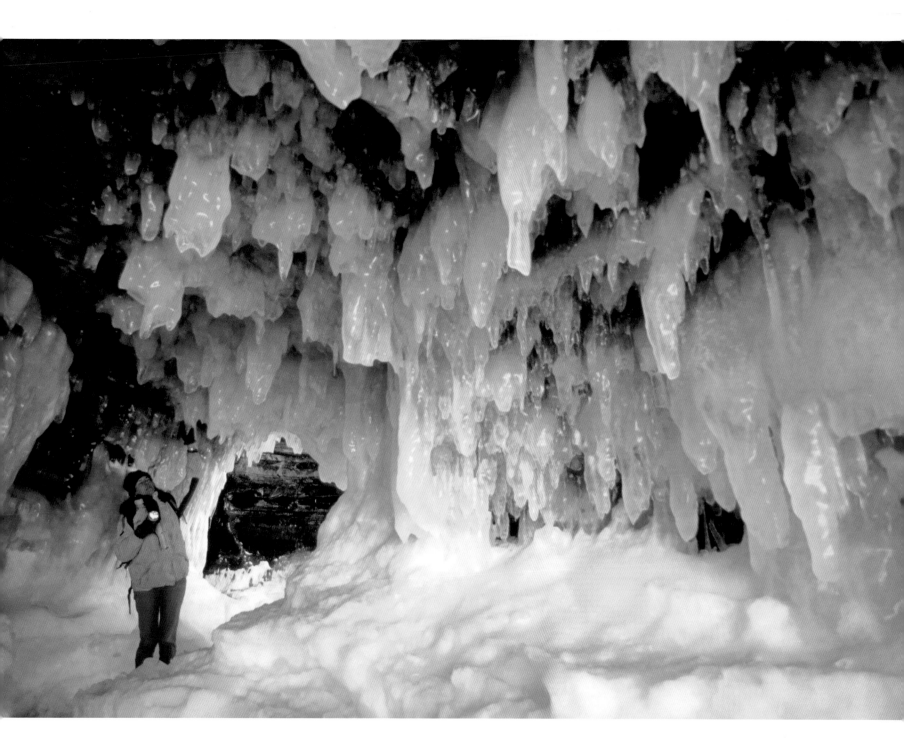

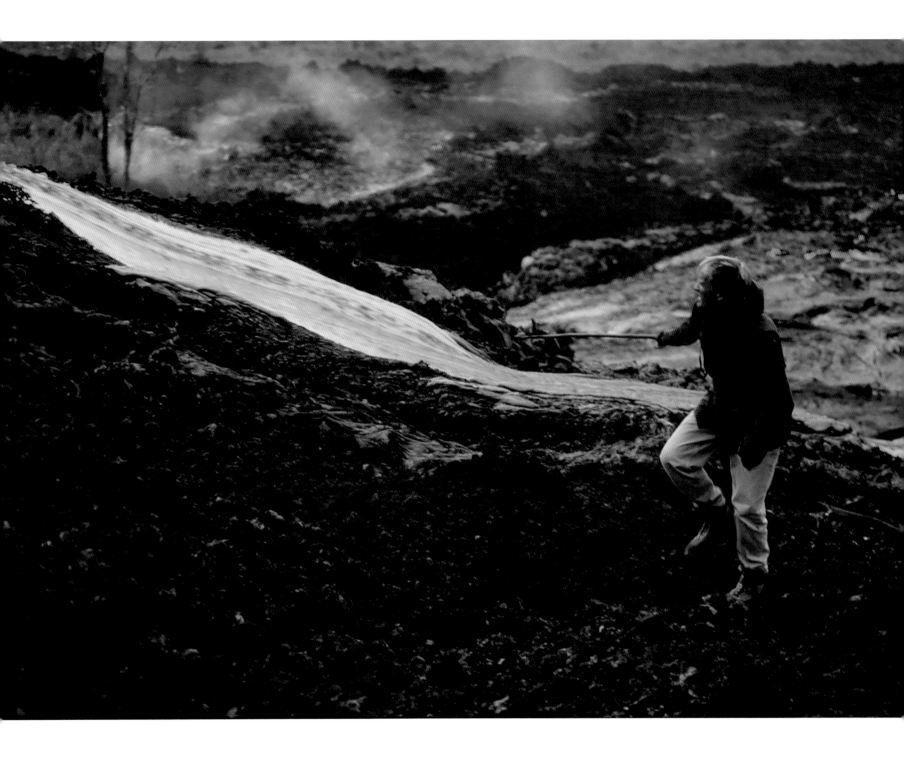

PENETRATING METHANE DEATH ZONES AT KILAUEA VOLCANO

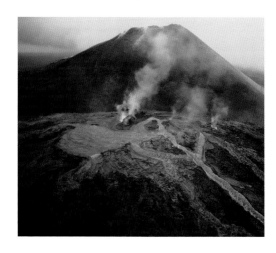

Out in the Pacific, the Hawaiian archipelago was first formed when hot spots of magma rose from earth's mantle and melted through the conveyer belt of moving suboceanic tectonic plates. In this tropical necklace, the Big Island of Hawaii received the most recent dollop of molten upwellings, growing land on the ocean, and is still cooking up a striking stygian landscape surrounding Kilauea volcano. To penetrate the noxious heart of a Dantean inferno, hikers furnished with water and long sleeves undertake an exhausting trek where the exercise most required is that of diligently careful observation. Deliberate footsteps avoid ragged shards of cold lava and boulders the size of Volkswagen Bugs tossed by steamy explosions. Approaching ropey pahoehoe lava flows, it's best to keep upwind of the phosphorescent rouge flowing rapidly toward bands of vegetation. Melting boot soles quickly become a minor concern compared to invisibly gaseous death zones of choking methane explosions sparked by decomposing organic material. Avoid being trapped by languidly moving piles of glowing a'a lava and burning bushes that etch a fiery creation scene out of Genesis.

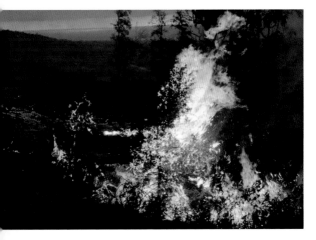

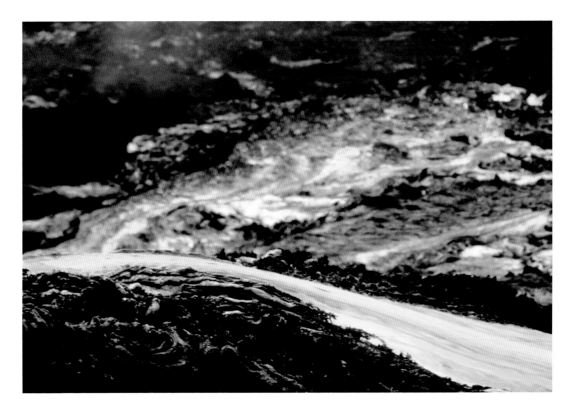

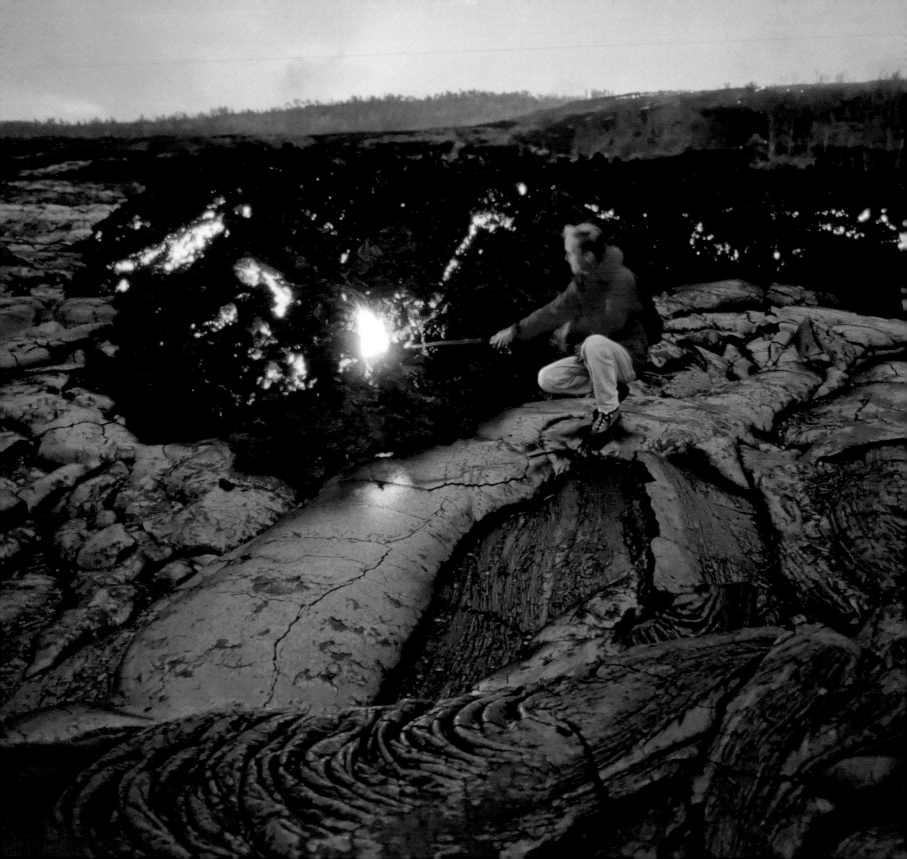

WAGON TRAIN PIONEERING ACROSS THE DAKOTAS

The upper reaches of the longest river in North America provided one of the original superhighways for early nineteenth-century pioneers. The abundance of beavers and otters along the Missouri's banks sparked a fur trade that prompted exploration of the region by intrepid explorers Lewis and Clark. Later, fortune-seeking adventurers were lured farther west by newly discovered gold fields. Creaking along in resolute convoys, waves of pioneer immigrants swept across the rugged American heartland. Today, overburdened axles are greased, Percherons are hitched, and canvas-topped, flare-boxed wagons jostle across rolling grasslands. Bouncing down rutted trails and kicking up clouds of dust, teamsters carefully chauffeur the prairie schooners into gully embankments as squeaking wooden wheels splash through waist-high creeks. On the horizon, ballooning nimbuses spawn a violent hailstorm that soon dissolves into a rainbow, lassoing distant cottonwood trees. After chasing a sinking sun, the caravan circles in a meadow to corral livestock as hungry eyes check the chuck wagon, its fragrant smoke dancing to the rhythm of a harmonica's cowboy tune.

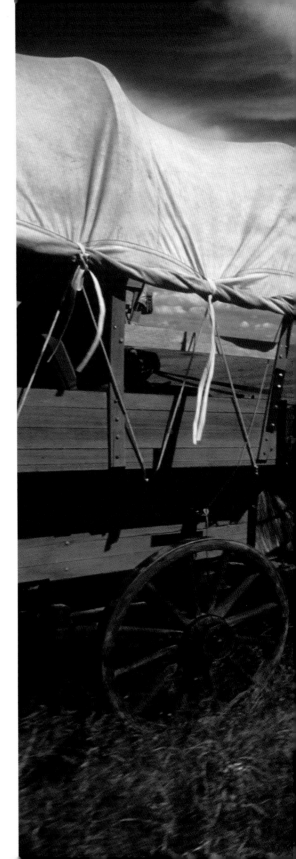

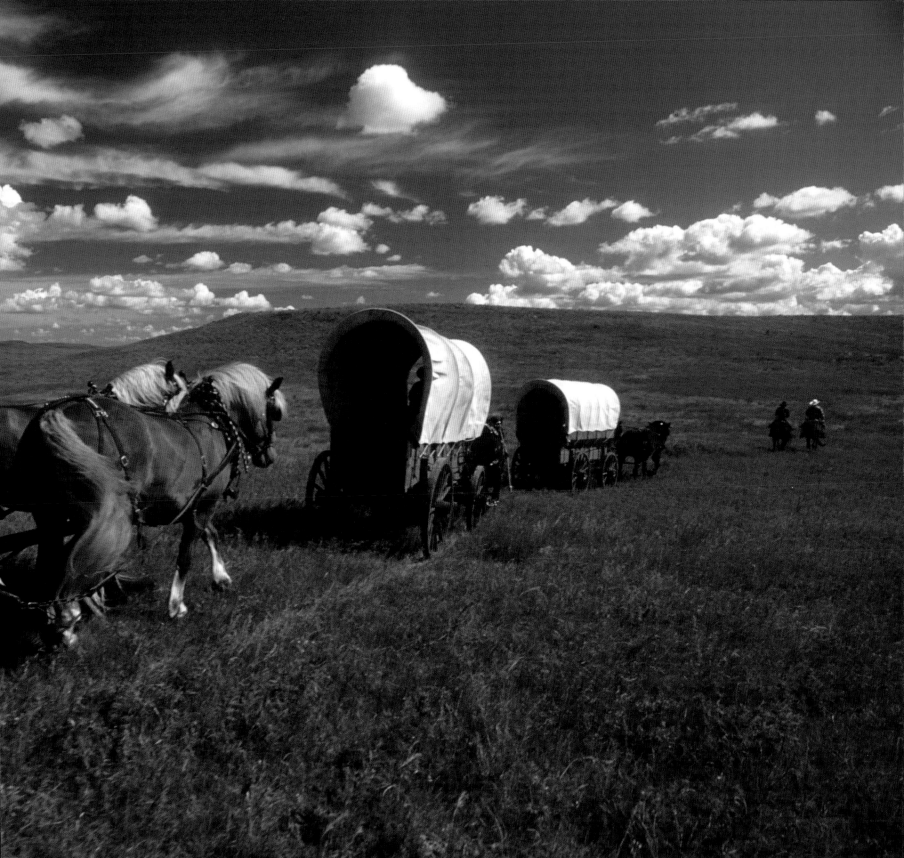

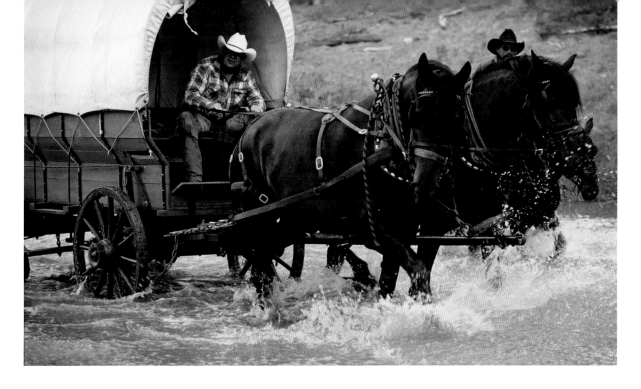

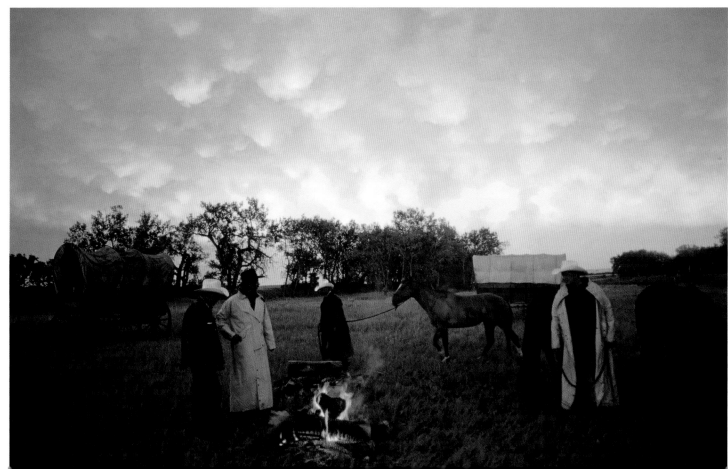

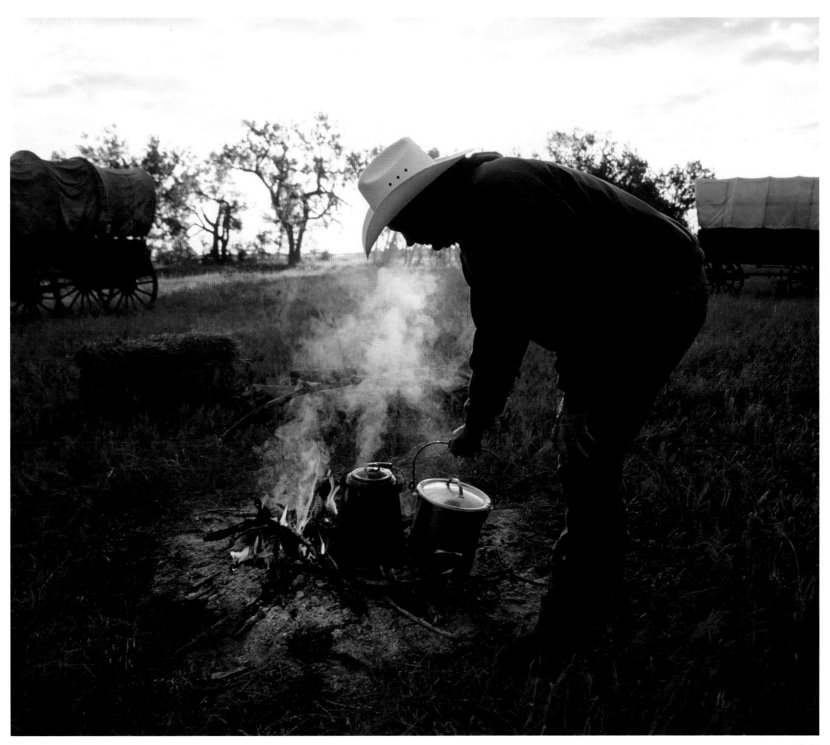

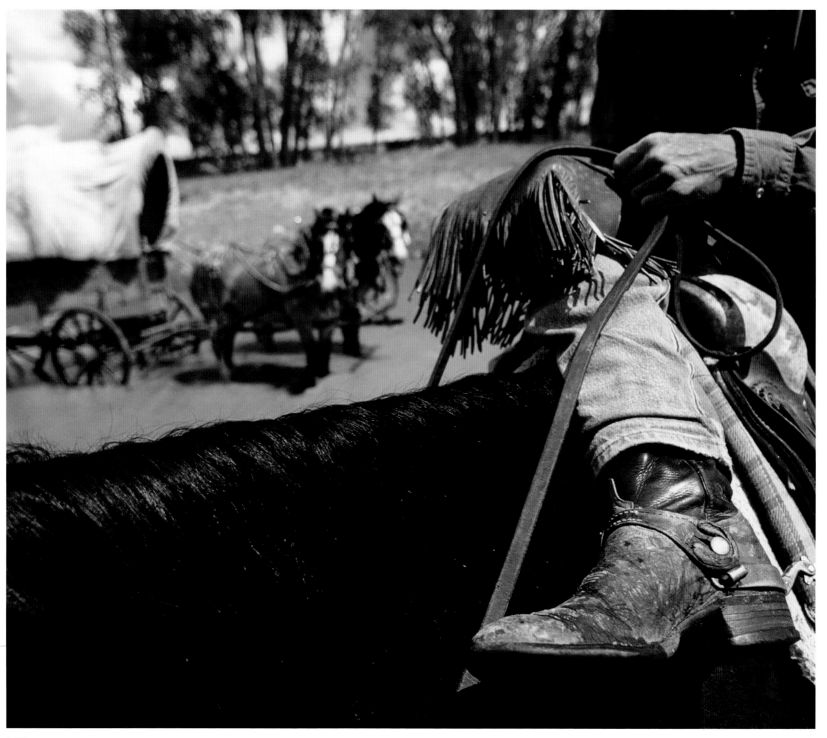

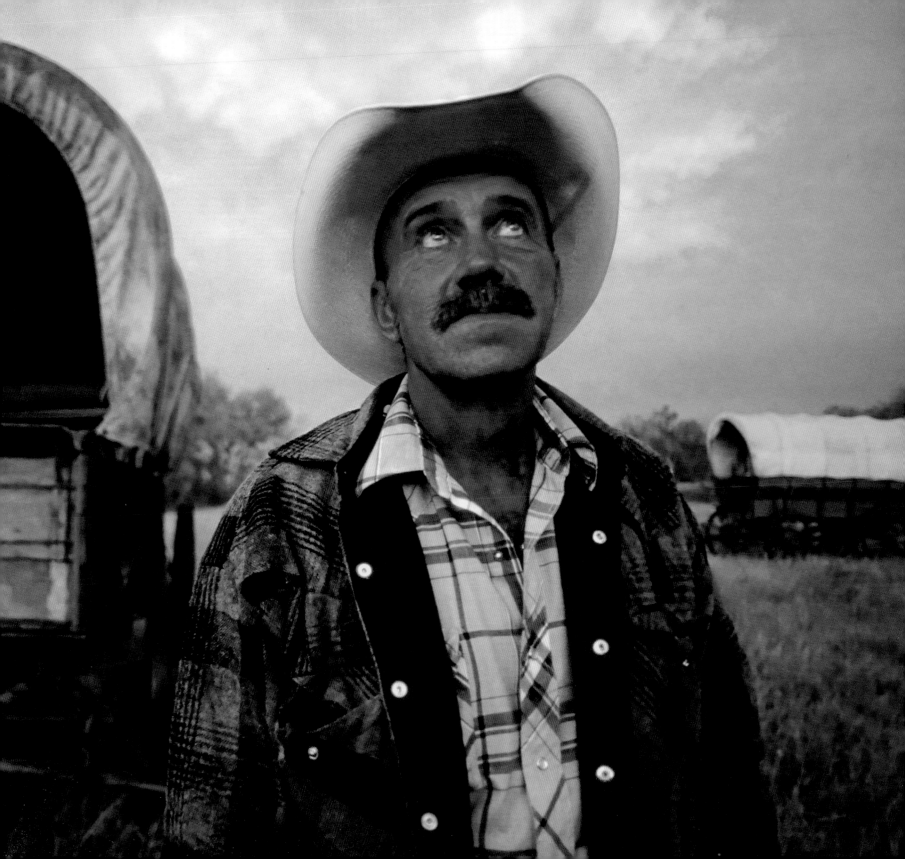

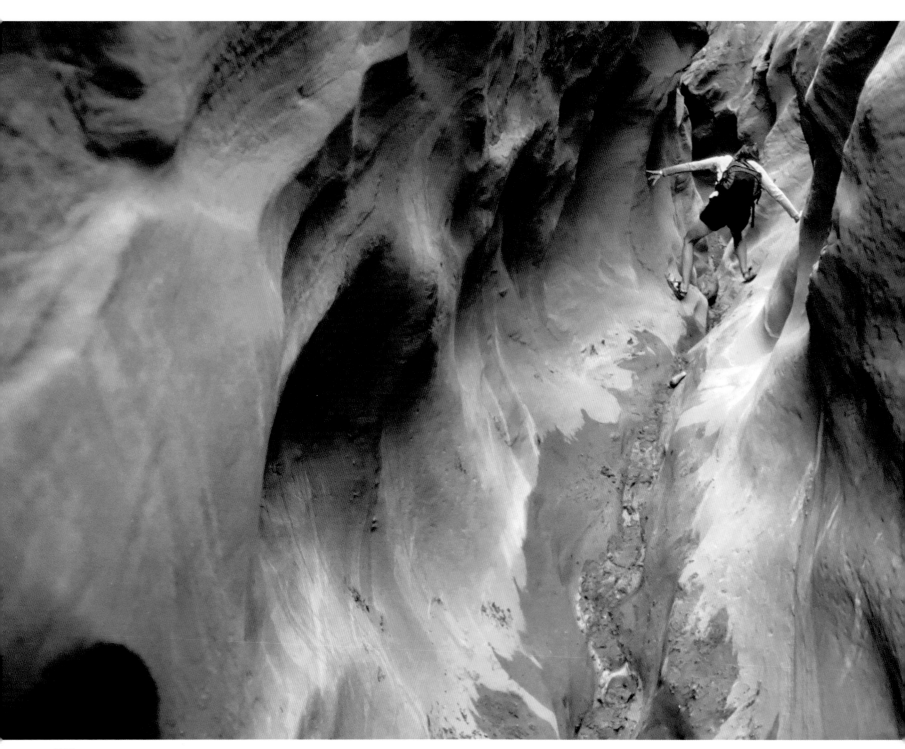

CANYONEERING INSIDE ROCK SLOTS OF THE COLORADO PLATEAU

Infiltrating the Colorado Plateau's gnarled, tortured geology and its confounding maze of chasms requires a triathlon's roster of herculean skills. Before entering the narrow slots slicing a thousand feet below the Paria wilderness, check weather forecasts to rule out flash floods that can roar down skinny corridors and erase escape routes. Inside Buckskin Gulch, neoprene booties reduce overexposure risks when floating your pack across numbing plunge pools. During an unrelenting boot camp for prune-like feet, lengthy days are filled sloshing through prismatic globs of shoe-sucking quicksand. Farther up the river system, serpentine Escalante tributaries demand you jettison your claustrophobia to squeeze through interlocking swirls of sandstone. During a baffling game of subterranean chutes and ladders, only sideways shimmying greases you through the sculpted incisions of the Spooky and Peek-a-Boo Canyons. While seeking scant footholds, chimneying, limb-stretching maneuvers bridge grotto walls to support your crawling ascent toward daylight above. On top, the blessed luxury of space allows planting an entire flat foot on the ground and delivers a deep smile.

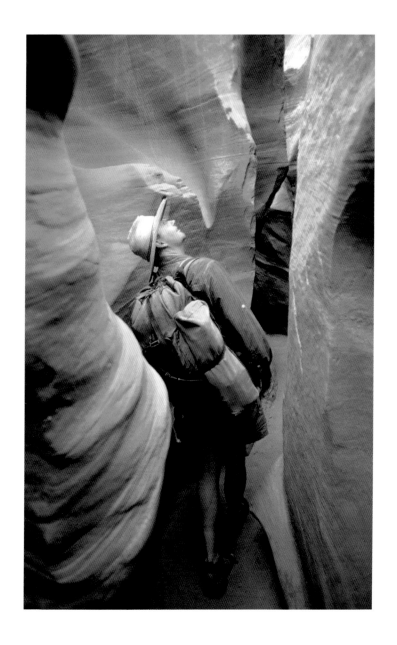

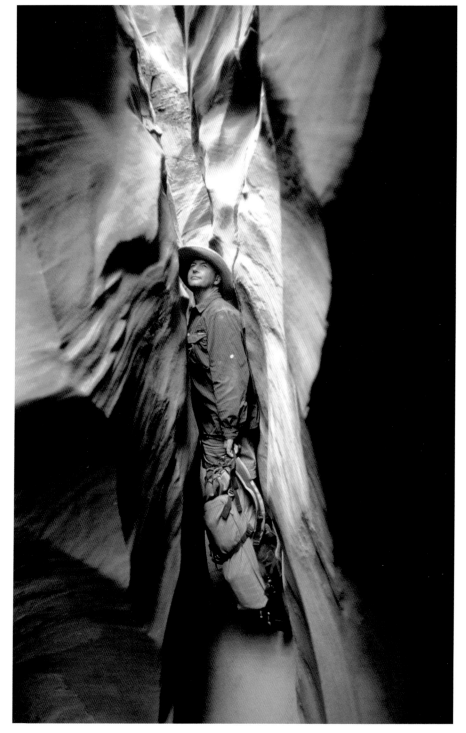

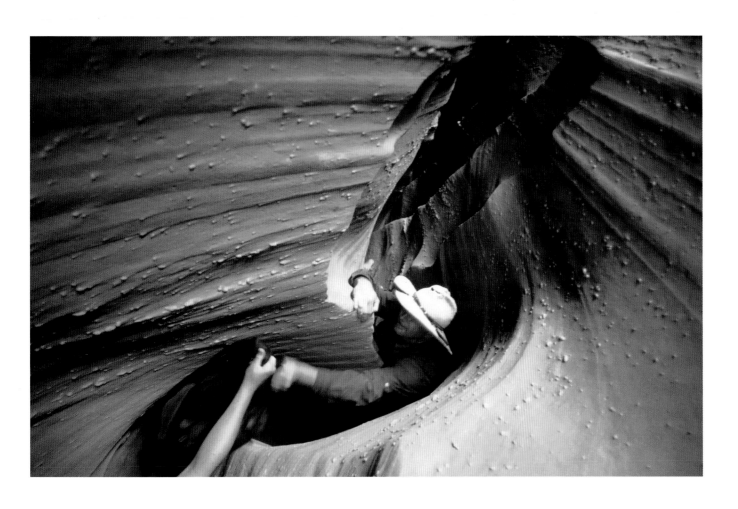

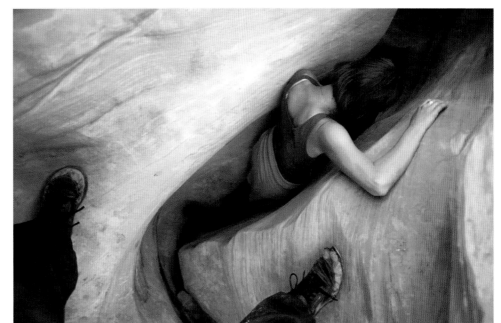

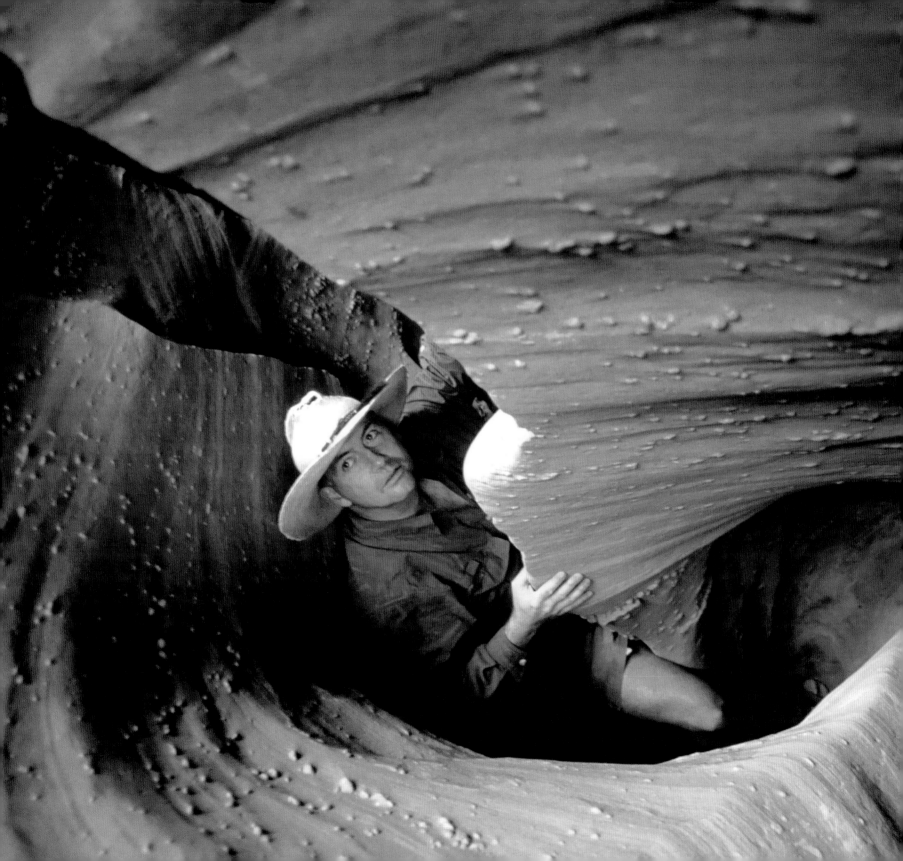

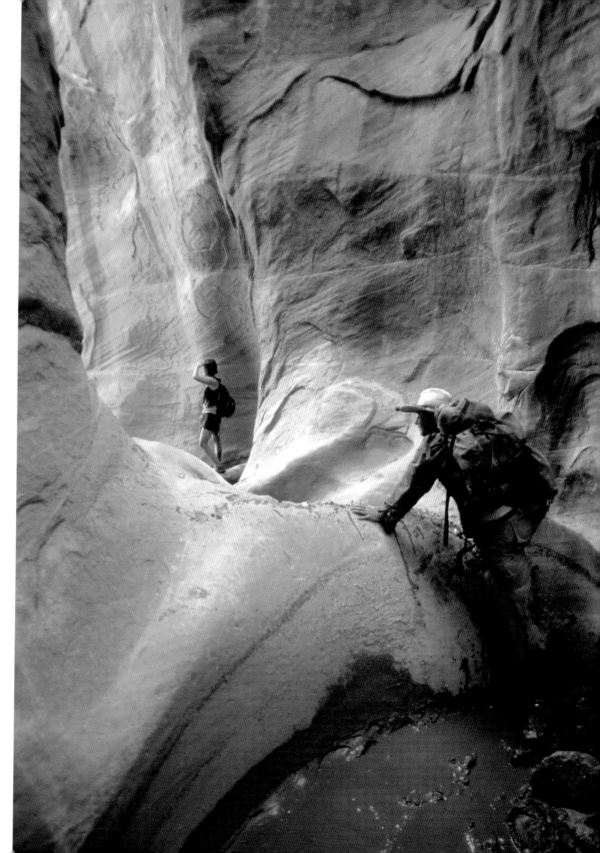

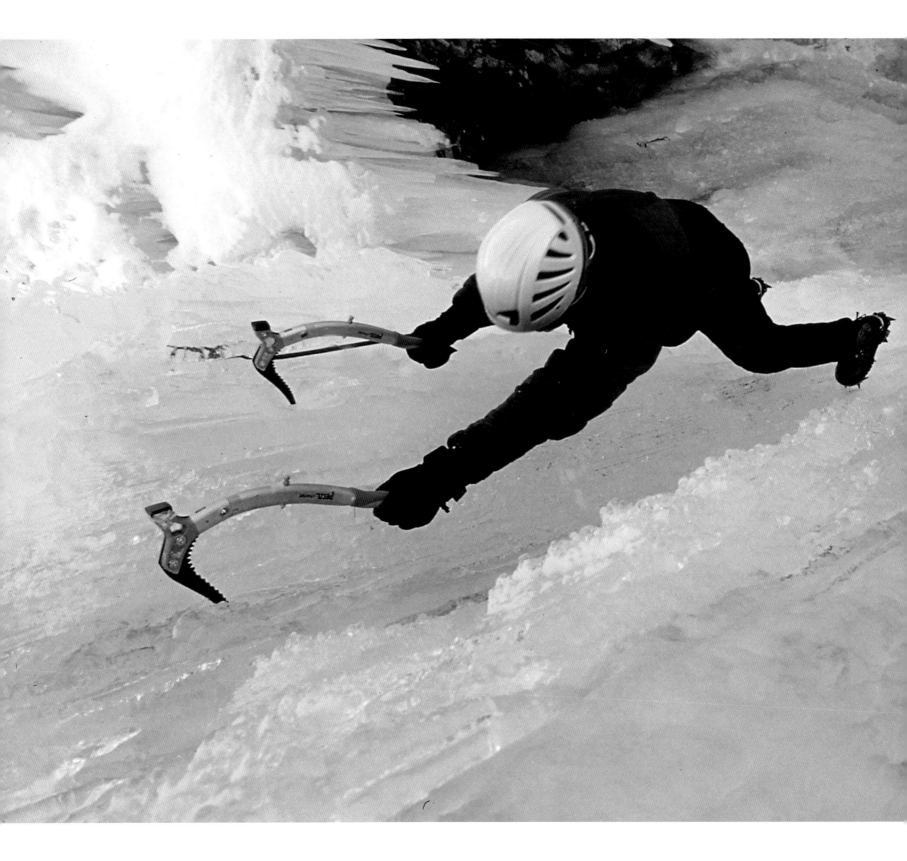

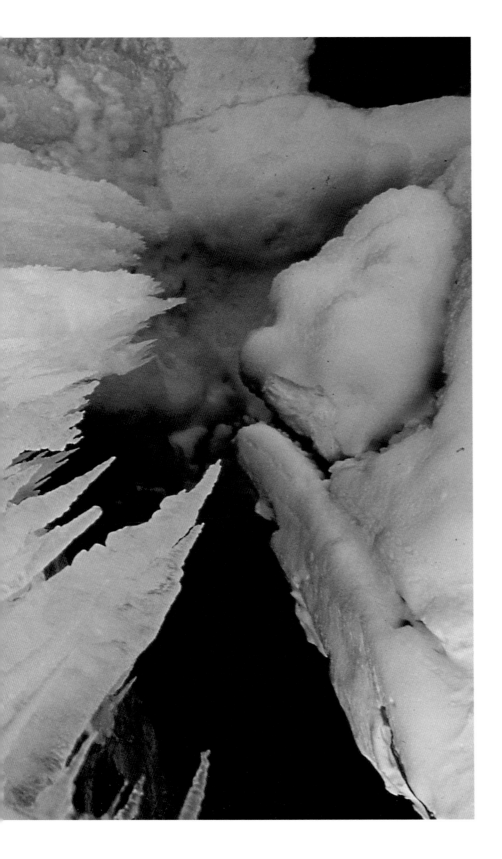

ICE CLIMBING IN A ROCKY MOUNTAIN GORGE

The majestic Rockies form the geologic spine and continental divide of the Western United States. To test their own backbones, aspiring adrenaline junkies gather here, having crowned this box canyon, at the northern end of Colorado's Uncompahgre Gorge, the Holy Grail for ice climbers. Judiciously placed ice screws and rope appear to offer scant protection when staring into the yawning void of a vertiginous ravine. To help negotiate footing and generate friction, work your calf muscles with friction-grabbing, boot-hugging crampons, a centuries-old footwear tool designed in alpine Europe for wintry forays. When ascending glossy stems of frozen water, a push off the feet will slowly shift muscle power to the gluteus maximus. Be ready to dodge crashing chunks of icy stalactites dislodged from cragsmen above. In a precariously frigid ballet, rhythmic equilibrium and agility are juggled as a balanced position is reached and the leveraging ice axe is swung ever higher. Once on top, a cooperative circulatory system hopefully reduces the excruciating sensation of hot pain, when refrigerated extremities thaw and organ-protecting blood flow returns with a vengeance.

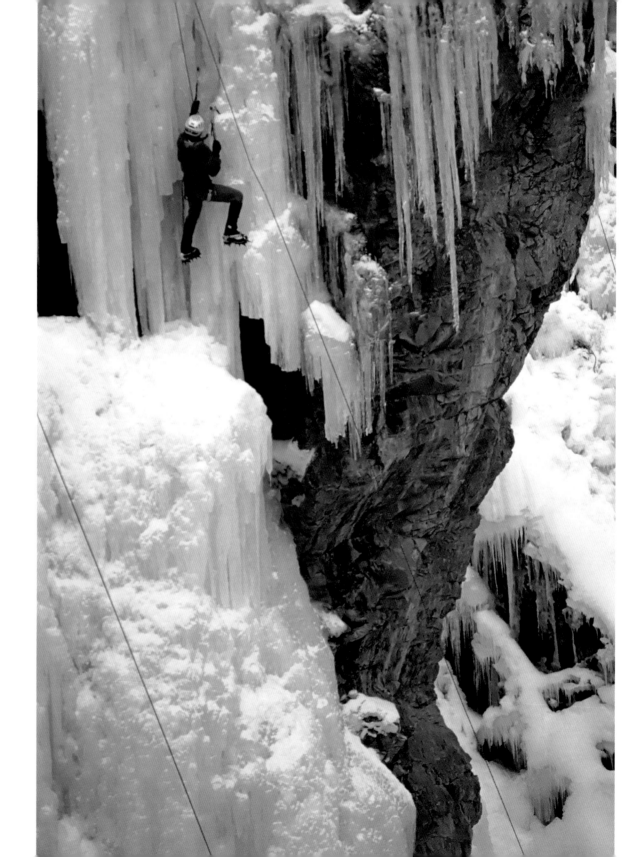

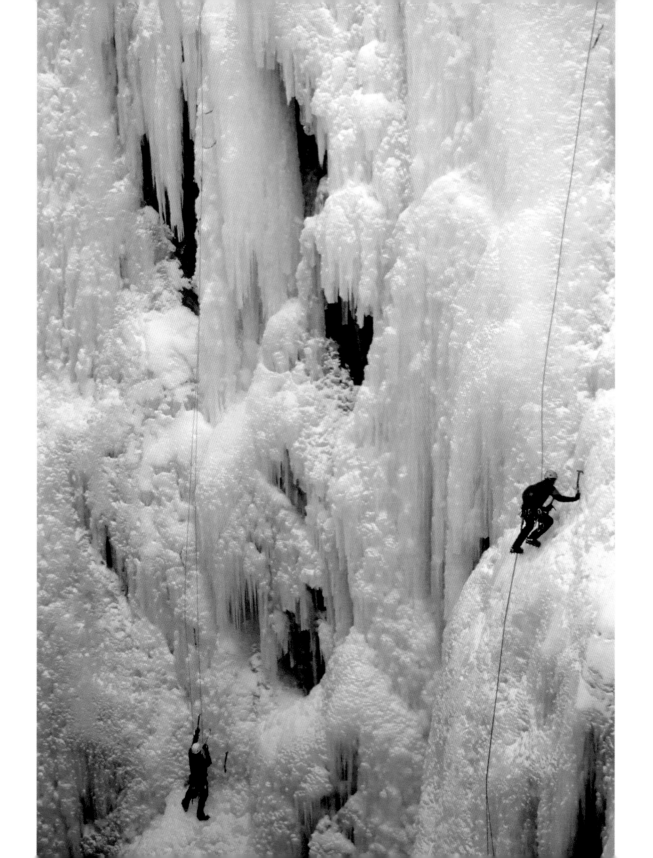

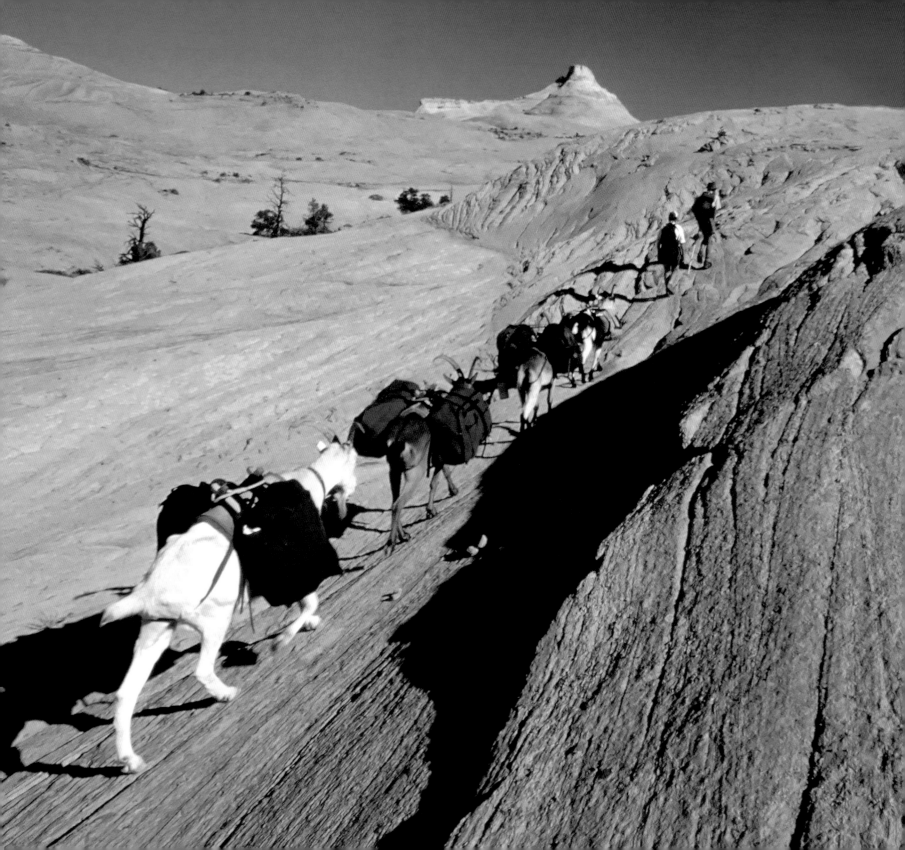

GOAT PACKING INTO GRAND STAIRCASE-ESCALANTE

Investigating the heart of the Grand Staircase-Escalante wilderness can require a camping commitment made feasible by the furry portaging services offered by an eager team more often associated with petting zoos. With tightened cinch straps and fastened rump belts, a determined caravan of bleating goats heads off into a maze-like jigsaw of intersecting canyons, isolated buttes, and soaring mesas of fossil-rich Navajo Sandstone. These environmentally friendly, soft-hoofed animals can nonchalantly carry sixty pounds stuffed inside their panniers while fording swift-running desert streams, deftly navigating both rocky cliffs and plunging arroyos. By thousand-year-old juniper trees, park your four-legged station wagon to explore ancient Anasazi petroglyphs while taking care not to touch their heat-dispersing horns, which provide them with a territorial sense of well-being. As evening descends on your tented encampment in this remote stretch of the Colorado Plateau, shooting stars race across canyon walls that echo softly with the sound of collared bells.

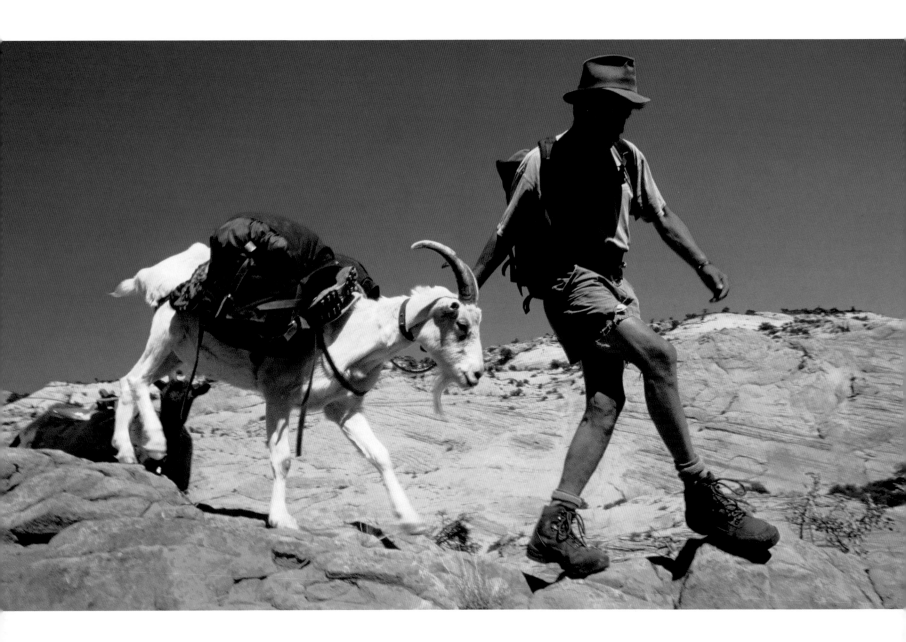

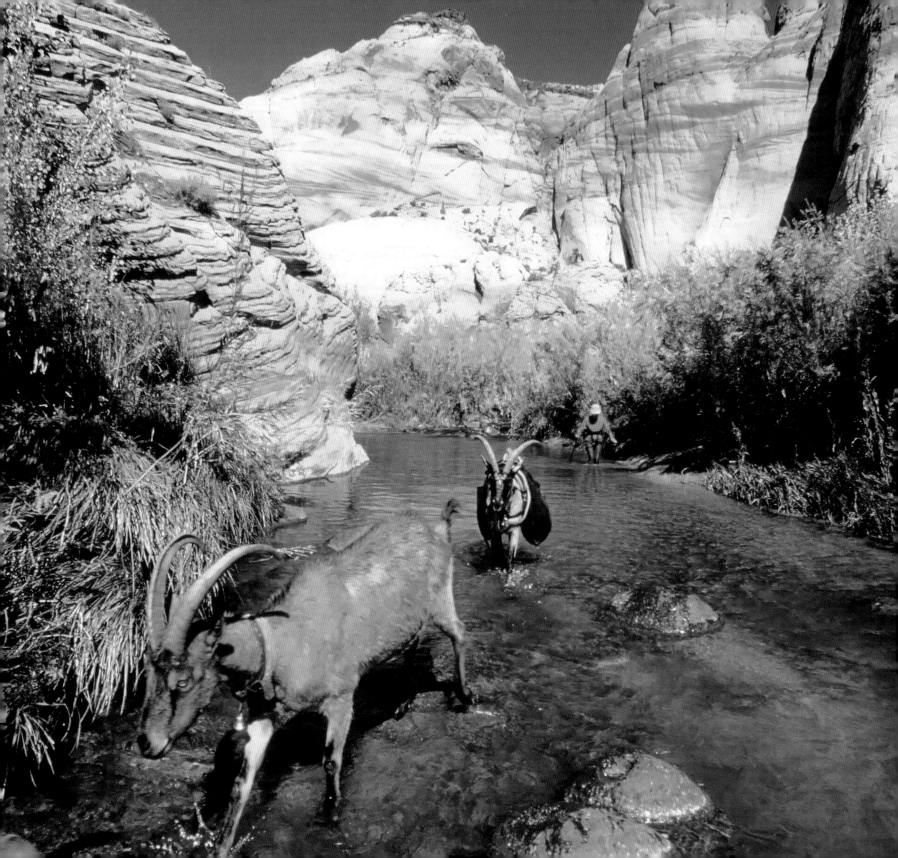

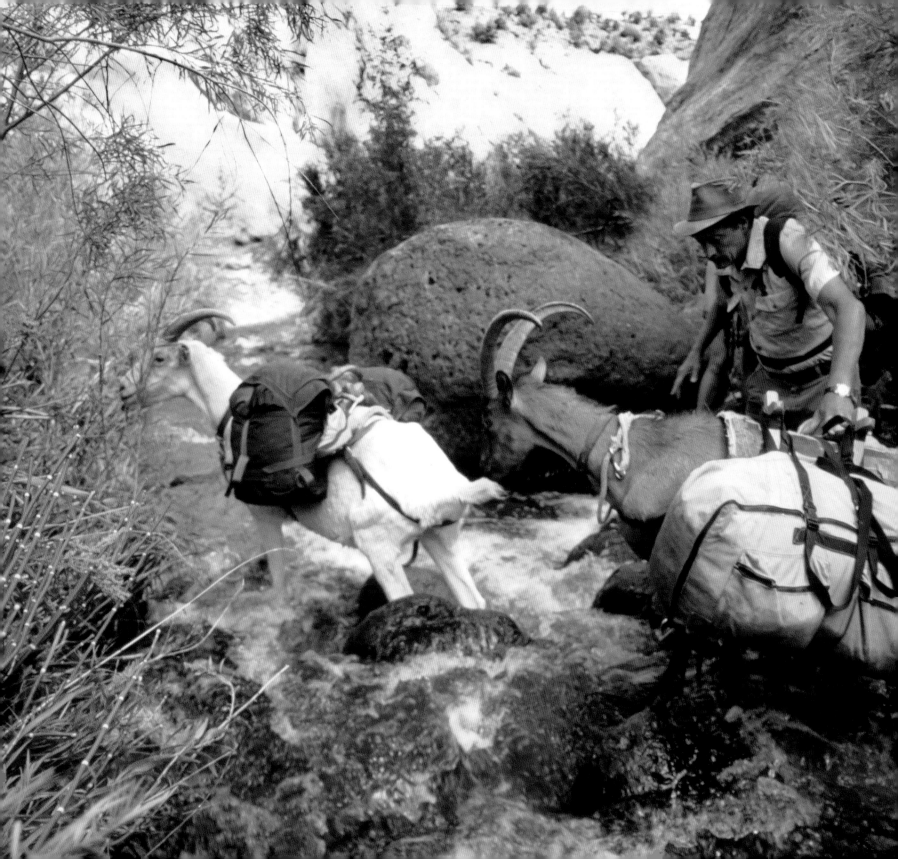

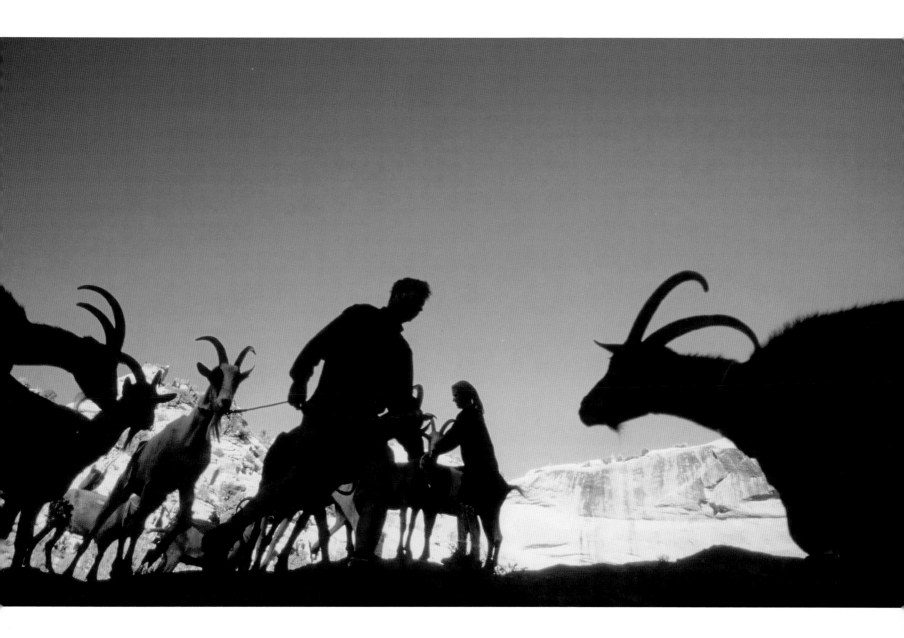

PURSUING ICEBERGS OFF THE LABRADOR CURRENT

While journeying to distant lands may not always be possible, cleverly stationing yourself at one of Newfoundland's rugged peninsulas may allow distant lands to journey to you. A dozen millennia in the making, frigid chunks of Greenland's slowly shrinking glacial sheets are shed from its coastline, beginning a southward journey from the Earth's frozen ice cap. During late spring, this nautical traffic jam of refrigerated castles, cottage-like bergy bits, and piano-sized growlers chokes the southbound Labrador Current. Here along iceberg alley, where the Titanic met its deep-freeze destiny, murres and shearwaters glide overhead during their northward migration. In Twillingate, board a chartered vessel or local fishing dory and set a course for the drifting turquoise mountains eroding into sculptures that dazzle on the horizon. The temperature plunges as you approach a rendezvous with the floating mammoth. Keep a cautious distance as its hugely hidden, rapidly melting hulk threatens at any moment to catapult into capsizing waves. Safely back ashore, nature's harsh beauty can be toasted with sailors' whiskey and the berg's explosively popping cubes.

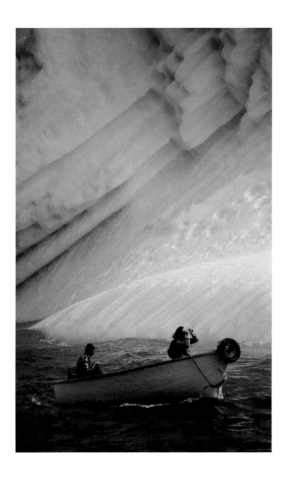

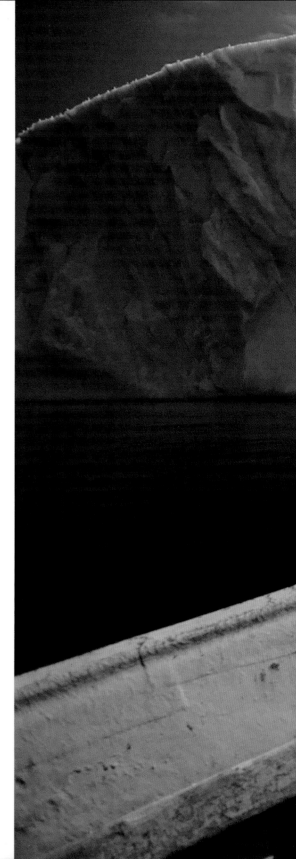

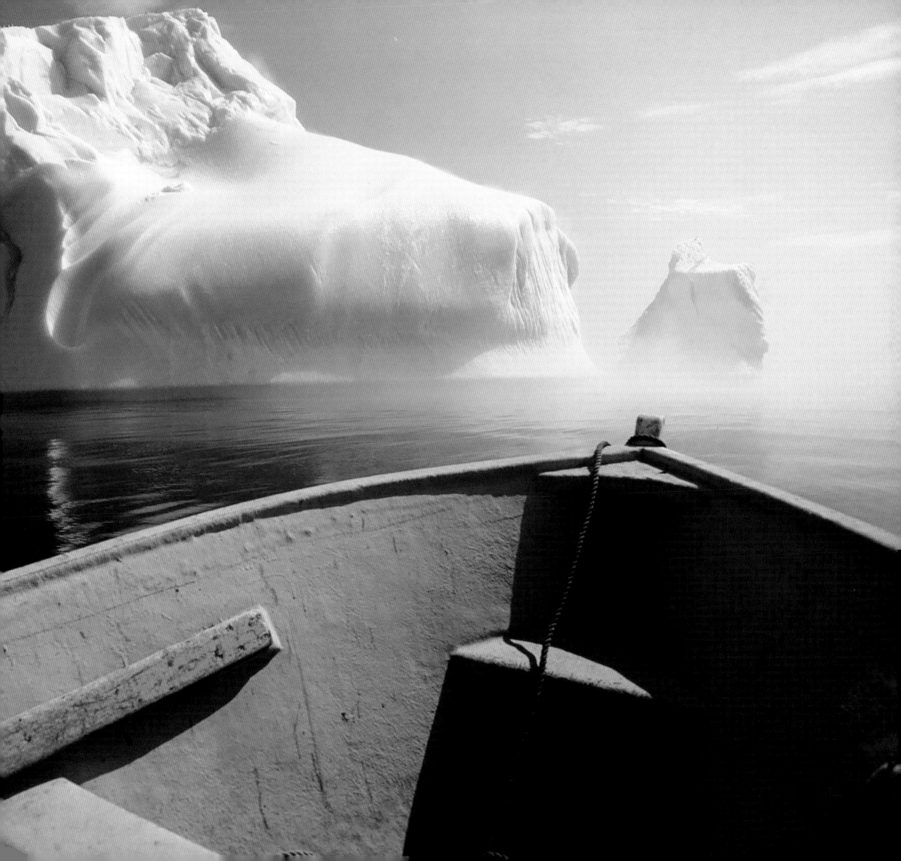

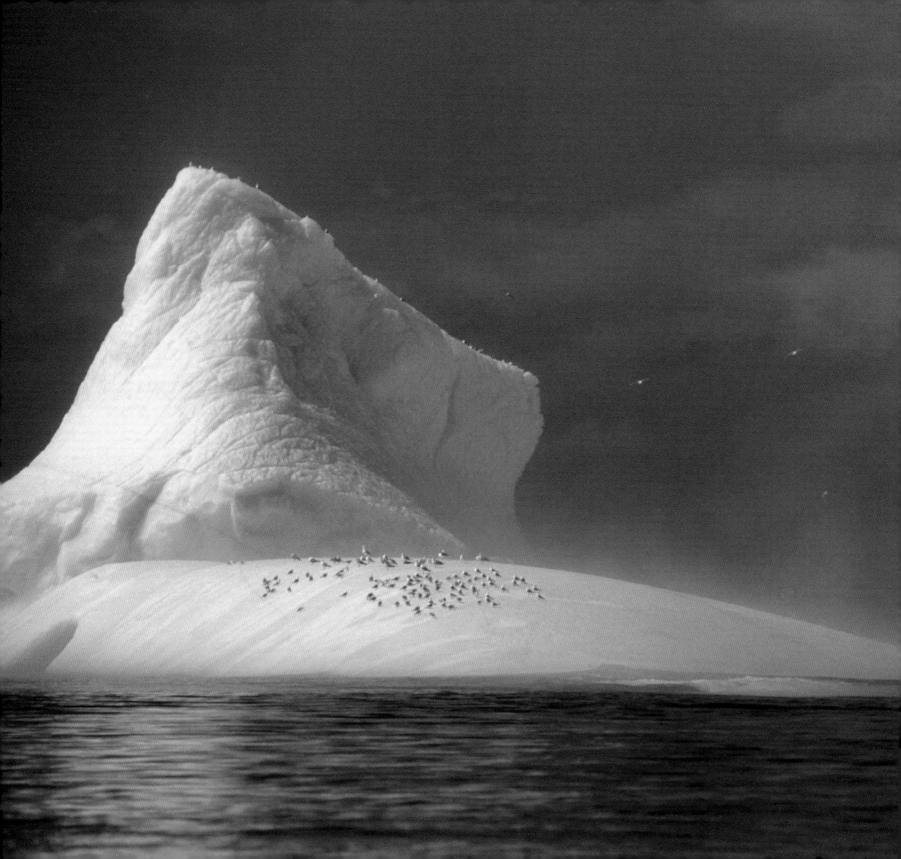

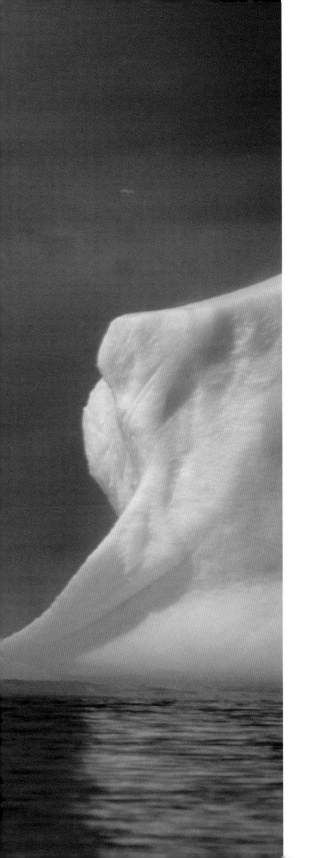
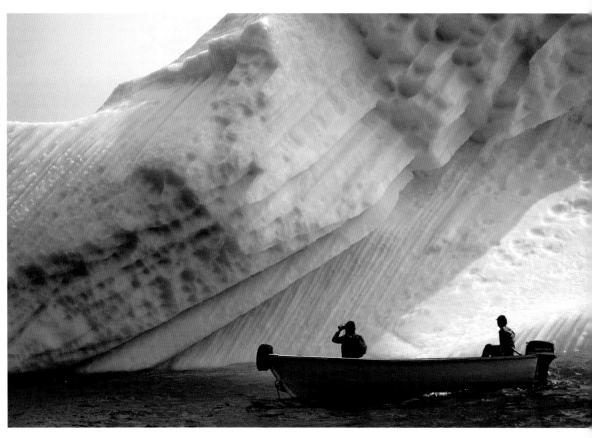

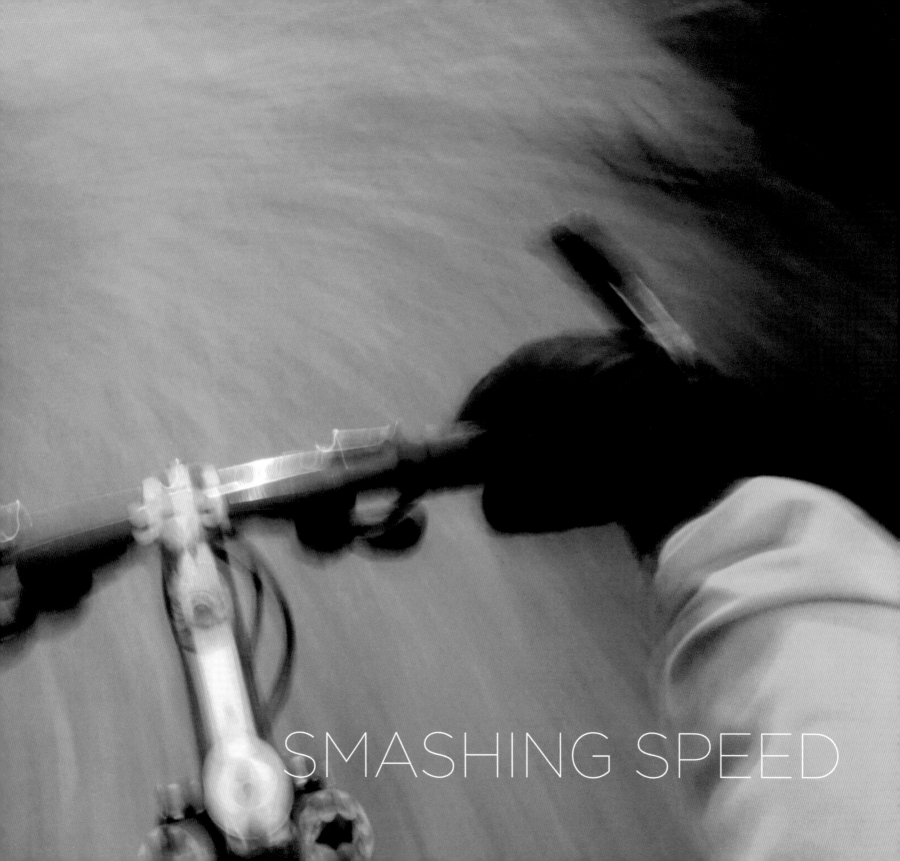

SMASHING SPEED

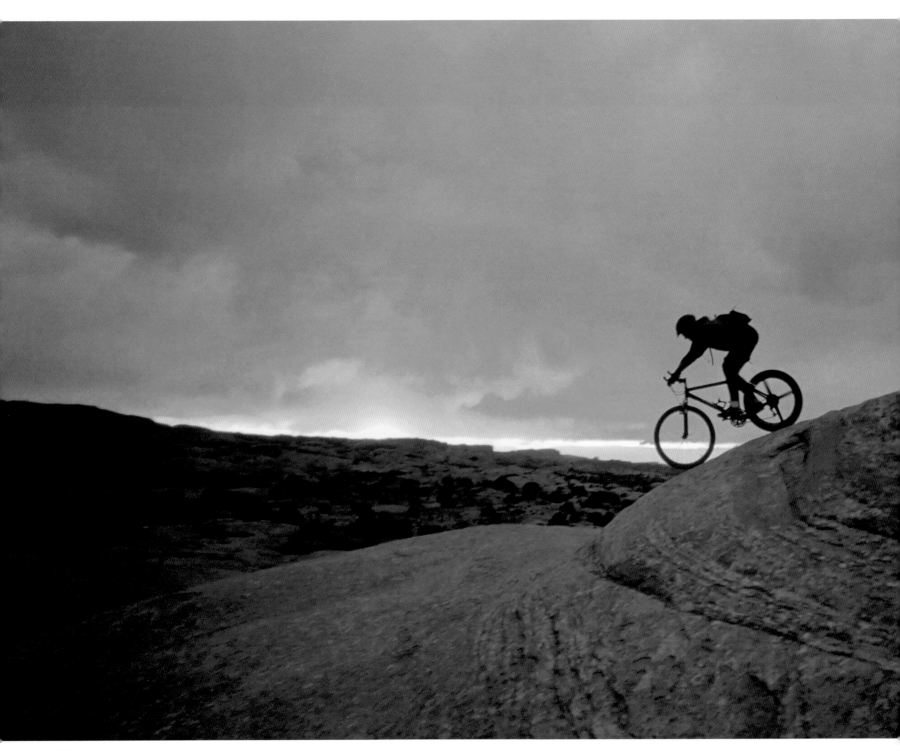

MOUNTAIN BIKING THE SLICKROCK TRAIL

Utah's lonely red rock outback serves up a serious slice of geological casserole for hard-core mountain bikers. Bumping down steep flights of rocky stairs and pogo-sticking your wheeled frame across a jagged landscape of fins, domes, and fossilized sand dunes is like riding a paint-shaking machine. A properly fitted helmet will feel particularly welcome should you find yourself unexpectedly examining the sky from a brand-new perspective. Breezes wipe your sweaty brow as burning legs pump out precision grunt work. During controlled descents, aspire to quick and seamless downshifts on an intricate assembly of cogged gears.

Keep up a satisfying, shock-absorbing momentum while surfing undulating waves of parched, ruby slickrock. As you swoop into gnarly stone bowls, momentum propels the bike up and over the next slope. Shift weight to negotiate tire-swallowing sand traps, then veer off the trail-edging narrow ledges with abrupt drop-offs. Feather the brakes to maintain control, whirling by tadpole-filled potholes and avoiding fragile cryptobiotic soil. After the desert's harsh obstacle course, bask in exhilaration still vibrating from a bone-jarring rodeo on wheels.

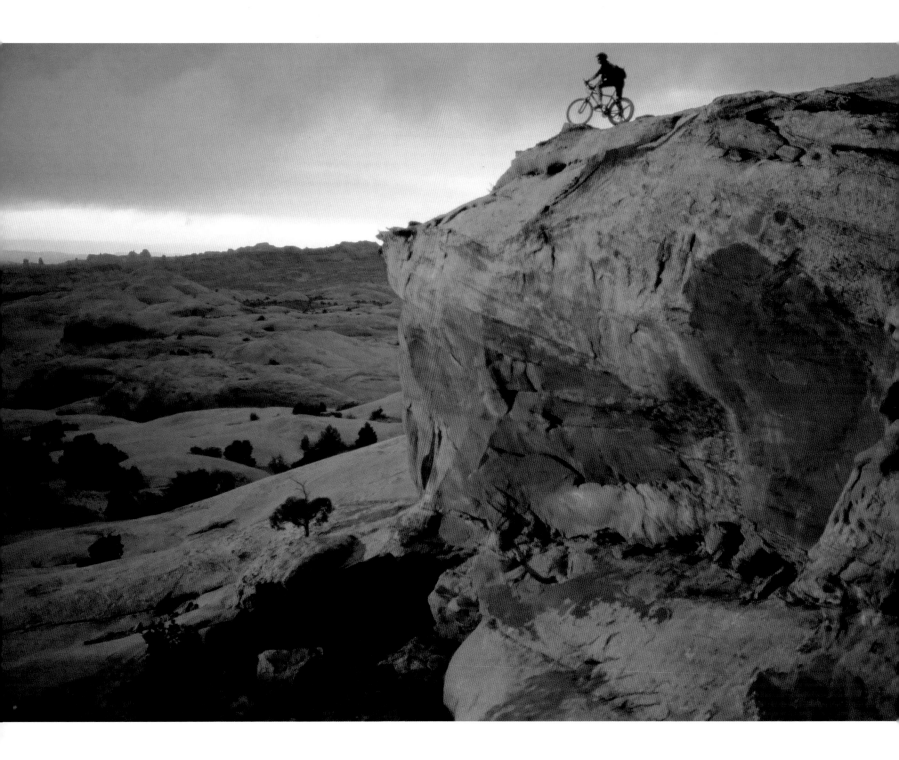

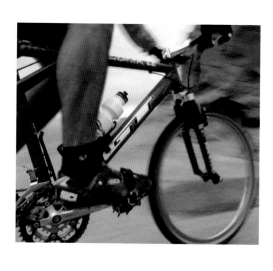
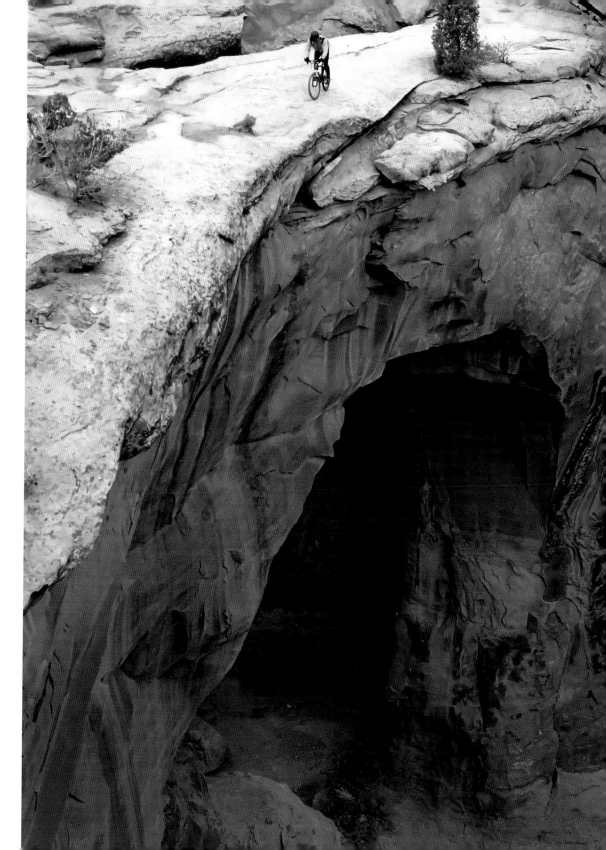

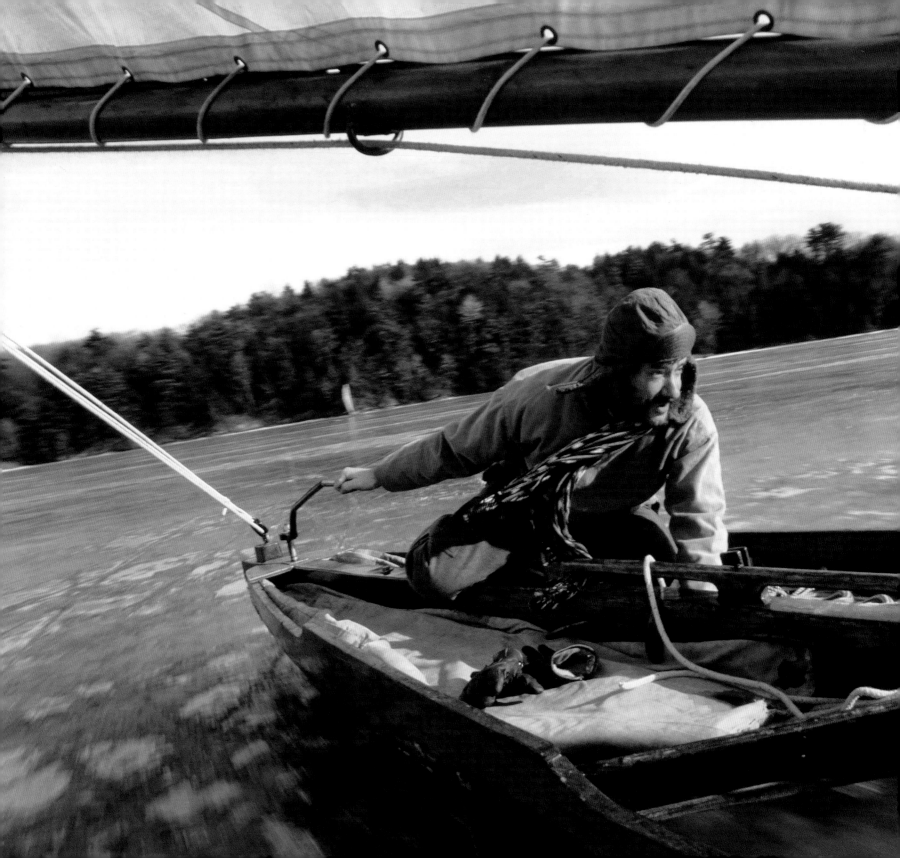

ICEBOATING ALONG THE HUDSON RIVER

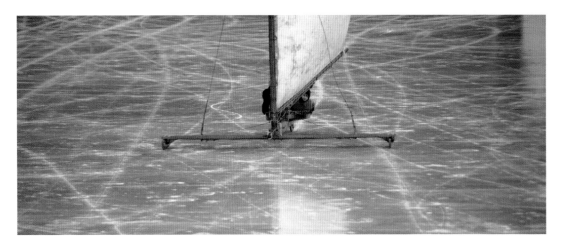

Sprouting imaginatively from fairy tales and Hans Brinker's frozen Dutch canal, iceboating became an obsession for nineteenth-century Hudson Valley aristocrats who erected conspicuous mansions dotting the river shoreline. With bowsprit and gaff-headed mainsail, the handsome mahogany yachts saluted the graceful lines of their seagoing cousins. Today, handcrafted and meticulously restored vessels glide across the ice only during the bitterest weeks of the year. Hunker beneath a bearskin throw and brace yourself within the oval tray shared with the skipper. Sailing at right angles to the wind, you whiz over the crusty, tide-warped ice faster than the air currents clawing at the sail. Briefly at full tilt, just below one hundred miles per hour, a spray of shaved ice pricks your reddened cheeks as ferocious gusts snatch tears off your lashes. The sizzling action heats up as the wind chill factor plunges. With a gloved hand on the rudder and stiff attention paid to keeping three sharpened runners from flickering out, it's possible to challenge a Manhattan-bound Amtrak on the nearby rails.

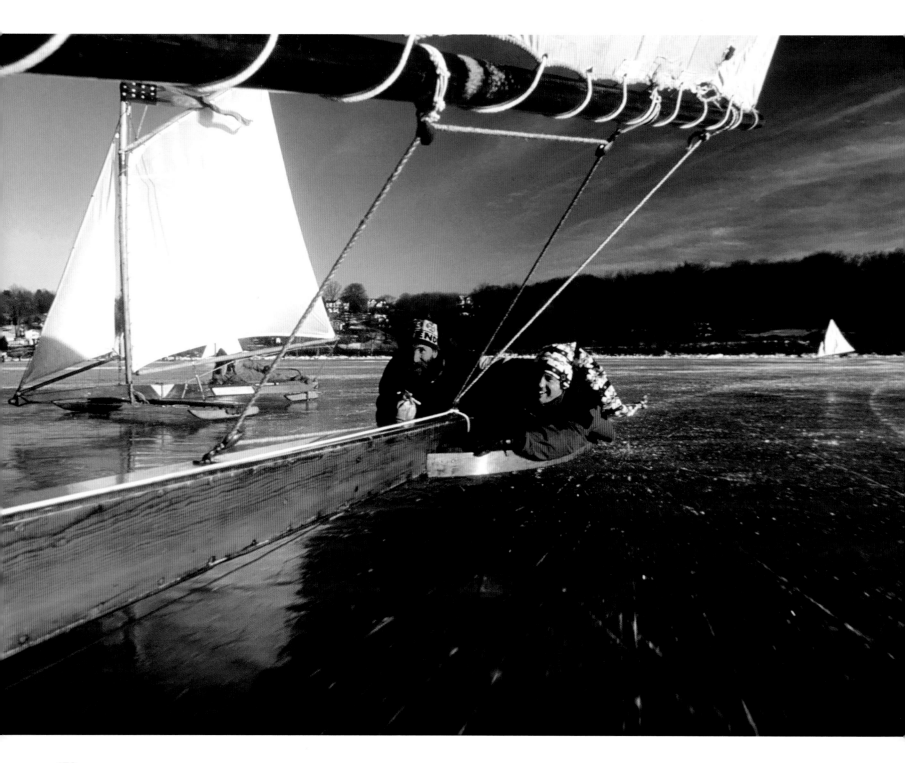

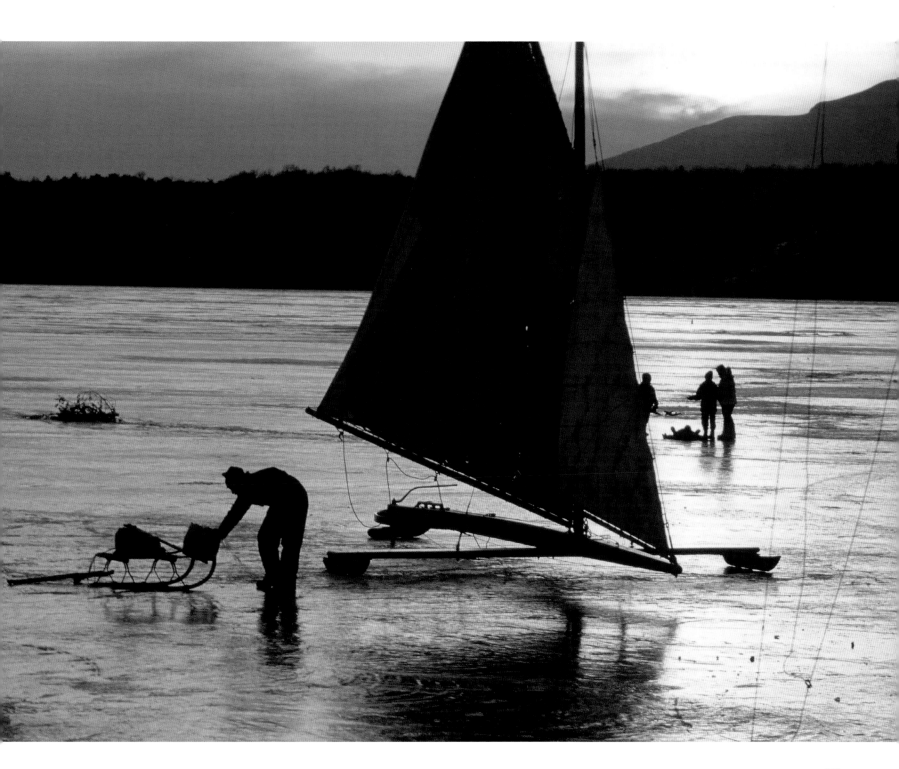

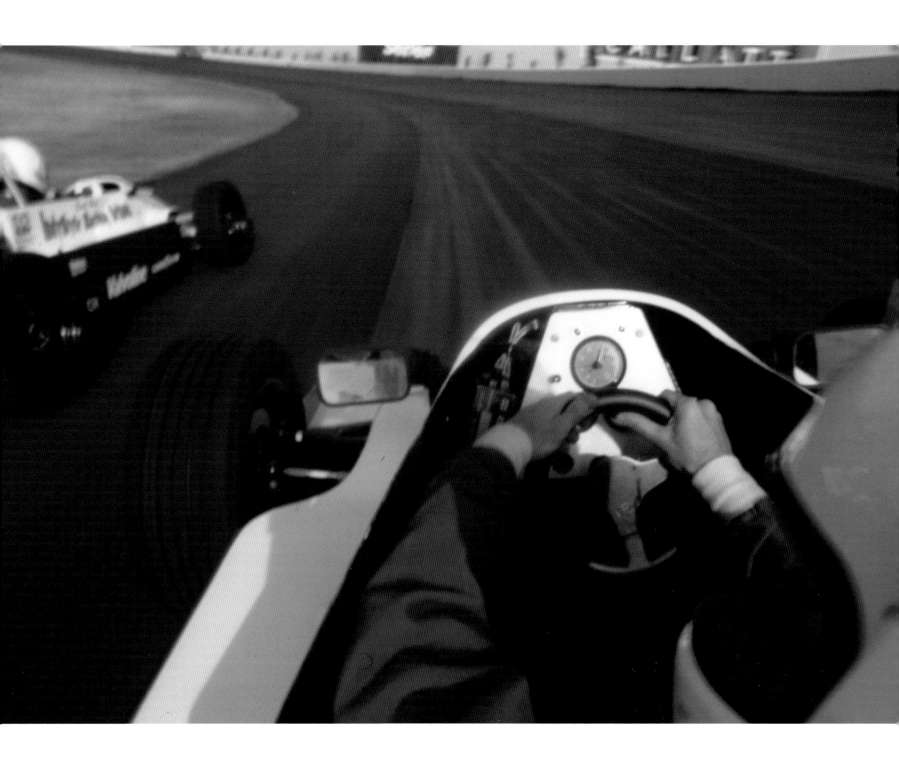

RACE CAR DRIVING IN
THE POCONOS

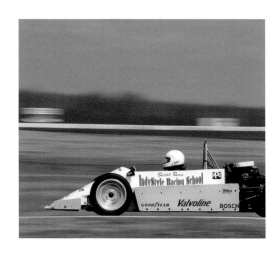

Hooded by a padded brain bucket, cloaked inside a fire resistant suit, and clicked and harnessed into a five-point safety belt, you feel perhaps like a cannon about to be fired. Scrunching deeply into the lone seat of a wide-wheeled, four-cylinder, two-liter 125-horsepower Scandia Formula 2000, with your rear end merely inches above the pavement, removes all doubt. A baritone rumble erupts with a pull on the ignition switch and a press of the starter button. Gripping the wildly responsive steering wheel, you throw your gears with short, snappy motions, weaving through a rapid sequence of turns and maximizing time on full throttle. With elbows pressed in toward your body, perfect heel-toe gymnastics of braking and downshifting will buy an instant's glance at the tachometer and allow a planned angle of attack on the next rapidly approaching bend. An emphatic, raspy engine drone provides the harmony for this hyperkinetic carousel, dissolving into a slow-motioned blur of raceway scenery and ending only as the checkered flag snaps you out of your trance and back into the pit.

TOBOGGANING IN THE ENDLESS MOUNTAINS

The remote hamlet of Eagles Mere, hardly a dozen miles from the spot billed as the icebox of the state, occupies one of the countless high ridges of Pennsylvania's rugged Endless Mountains. What distinguishes the hilly landscape in this charming Victorian village is the way that terrain takes advantage of both the winters' brutal temperatures and the simple principle of gravity. For over a century of winters, hardy volunteer firemen have utilized saws and harpoons to hoist about a thousand three-hundred-pound blocks of frozen lake into position on the edge of a steep incline to create one frictionless ribbon of descent. Fitted neatly into its icy three-sided cradle, a handbuilt wooden toboggan is filled with the heavily clad limbs of fellow passengers, all intertwined to provide most of the stability as you begin your descent. Hitting the curvature of the slope, you tightly grab the side ropes when rocketing speeds increase exponentially. Howling winds fail to drown out shrieks of thrilled adrenaline tossed into a blur of scenery passing at forty-five miles per hour. It all comes to a halt only one minute later, but engenders determination for repeat performances.

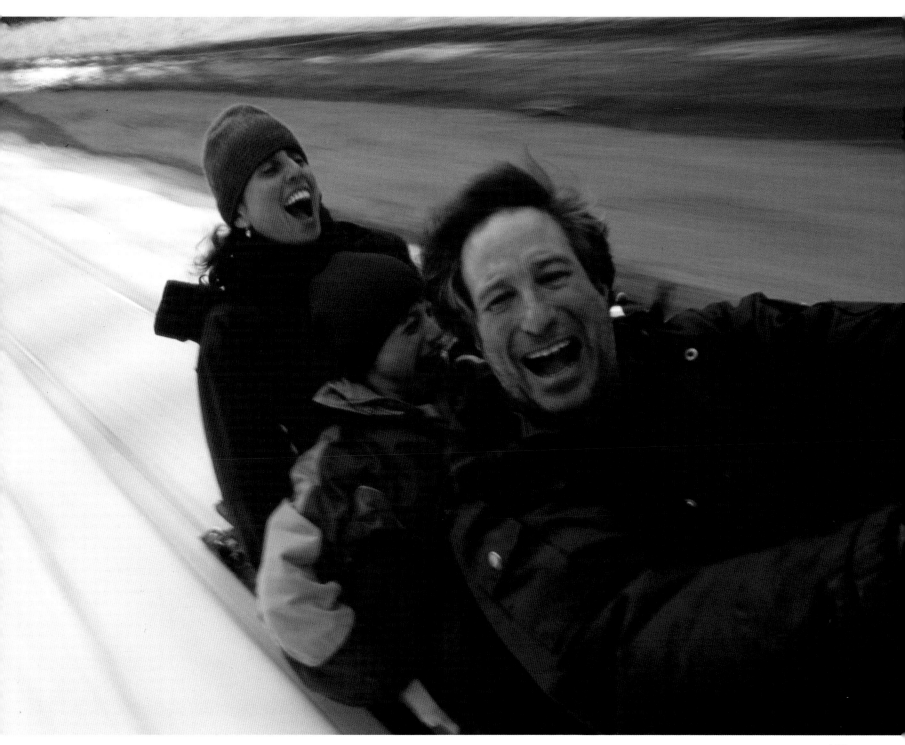

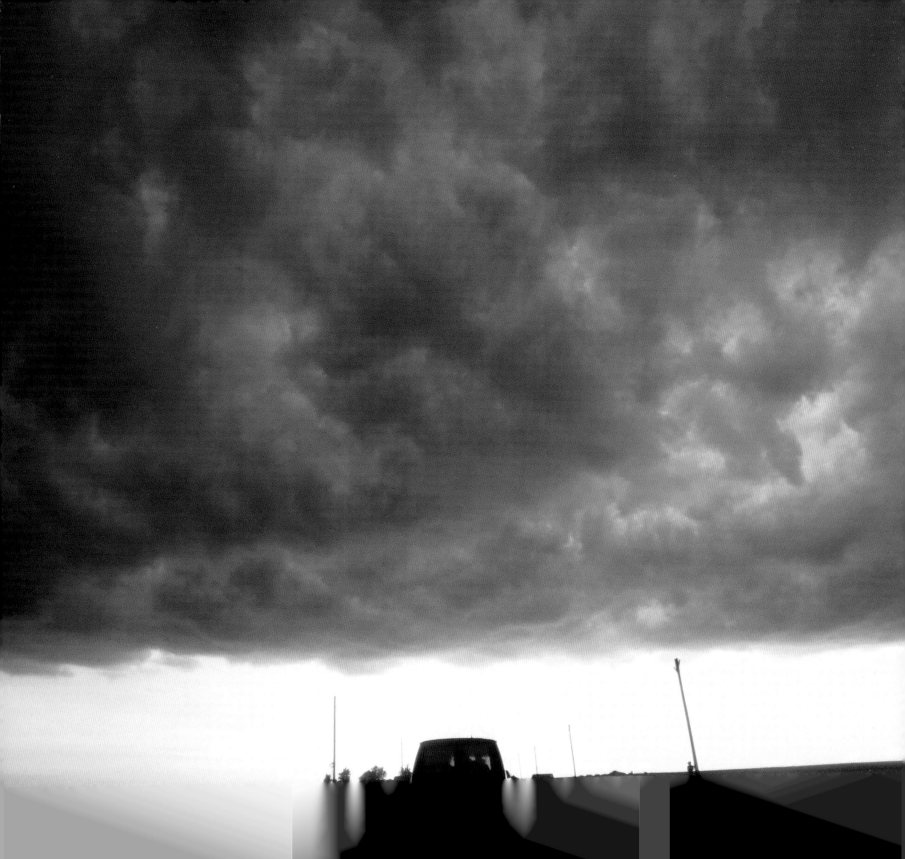

TORNADO CHASING ACROSS
THE GREAT PLAINS

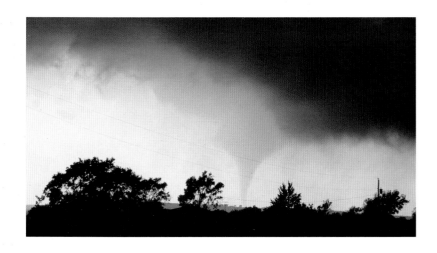

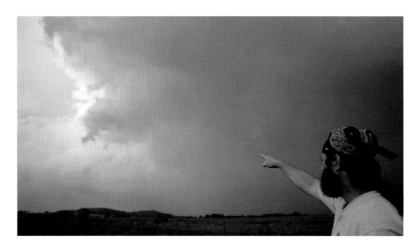

A rare battleground on this planet, Tornado Alley is the flattened immensity of plains visited each May by enemy weather fronts poised for violent conflict. Storm chasers, armed with GPSs, tattered road maps, laptop weather radar, and an exquisite instinct for reading severe skies, jockey for front-row seats to one of nature's most striking spectacles. For this hell-bent race across a checkerboard of blowing wheat and alfalfa fields,

you'll arrive at the targeted area and begin the hunt for a dry line boundary, marking the spot where the Gulf of Mexico's sultry air streams into moisture-drained Arctic forces.

The speeding caravan forges ahead toward floating mountains of boiling cumulonimbus vapor that is angrily blooming to twice the height of Everest, tinged by garish shades of turquoise and cantaloupe. Blinding lightning stabs

the prairie as you deploy hail guards to minimize damage from golf ball-sized hailstones percussively pounding on your already dented vehicle. Core-punching the storm's center, scout for southwesterly escape options, while overhead a scowling wall cloud begins its menacing pirouette. Winds scream, and a tightly whirling spindle of deadly energy descends to scrape the earth. Entering a state of terror, you'll soon realize you're not in Kansas anymore.

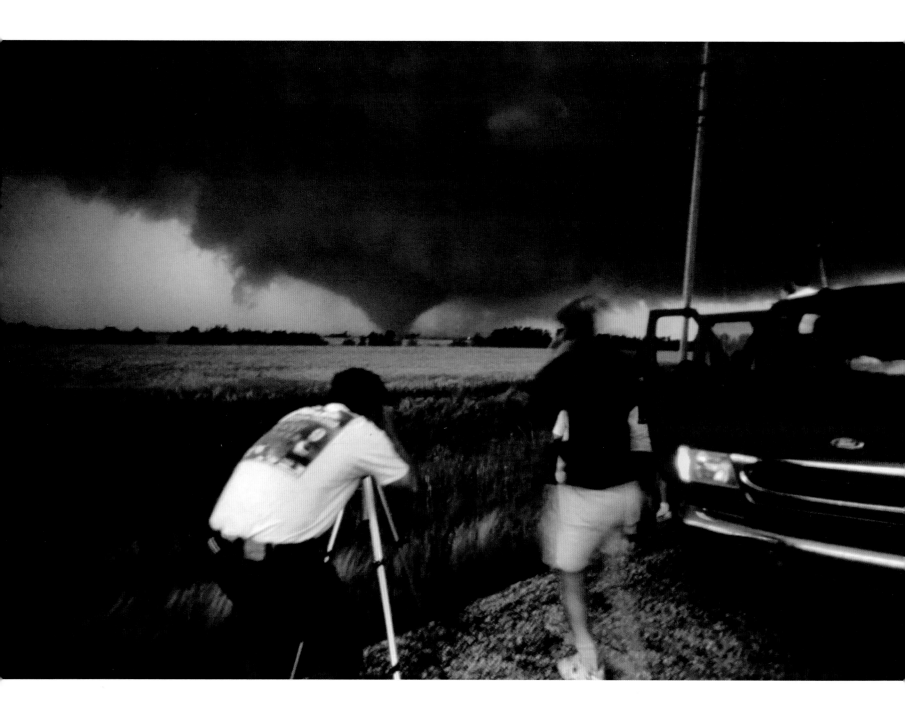

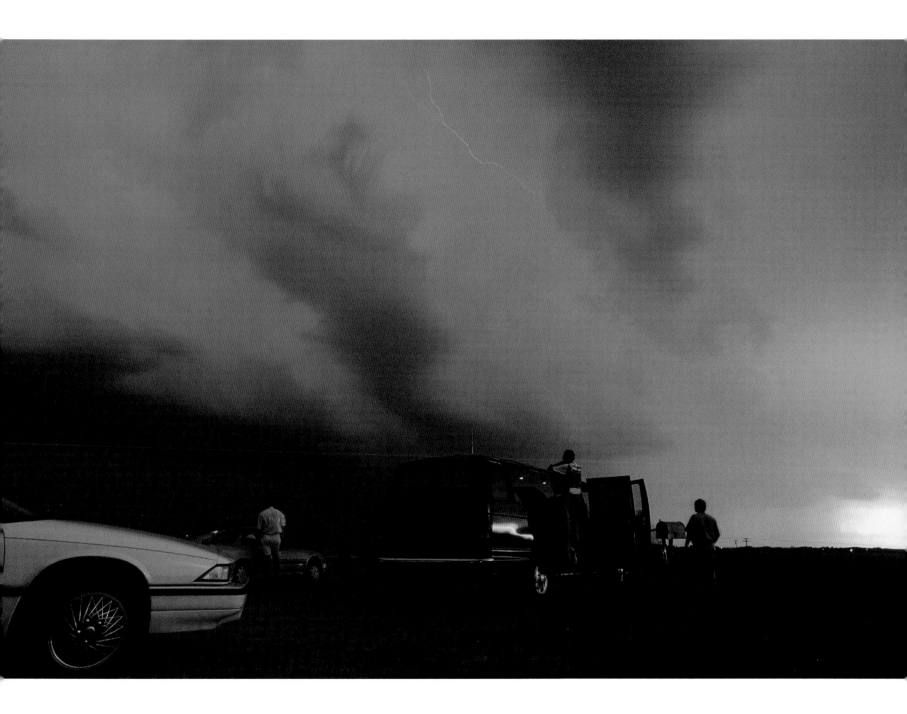

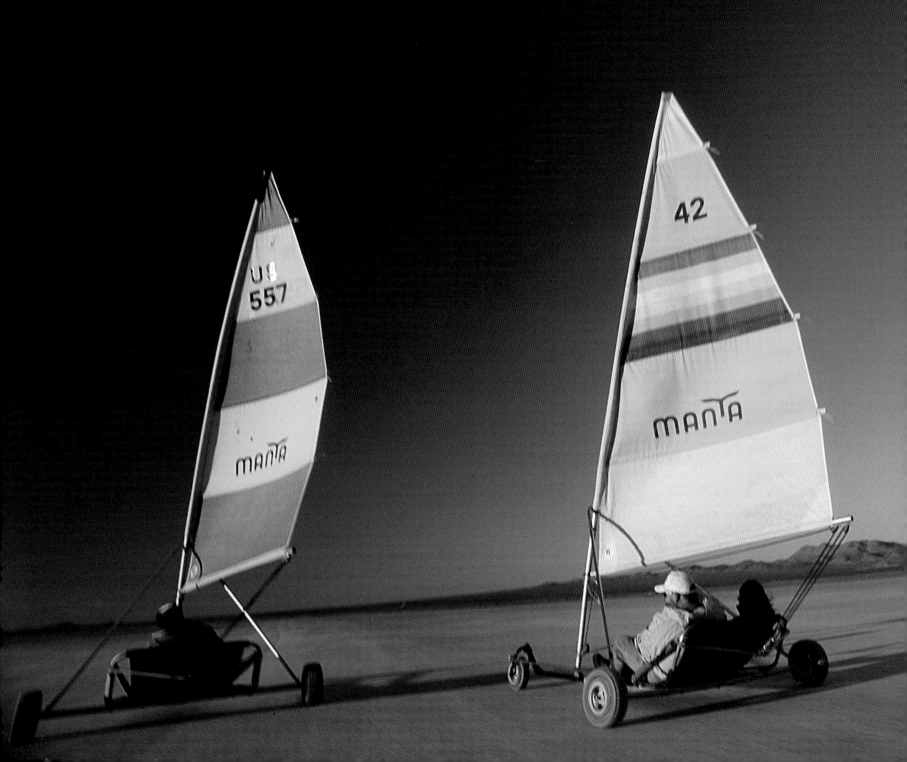

LAND YACHTING THROUGH THE MOJAVE DESERT

Out on the vast playas formed in the rain shadow of the Sierra Nevadas, cracked expanses of El Mirage Dry Lake seem to form an endless desert speedway. Tightly interlocked hexagonal polygons of dried mud are ironed smooth by scorching breezes that toss errant tumbleweed toward the distant Shadow Mountains. Seeking the holy gale, a colorful fleet of land yachts fly across uninterrupted barrens, chasing the horizon's mirage. Hitching a daredevil ride on these winds, courageous terrestrial sailors maneuver aluminum crafts, magnifying their speed with an agility that manages to triple the wind's velocity. Steering with your feet, while belted into a bucket seat, runaway gusts are captured while concrete-hard ground slides beneath you at speeds of more than sixty miles an hour. Near sundown, golden plumes of dust explode during a reversal of direction as the three-wheeled contraption teeters at precarious angles. Wafting across this moonscape like an errant dandelion spore, you steer directly into blowing currents and let out the rigid sail. Nighttime racing here is taken over by hungry predators pursuing scores of nocturnal kangaroo rats.

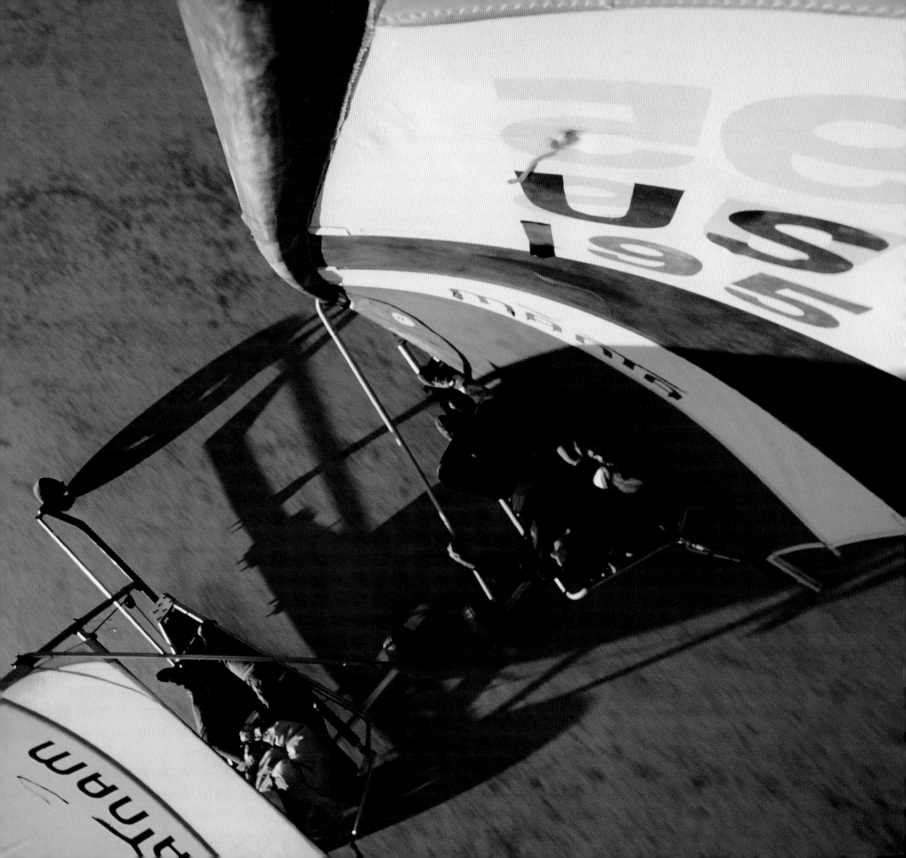

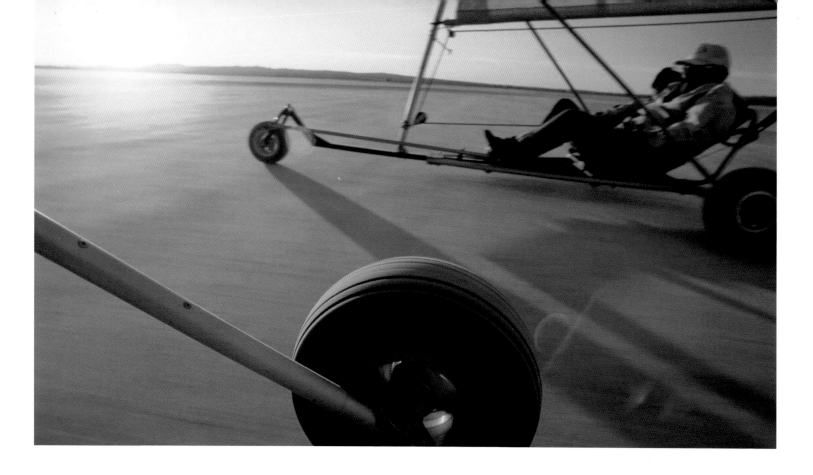

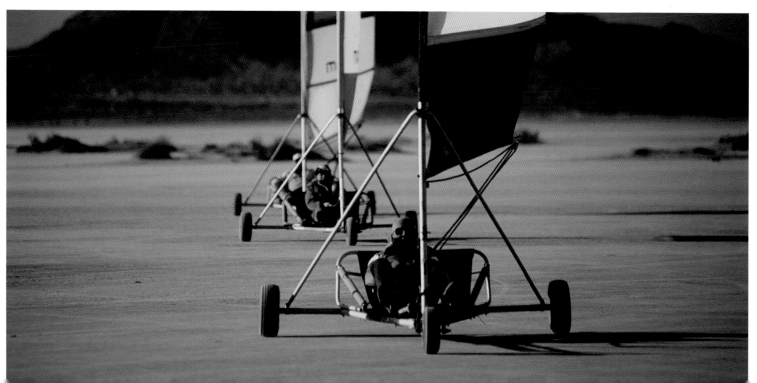

TIDAL BORE SURFING ON THE BAY OF FUNDY

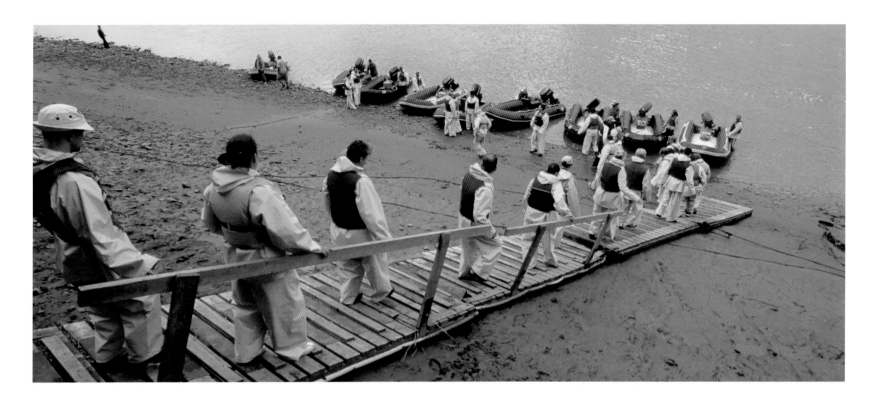

Tidal bore surfing is surely the only adventure regulated from as much as a quarter of a million miles away. The twice-daily magnetic pull of the moon creates the earth's tide, a huge bulge of water whose ebb and flow conducts the rhythmic pulse of our planet. In just a few places on the globe, that extra seawater is dramatically funneled into a constricted, ever-narrowing course, growing in height as the river floor becomes shallower. The Bay of Fundy offers the highest tides, where one hundred billion tons of chilly brine accumulate in twelve-foot walls of ferocious whirlpools and eddies, swamping huge sandbars as the direction of the currents are dramatically reversed. The passengers of a self-bailing Zodiac head out from muddy flats to rendezvous with the oncoming tempest. You'll discard your paddles and surf the roiling seven-mile-an-hour surge, preceded moments earlier by the low frequency, rumbling noise of entrapped air bubbles. During this riverine roller coaster, as frigid waters appear to be on the verge of swamping the craft, special waterproof suits do a reassuring job of warding off hypothermia.

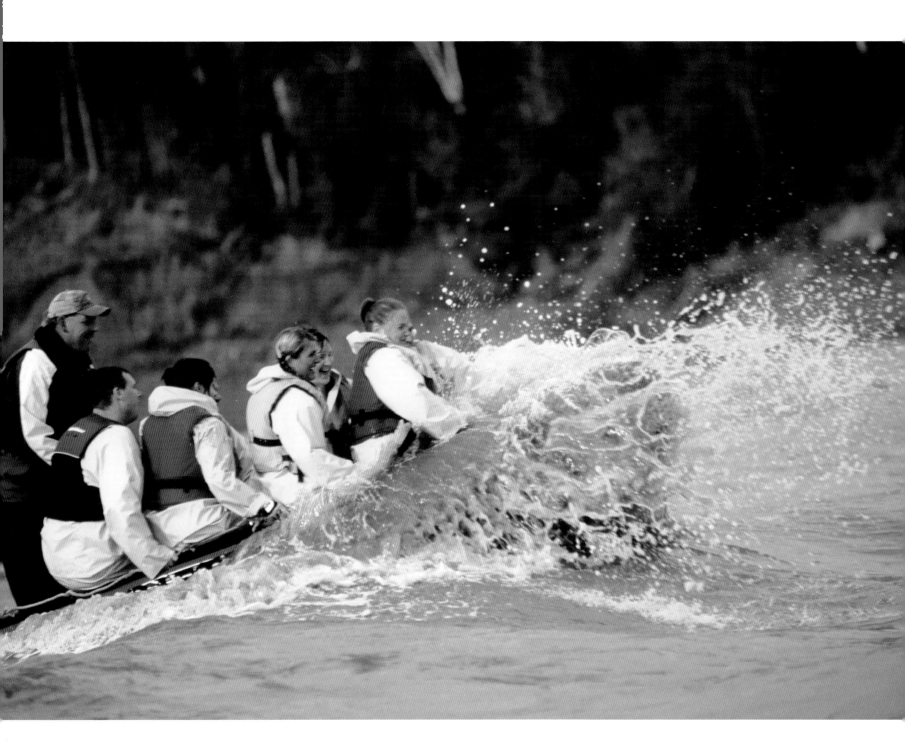

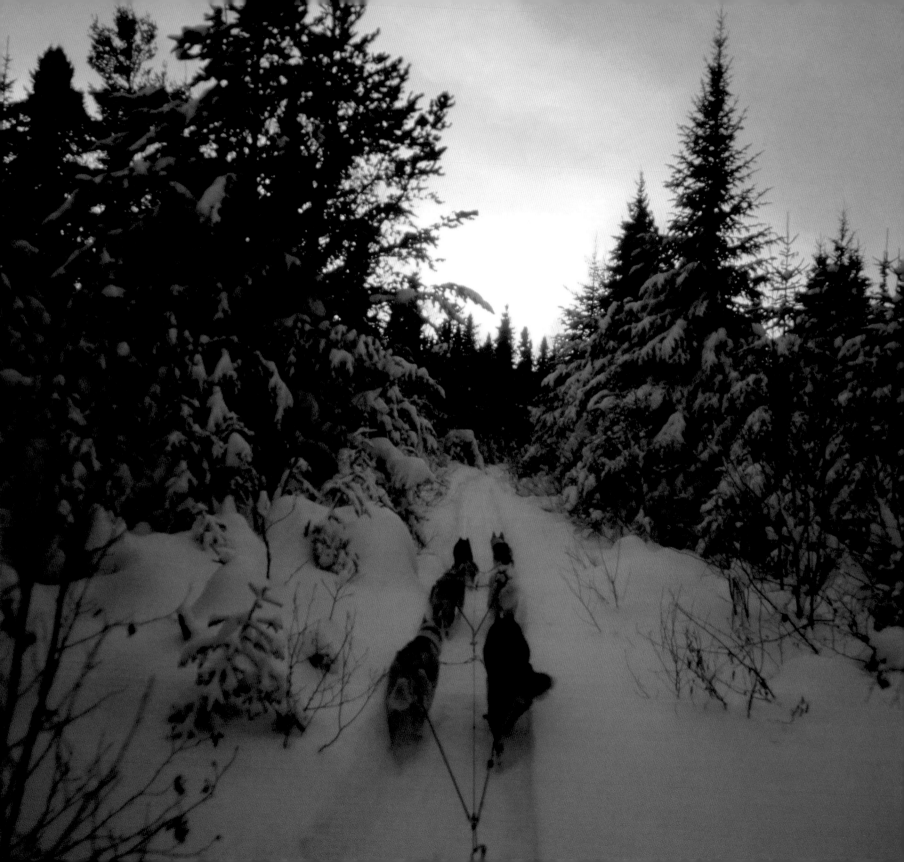

DOGSLEDDING ACROSS MINNESOTA'S BOUNDARY WATERS

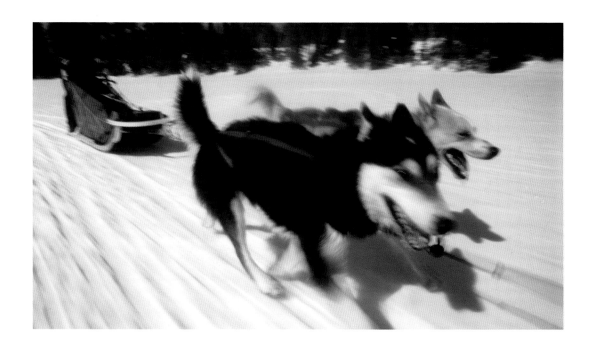

At the edge of Horseshoe Lake's icy surface, jumping Alaskan huskies are gathered and cinched together. Nervous yelping bursts of canine breath emit steamy clouds that signal the team's imminent departure. As an iron-clawed snow hook is released, the animals hurl instinctively into a rhythmic, tail-wagging gallop, now silently accelerating with eager paws toward a breakneck speed.

In dogged pursuit of the distant forested shoreline, the endurance-bred marathon mutts seem to try outrunning their gangline harness. Entering the woods, where pine martens scramble for seeds, test your braking skills as you negotiate brambled slopes and barrel down the historic Banadad logging trail. Guard your face from splayed limbs of evergreen that are burdened beneath thick frosting.

Bear down on your moosehide mukluks and lean on one runner to keep from smacking stumps and executing an unscheduled somersault over the handlebars. Weathering wipeouts that unhinge canvas-covered cargo holds, you at last approach the yurt's pocket of warmth where, beneath swirling stars, the resting dogs will answer the call of the wild, their howls mirrored by faraway wolves in a primal chorus.

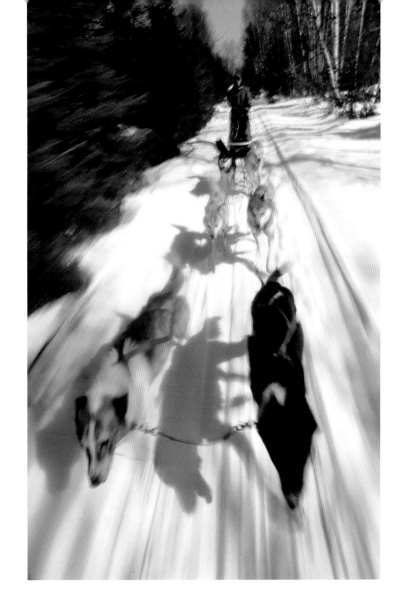

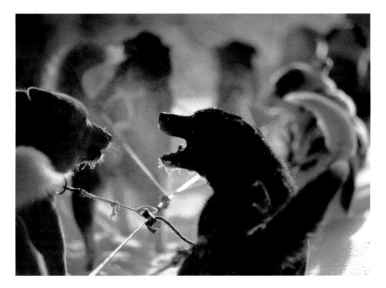

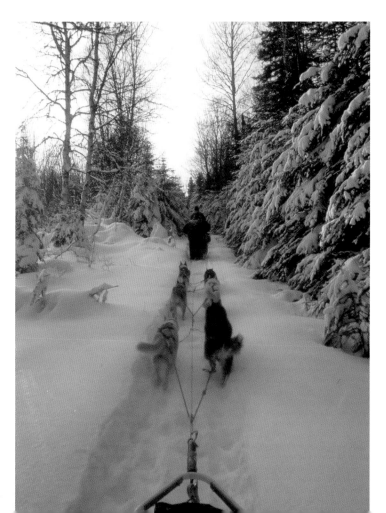

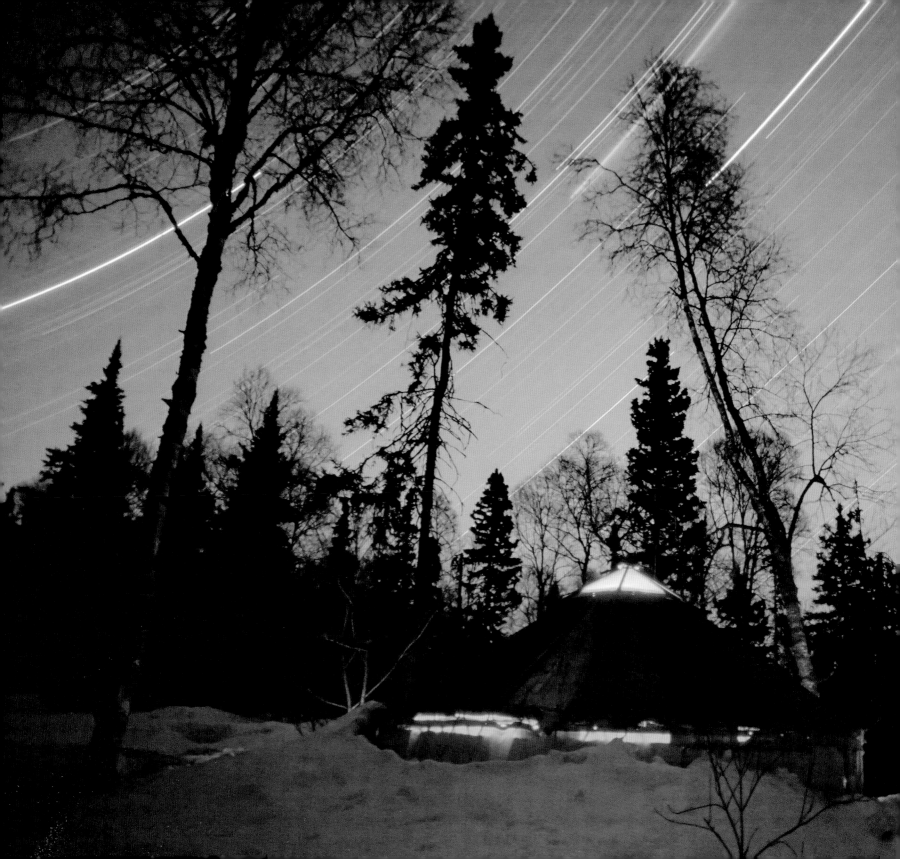

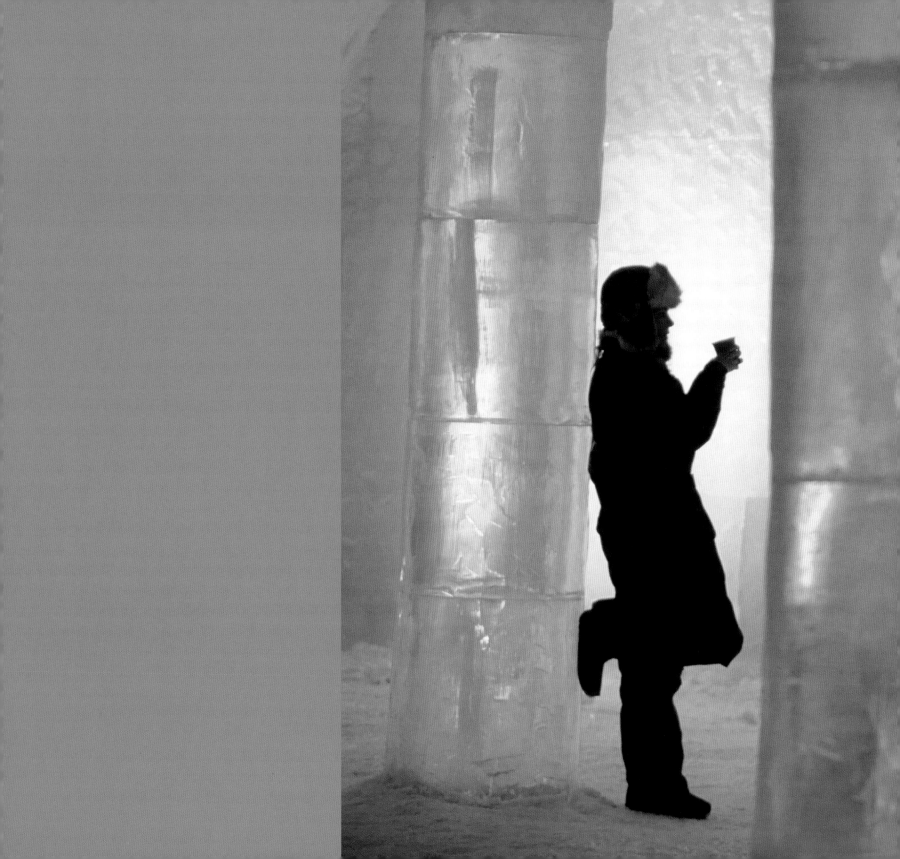

LODGING INSANITY

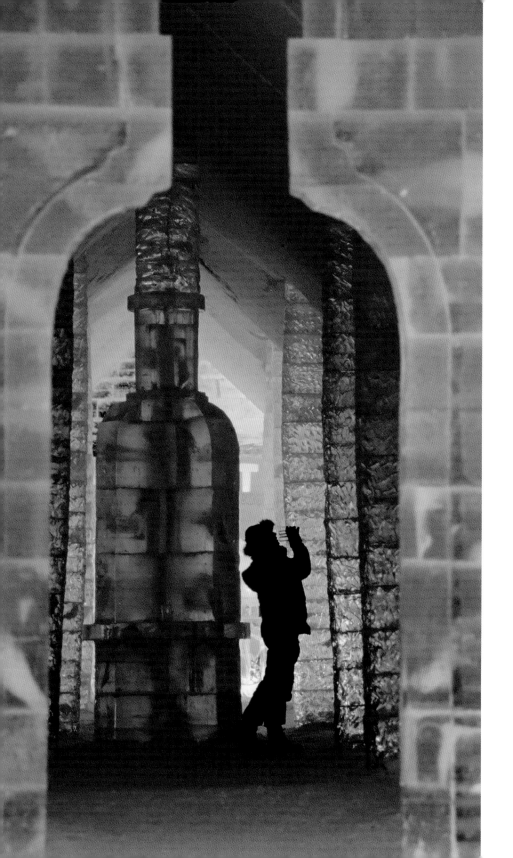

SLEEPING IN ARCTIC SWEDEN'S ICE HOTEL

Arrive at your glistening resort beneath an aurora's shimmering blanket, north of the Arctic Circle in a taiga wilderness where Sami herders have just finished corralling their errant reindeer. Created from the purest substance on earth, the Icehotel is a palatial igloo painstakingly assembled with five thousand tons of water from the frozen Torne River. Clad in provided overalls, boots, and mittens, you waddle into the 20-degree Fahrenheit teeth-chattering temperatures of the lobby, where frigid breath fogs the crystal chandeliers illuminating a Christmas tree by the fireplace, all sculpted with polished artistry. Enjoy a vodka toast to your chilled adventure, delivered by a fur-capped bartender in the shiny bar where cubes clink in glasses carved from that same freezing liquid.

Sliding past the gleaming church and cinema, you arrive at your refrigerated bed and snuggle into polar-tested sleeping bags, cushioned by ungulate hides. Be mindful of bedtime routines, as moisturizing cream will produce frostbite and undisciplined bladders can spark a hundred-yard dash to the nearest loo. In the immense, frosted silence, a thrumming heartbeat seems to echo within your Eustachian tubes. Warm lingonberry juice is delivered in the morning just before your sauna, a blessed reminder of the thermal rejuvenation that blossoms in the springtime, when your boudoir will melt into the Swedish landscape.

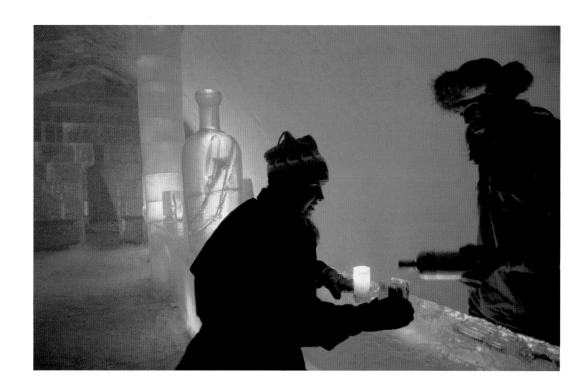

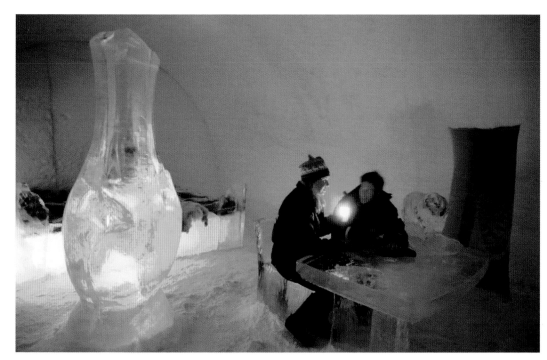

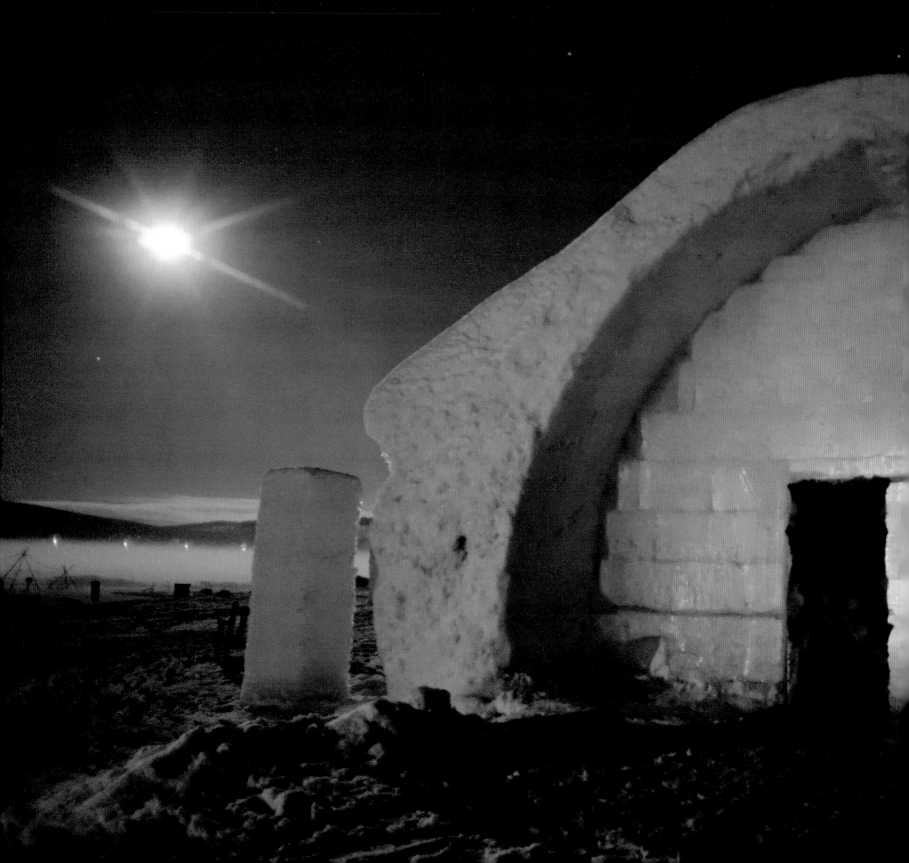

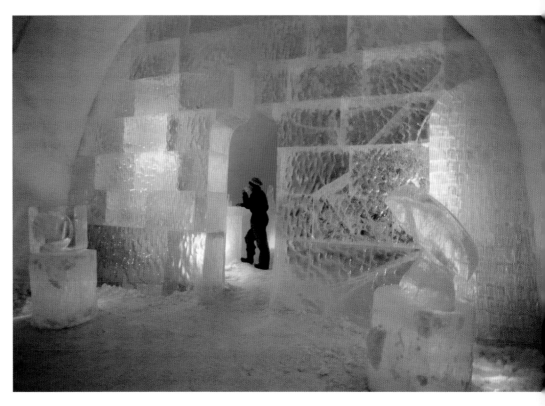

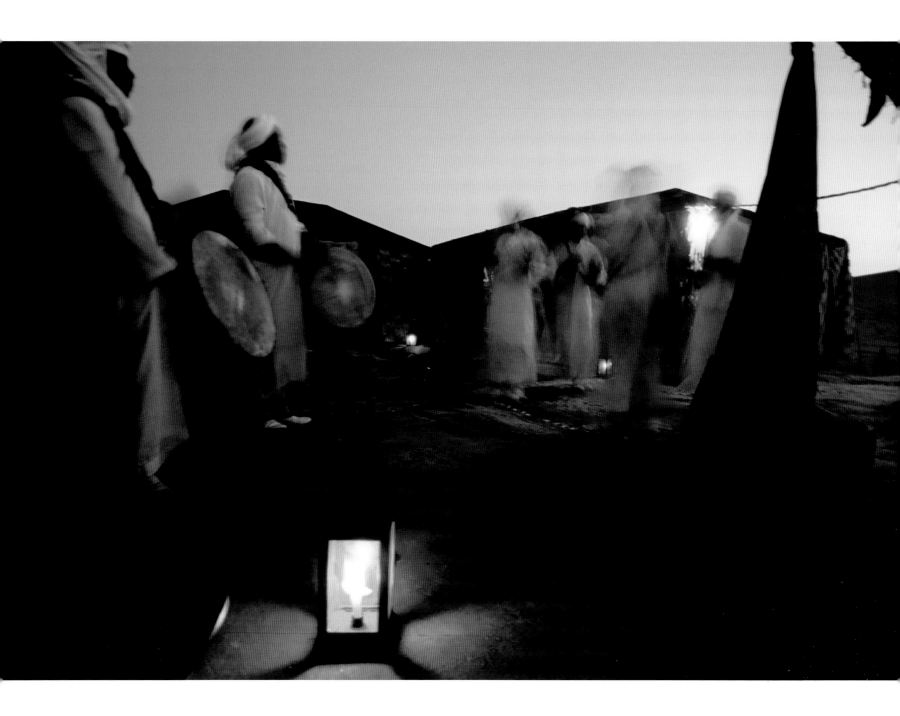

CAMEL CARAVANING TO A SAHARAN OASIS

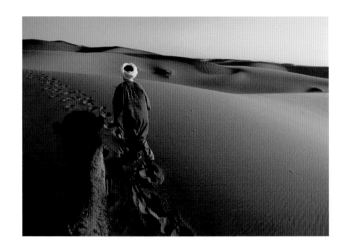 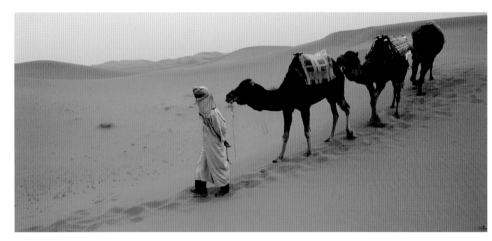

The Sahara is the earth's largest desert, and its meteorological oven has baked the highest surface temperatures ever recorded. At the northern edge of Erg Chebbi, a fleet of camels carpeted in Berber kilims kneels to permit human straddling. Leaning backwards, riders guard against being catapulted headlong as the dromedaries hurl into their awkwardly loping stride. Grunting mammalian lifeboats on a scorching sea of hissing windblasted sand, the dromedaries thrive, aided by bushy eyebrows and long eyelashes to protect against the cruel abrasion of fierce gusts. During parched sojourns they manage to keep moist by recycling water vapor trapped inside their nostrils. Caravans led by indigo-swathed nomadic Tuaregs plod their way across soaring corduroy-textured dunes spreading amber waves of sand toward the Algerian border. Tracing ancient trading routes enables the location of a distant oasis of thirsty date palms. Here, the moonlit encampment of goat hair tents is hypnotized late into the evening by the thrumming percussion of swaying Gnawa musicians. After a deep, posterior-healing sleep beneath a dazzling display case of constellations, camel milk yogurt leads off a breakfast prepared just above the curious eyes of wandering scorpions.

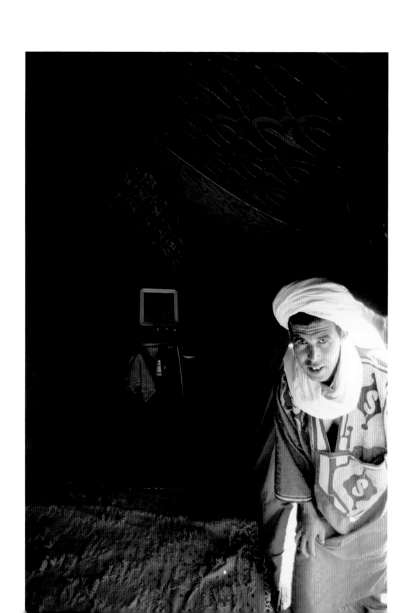
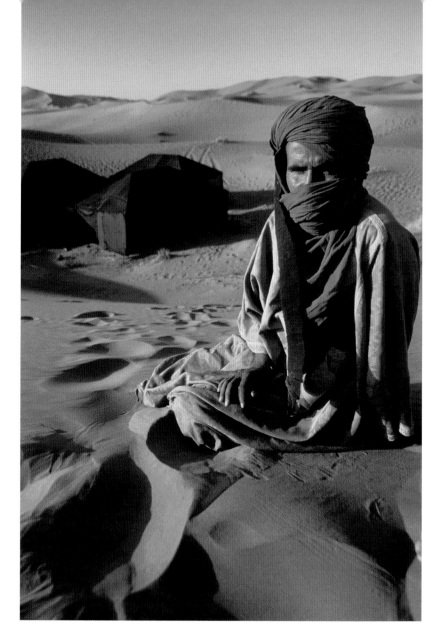

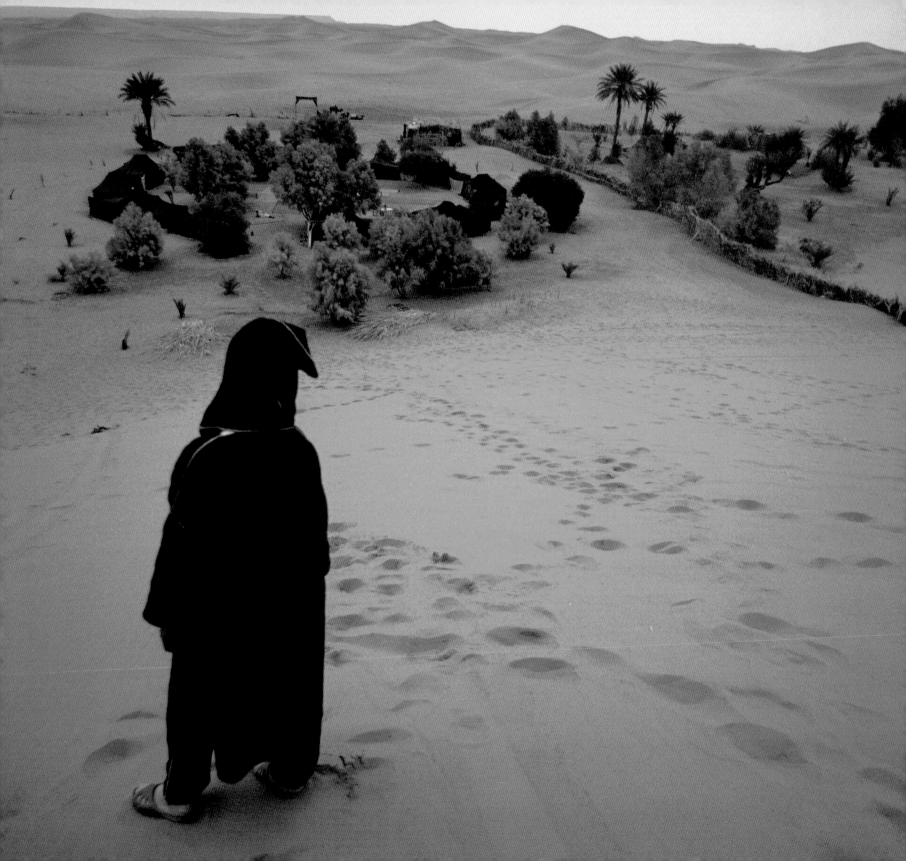

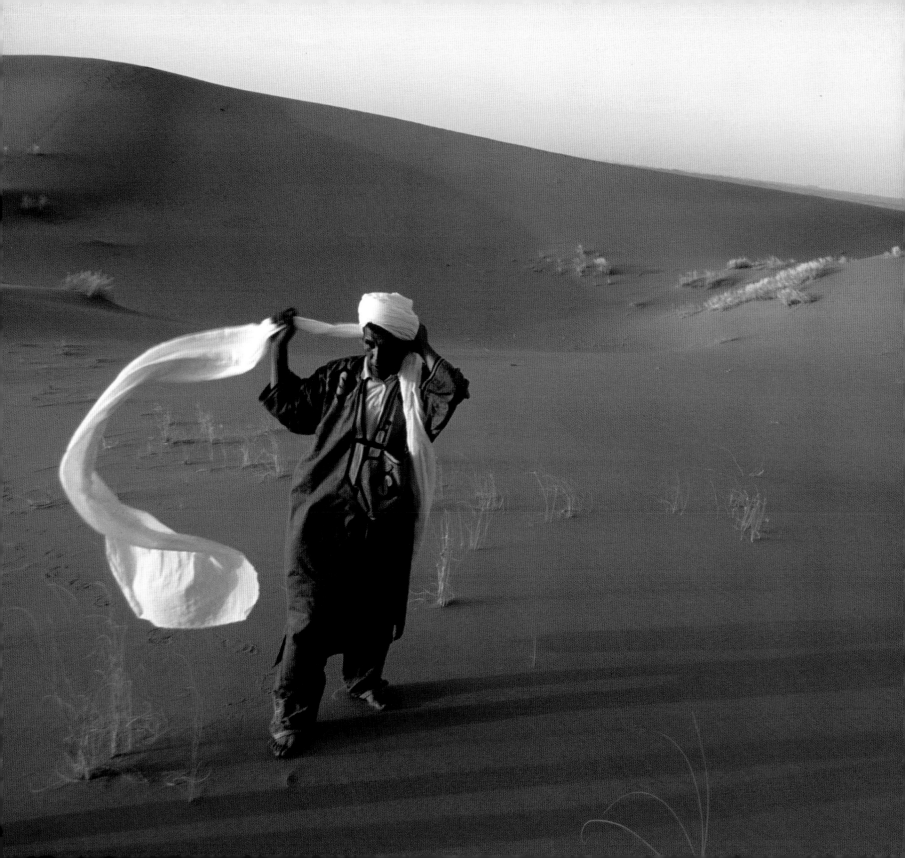

LODGING WITH HEADHUNTERS AT A BORNEO LONGHOUSE

Abandon any last vestiges of modernity as you squeeze inside a buoyant timber and glide up pellucid waters deep within Borneo's rain forest. Swirls of olive canopy slide through gentle breezes that kiss the Skrang River, a principal circulatory system for trade and warfare amongst distant settlements of Iban people. Above, a company of hornbills flee as fuzzy-headed orangutans shake the fruit trees for odoriferous durians. As the vegetation thickens, you enter a narrow, twisting avenue of water that mirrors ancient condominiums for retired headhunters. Parking the dugout, scurry up a notched log and cautiously ascend the muddy bank.

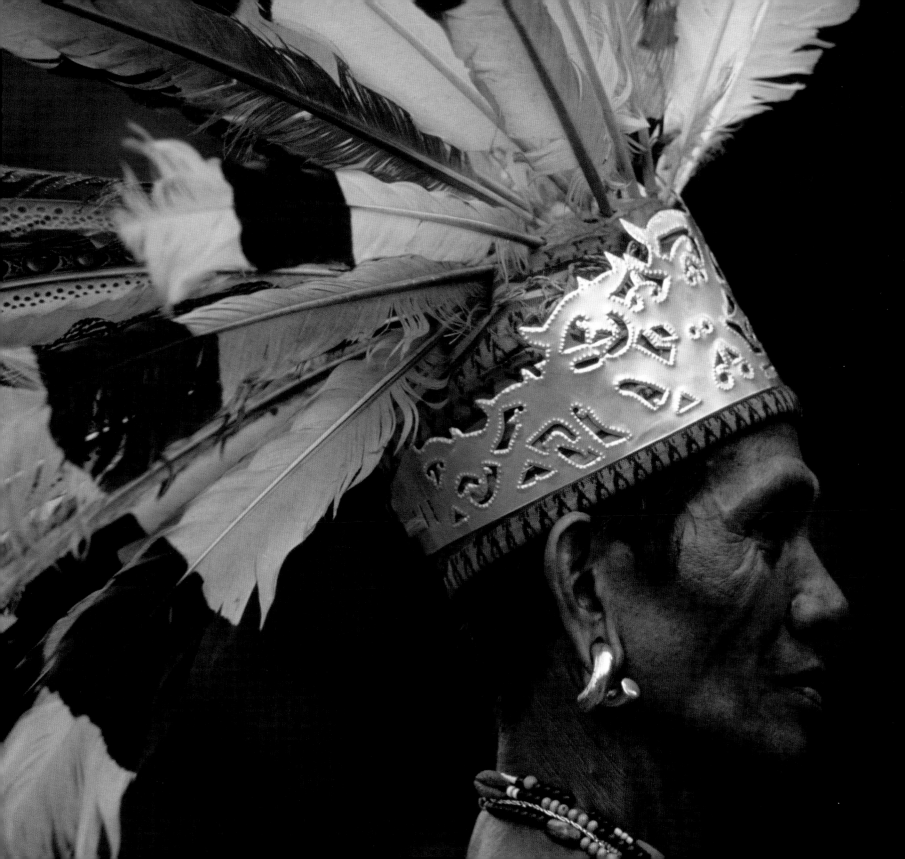

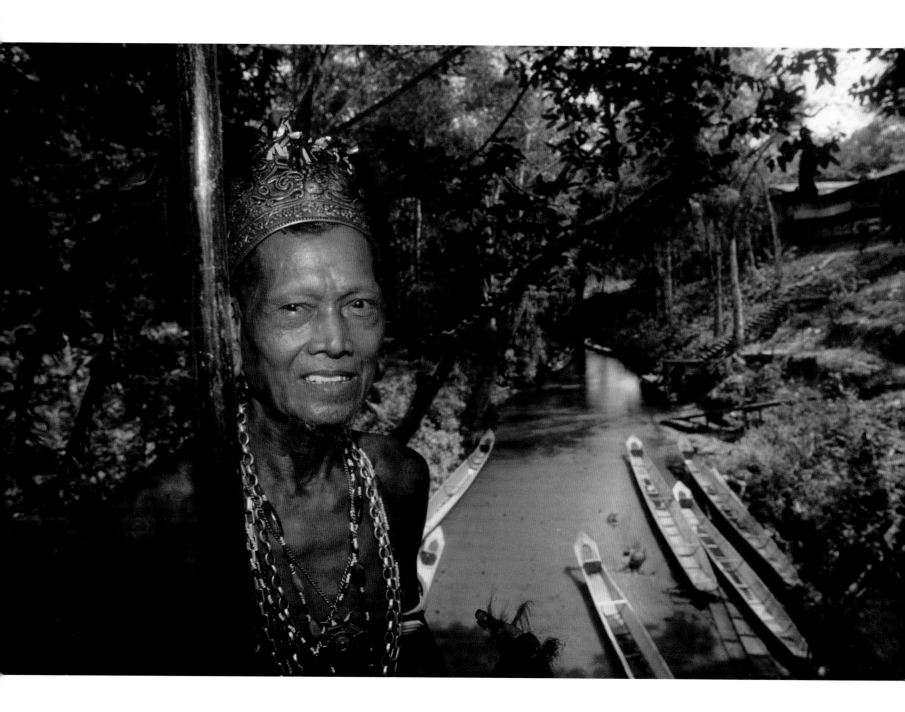

Remove your shoes before entering an eight-hundred-foot-long shed roofed with thatch and perched on towering stilts tied with creeper. Inside the longhouse, a bouquet of human skulls dangles from the rafters like a chandelier. Their ancestors' vacant eyes spy on tribesmen below, tattooed, feathered, and busy mending fish traps or inspecting blowguns. An offer of biscuits and fruit to the headman smoothes your arrival, as you pass a column of weavers tethered to backstrap looms. Obligatory rice wine ferments in mammoth jars as sonorous gongs keep time to the fluid movements of a paraffin lamplit warrior dance. Mosquito netting thwarts malaria, and, comforted by the notion that the gathered scalps are probably only mementos of another time, you try to sleep with both eyes closed until cockfighting roosters signal the approaching dawn.

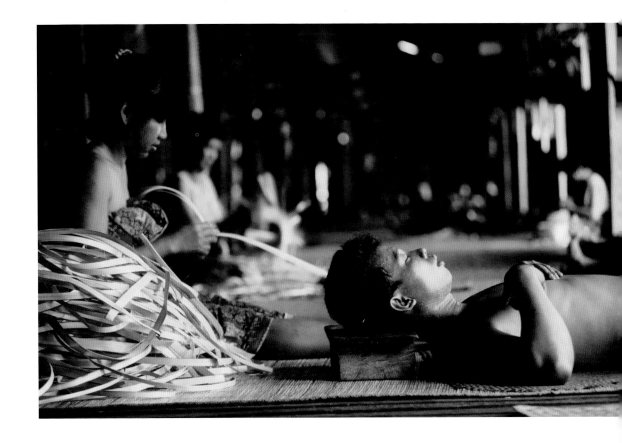

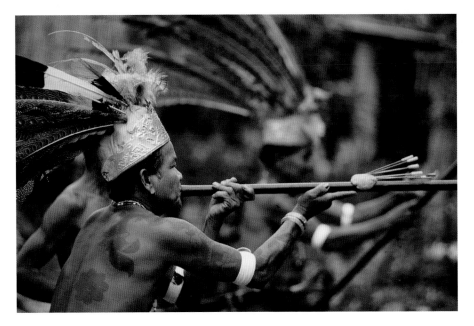

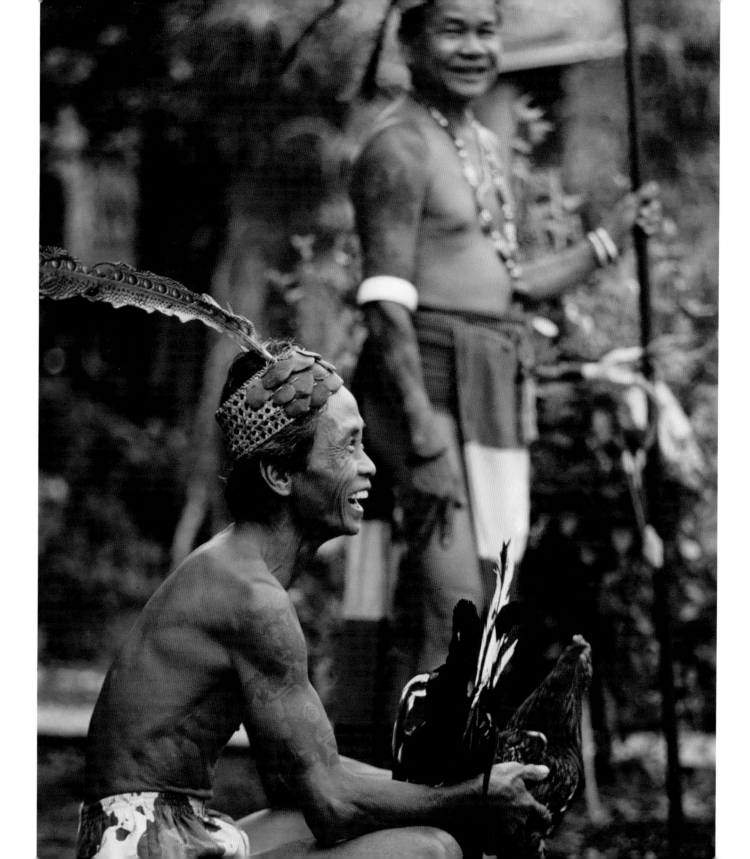

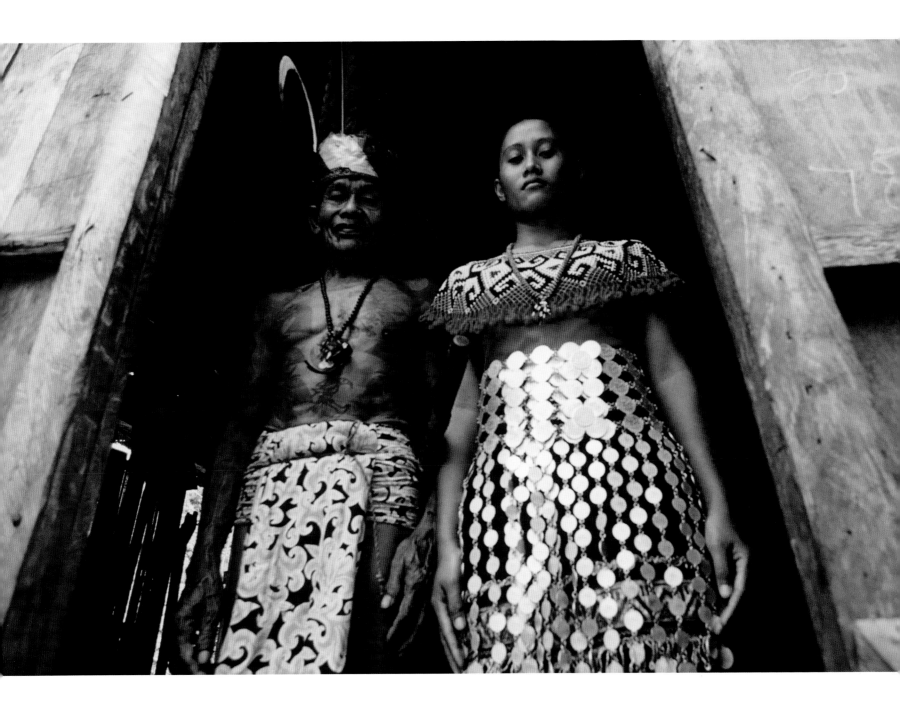

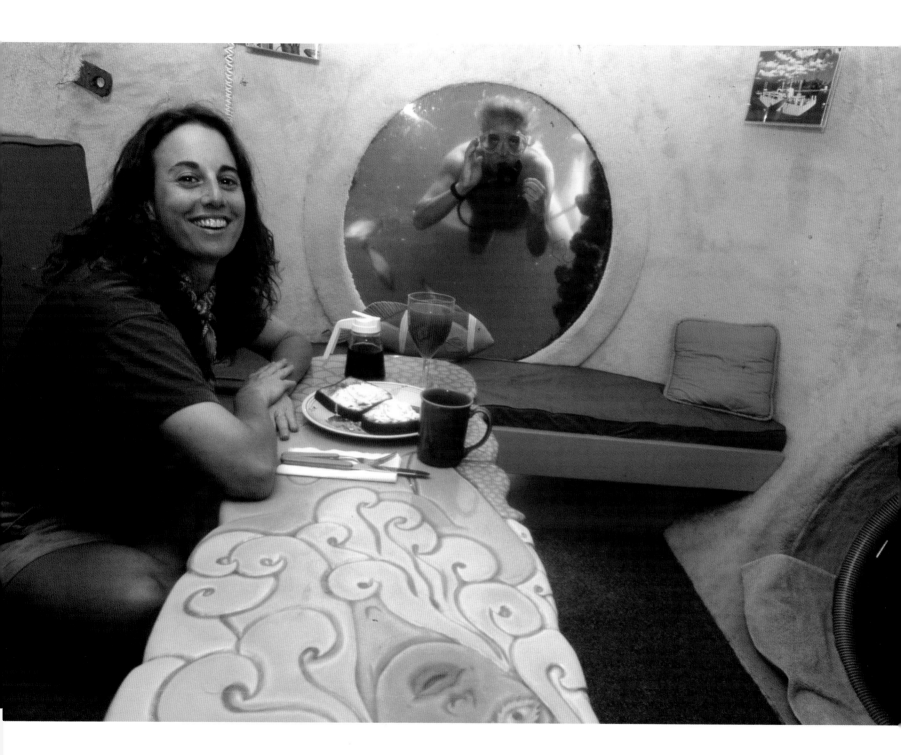

SCUBA DIVING TO A BEDROOM
UNDER THE FLORIDA KEYS

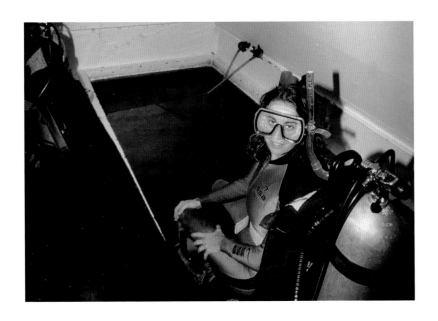

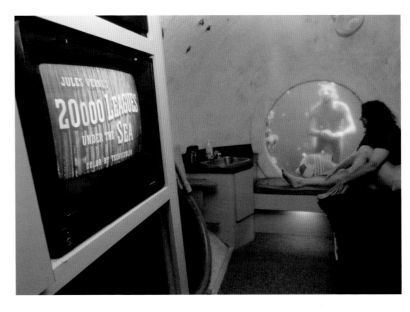

In the Florida Keys, a gracefully curling archipelago of palm-fringed islets points toward the Caribbean. Here, not far from Largo Sound, sleeping with the fishes has an altogether different, non-gangster related connotation. To find your bedroom for the evening, strap on scuba gear and follow the trail of opalescent bubbles as you head toward a former scientific habitat. In a sun-dappled lagoon anchored nearly thirty feet

beneath the surface, you wind through billowing curtains of parrot fish as the barnacled hulk on the ocean floor looms ever larger. After popping up into the lobby and kicking off your flippers, breathing without your tanks becomes the first amenity you notice. An aquatic bellman will deliver your watertight luggage, returning later to prepare meals in the suboceanic kitchen. In a rare role reversal, angelfish and curious nurse

sharks observe through the porthole as residents are fed daily in this human terrarium. A hookah-powered twilight stroll across a darkening cove illuminated by phosphorescent plankton precedes bedtime, a deep sleep to the soundtrack of the burbling life-support system.

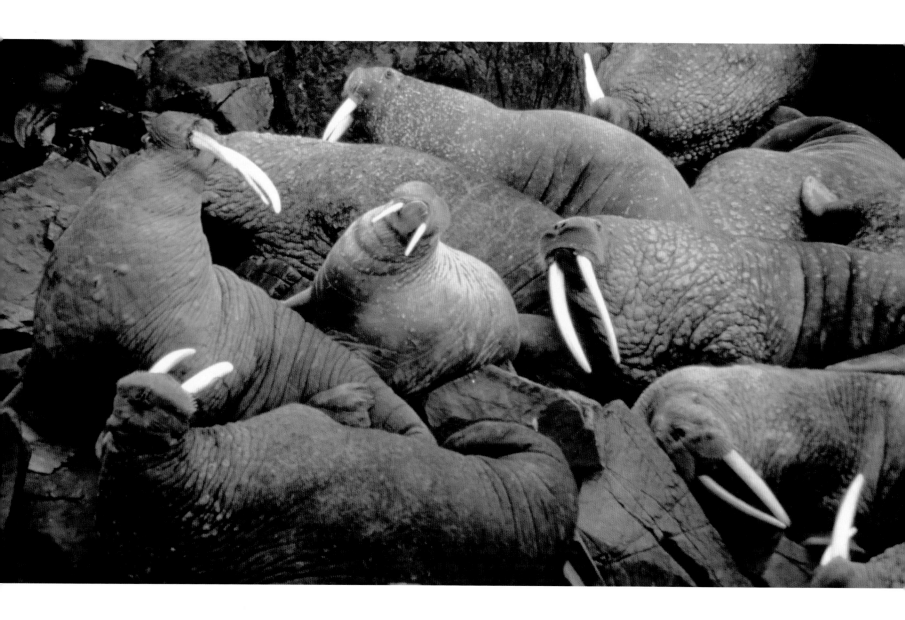

CAMPING WITH WALRUSES
IN THE ALEUTIAN ISLANDS

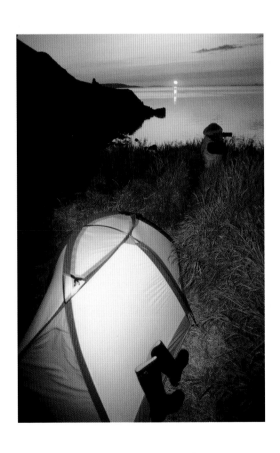

Accessing one of the most faraway campsites in North America requires perseverance. After hopscotching with an Alaskan bush pilot, a landing near a remote outpost is followed by an malodorous stay at the nearby salmon cannery. Here it's necessary to await optimal weather conditions that allow a fishing boat through choppy waters, in a region that's typically the birthplace of this continent's low pressure systems. Trailed by clouds of squawking seagulls, the craft approaches the soaring grassy cliffs of Round Island, forlornly anchored in Aleutian waters. Though equipped with a sleeping permit and tenting paraphernalia, it's critical to also bring along certain knowledge that your food supply may need to outlast a lengthy stranding. Negotiating precipitous bluffs, you'll pass kittiwake colonies that peer down on an unruly bachelor party of fifteen thousand snorting ivory-tusked pinnipeds. For days, observe this whispered men's club enjoying their journey's fogbathing rest stop. During a comic ballet of insomnia, each two-ton bundle of bouncing pink biomass fidgets to the rhythm of its neighbors' snores. The wistful strumming sounds of contented walruses lulls you to sleep.

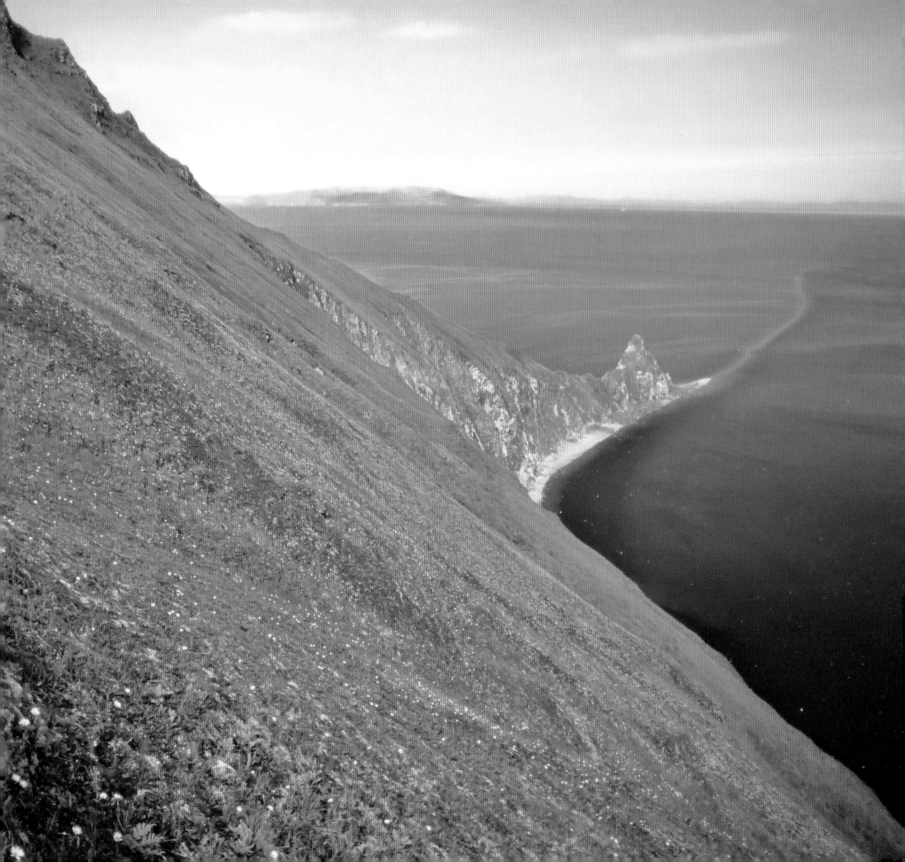

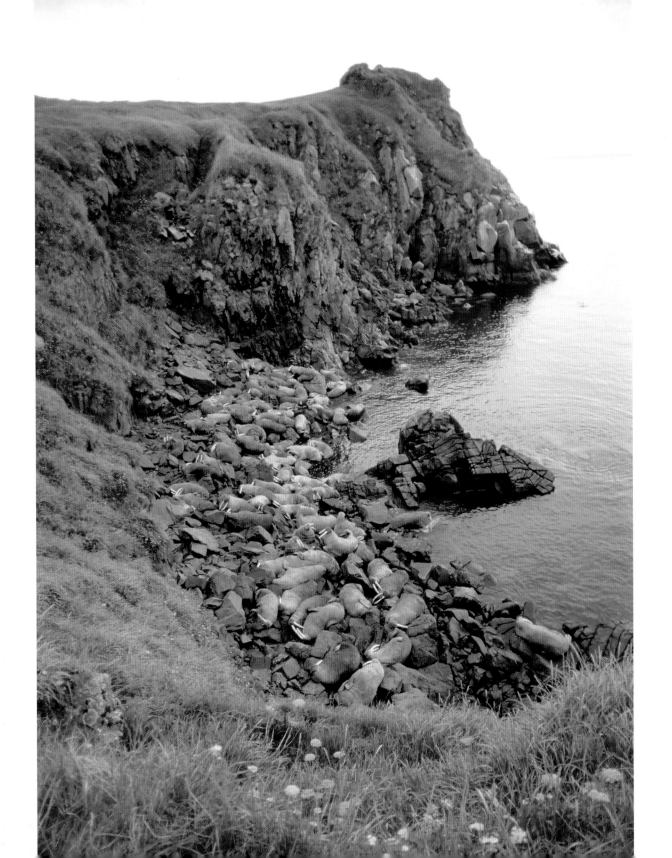

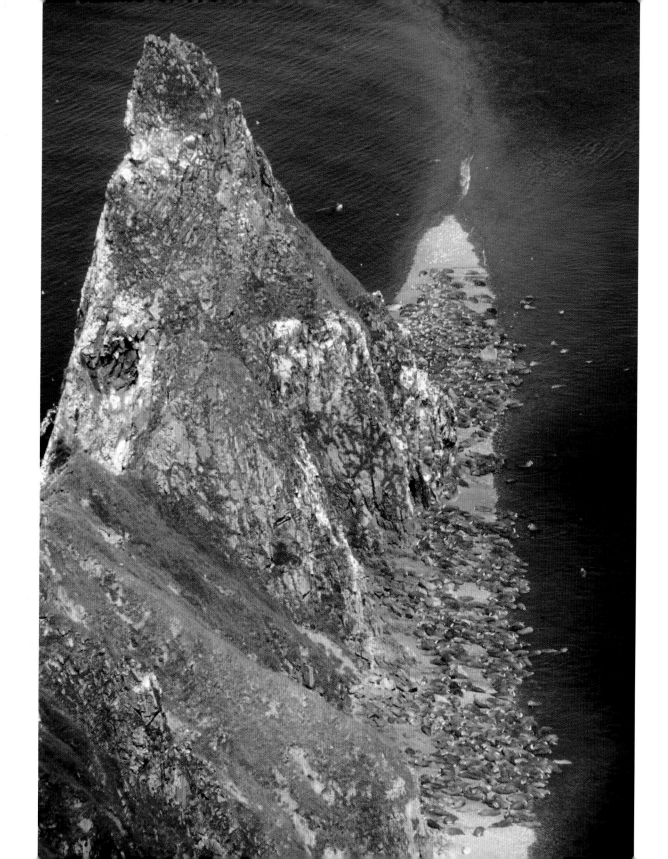

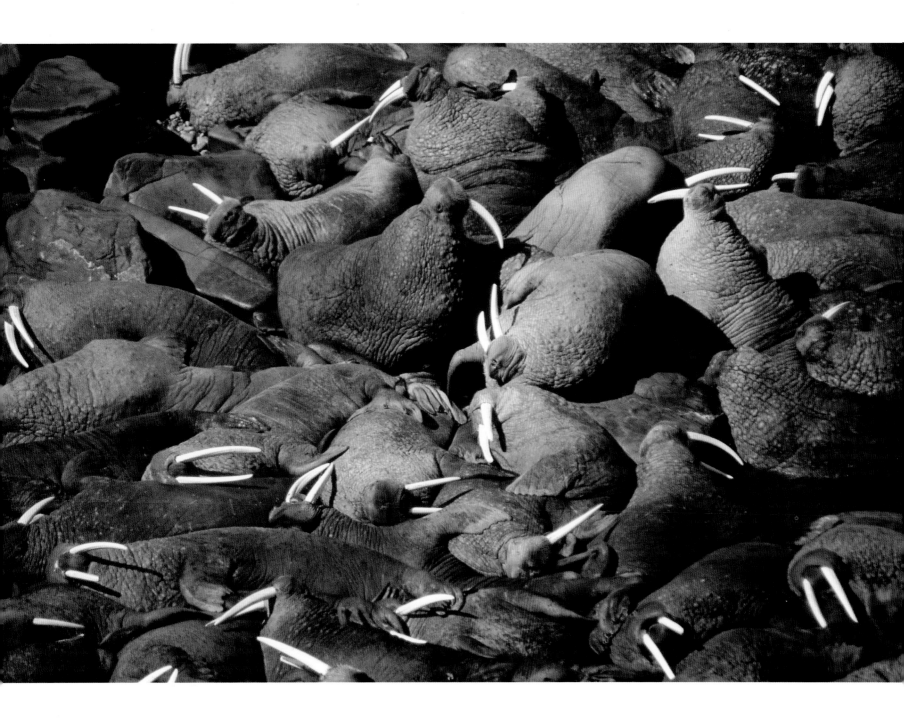

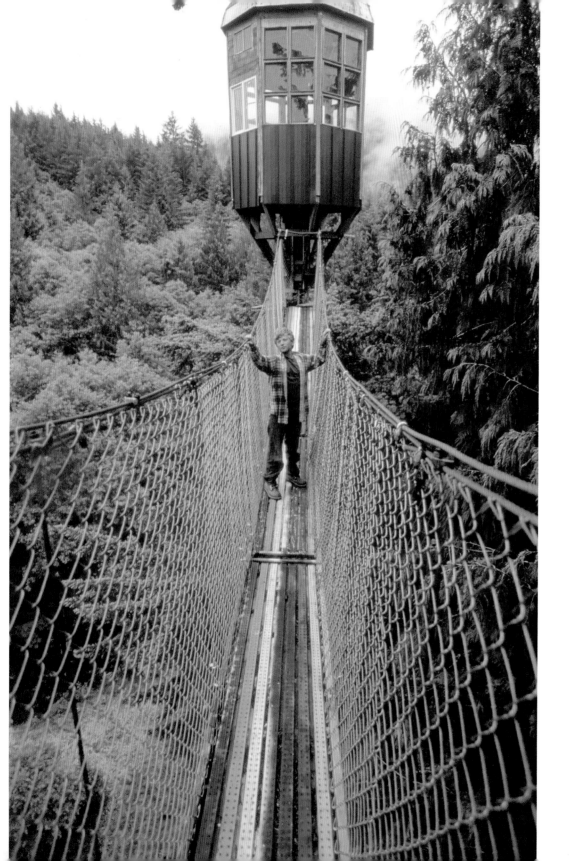
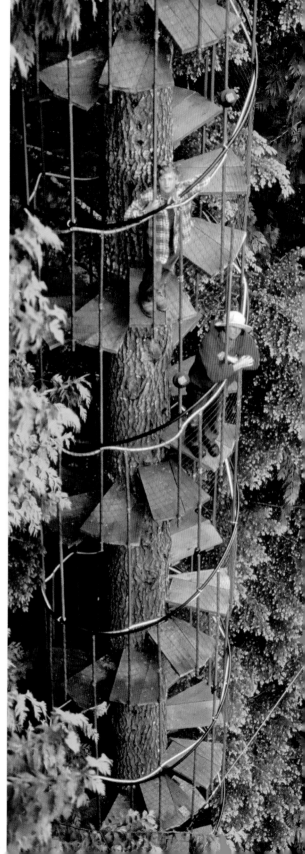

ASCENDING TREES TO LODGE IN THE SHADOWS OF MOUNT RAINIER

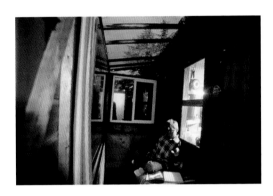

Deep in the damp old-growth forests that sit near the base of Mount Rainier, the mists of a temperate rain forest lift to reveal an astonishing vision out of *Jack and the Beanstalk*. A regal Douglas fir tree serves as support for an amazing series of steps, all anchored by lag bolts and spiraling eighty-two feet around the main trunk in a dizzying 360-degree climb toward the forest canopy above. Tapping into the primate heritage chiseled into your DNA, the climb's summit is only a jumping-off point for the swinging suspension bridge that, with each footstep, shakily leads toward a wind-shedding crow's nest—a cozy observatory aerie. Once you are inside, you can train powerful binoculars on mountain goats enjoying their pastures on distant Mount Wow. Just below, yet another Swiss Family Robinson construction claiming the treetops appears as a ramshackle mirage in its swaying arboreal setting. Pierced by a red cedar, the treehouse boasts several stories that include a kitchen nook, sunroom, and skylit loft that at night reveals a shining heaven, loaded with the only objects that seem even higher than your bedroom for the evening.

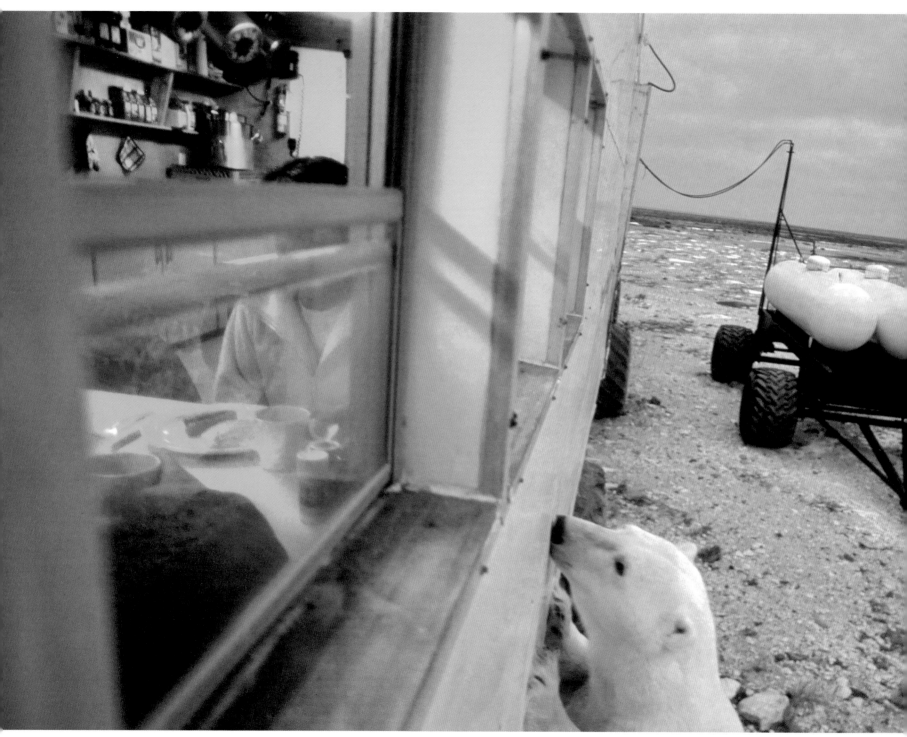

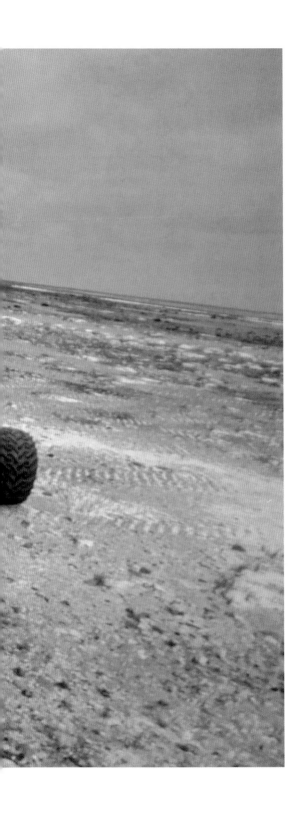

CONFRONTING POLAR BEARS FROM A TUNDRA BUNKHOUSE

In the high-latitude plains of northern Manitoba, Arctic foxes and flightless ptarmigans scramble against fierce boreal gusts, ripping white caps off the surface of nearby Hudson Bay. At these hardscrabble hunting grounds, hundreds of roaming polar bears gather each autumn, eagerly awaiting the grand opening of their icebound take out cafeteria. Ferocious snow-white carnivores, peeved by their meager summer diet of berries, wait by the shore for the waters to freeze. They'll station themselves by the icy roof over the ringed seal's domain and the breathing holes that these pinnipeds will maintain during winter.

Amidst this highly charged ecosystem, you lumber into position on specially designed tundra buggies, whose oversized tires carry you just high enough to escape the swipe of knife-sharp claws. Shotgun-wielding scouts safeguard the Arctic safari while discouraging unruly ursine behavior. Extending your stay overnight at this mobile home on the range, you bunk down in what amounts to an inverted zoo. Encased inside your metal cage, you'll dine on prime rib while curious black noses nuzzle outside at the frosted windowpanes.

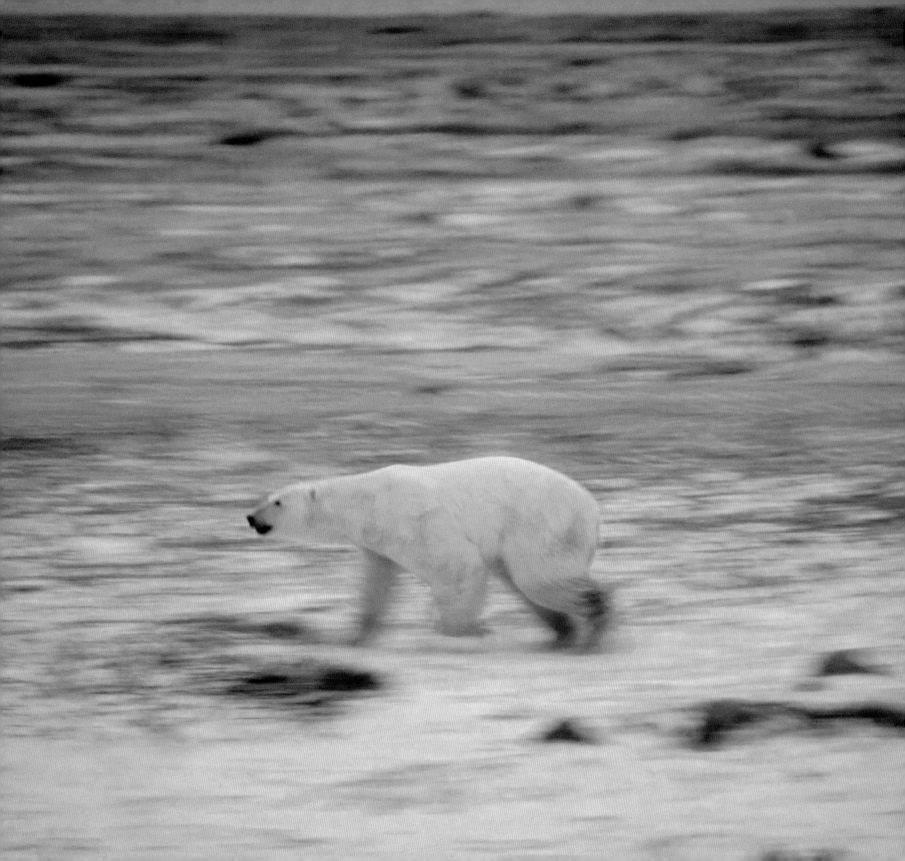

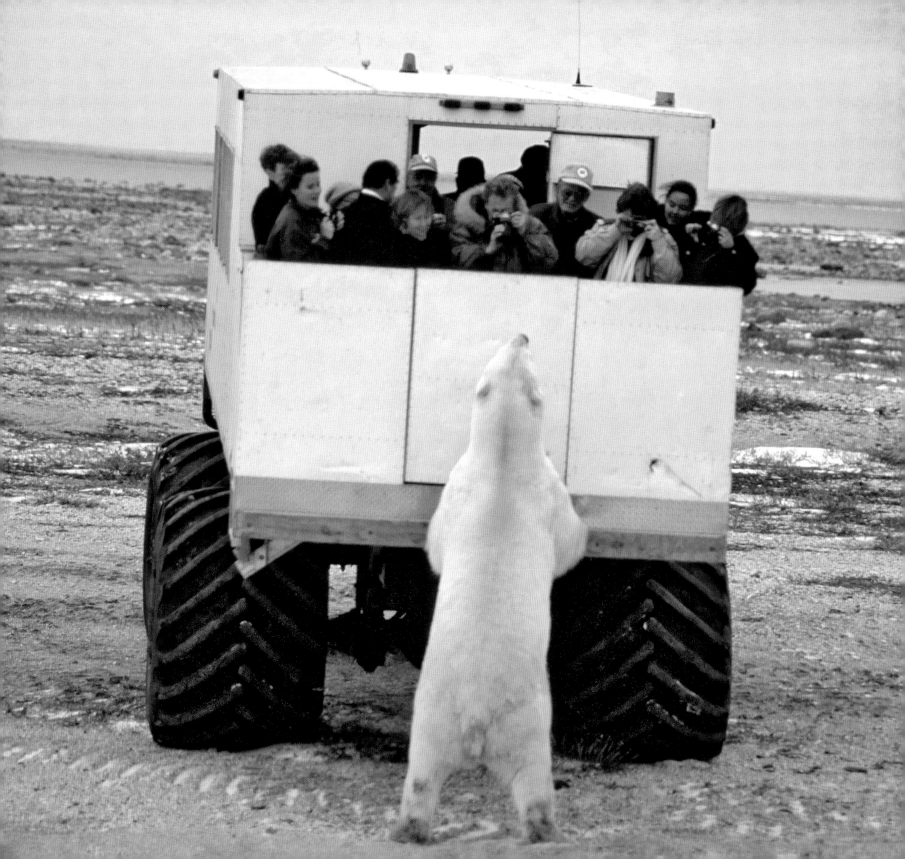

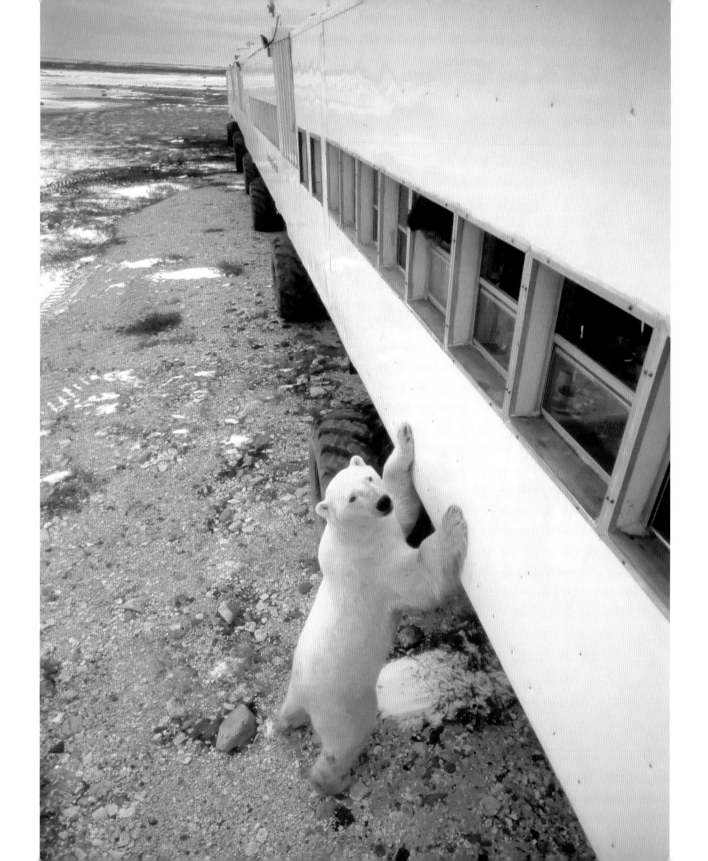

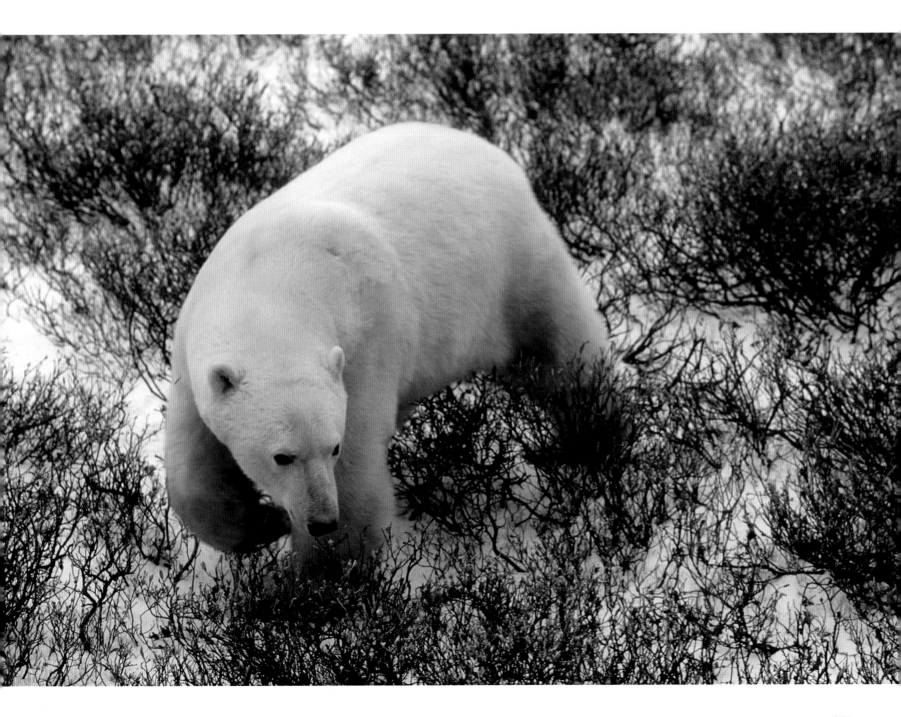

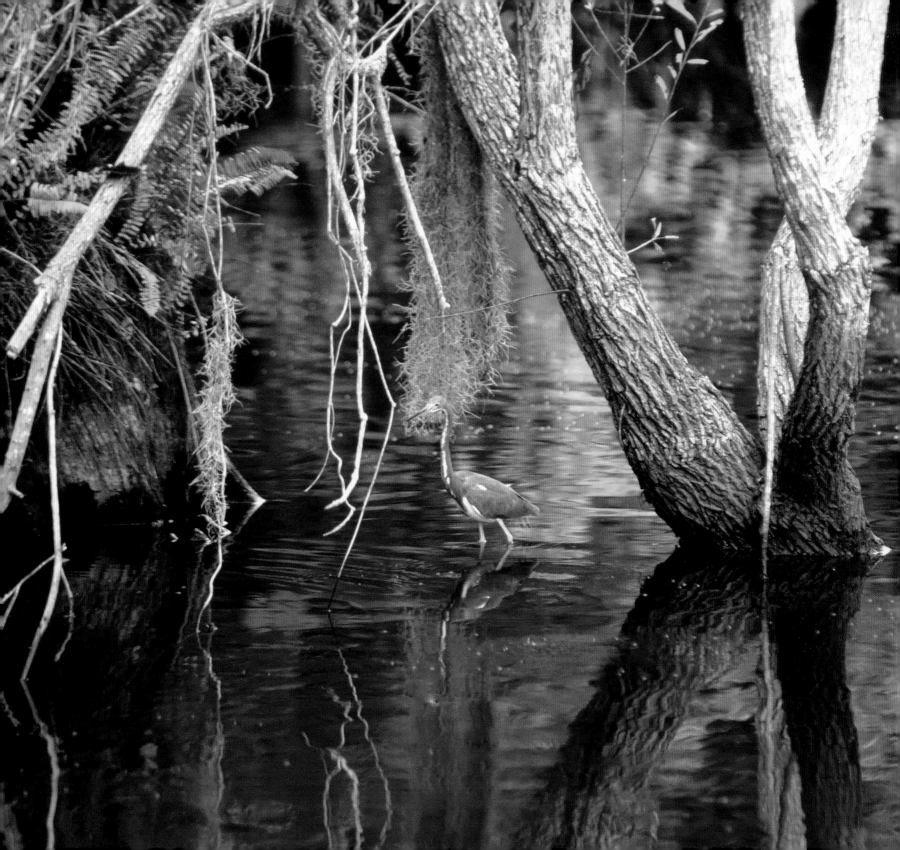

CANOEING THROUGH AN ALLIGATOR HABITAT TO AN EVERGLADES CHICKEE

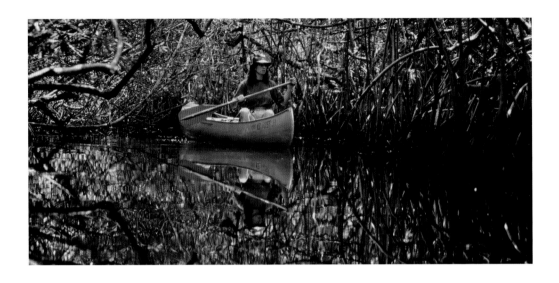

Effort and patient observation yield dramatic rewards when penetrating one of nature's most mysterious ecosystems. The Everglades is a zoologically dense, slow-moving, sixty-mile-wide river of grass that seeps past spongy peat deposits, thick stands of cypress hammocks, and archipelagos of sawgrass prairie. After you launch a canoe onto the languid Turner River, a drift downstream is aided by faint winds that comb strands of Spanish moss from fragrantly blossoming branches.

Paddle beneath soaring ospreys through a bewildering maze of red mangroves, a favorite nursery for ocean-bound crustaceans. Amongst a fragile kingdom of Disneyesque tableaux, striped snakes drape tree limbs and fractured logs serve as diving boards for sunbathing turtles. Glide toward the gulf through salt marshes, where fiddler crabs jitterbug away from scavenging pelicans. As the horizons widen, head toward shallow bays that are a playground for bottlenose dolphins.

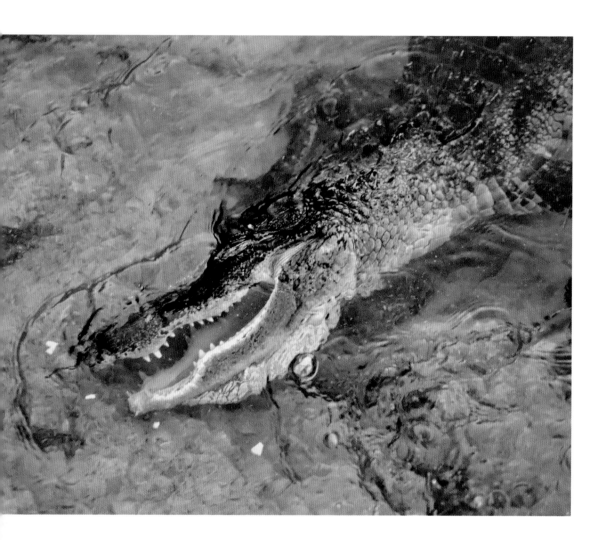

As you return to the glades, glistening surface-level eyeballs serve as reflectors, guiding you through a profusion of alligator-infested sloughs. These watery pockets are cleverly sculpted by leathery reptilian snouts to clear vegetation and create inviting watering holes for their thirsty, unsuspecting prey. Amongst this Jurassic community, you'll finally reach your bedroom's porch atop the wooden chickee, a roofed, rustic platform based on traditional Seminole dwellings. From just inches below, you'll probably hear the splashing death-roll sounds of muscular jaws preparing their dinner, and then decide to guard against a very different kind of meal. Slip into an evening gown of protective netting designed to thwart the appetites of at least forty neighboring varieties of hungry mosquitoes. As dusk descends and bedtime approaches, crickets and cicadas weave a lullaby refrain of undulating crescendos.

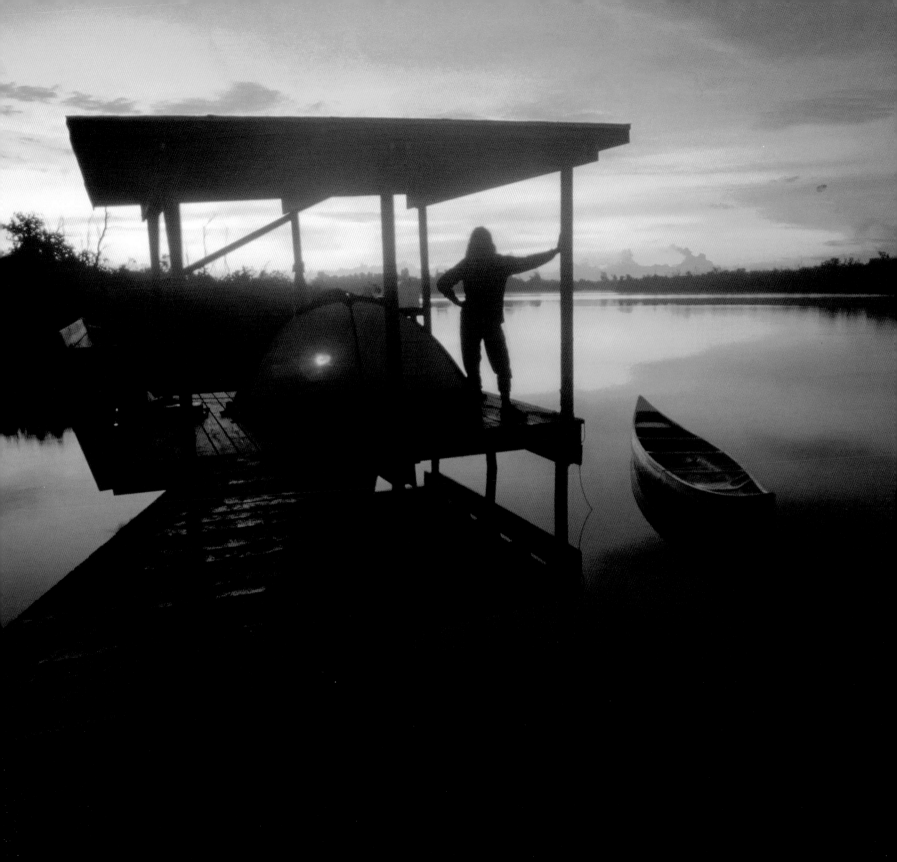

DIRECTORY

To assist readers determined to consummate their own adventure fantasies, a listing of outfitters, providers, and pertinent authorities are included on the following pages. Their websites presumably incorporate the latest updates, rates, and contact information. All information is subject to change. Take care to call ahead and also when embarking on any extreme adventure.

SCALING HEIGHTS

Scaling the Sydney Harbor Bridge
BridgeClimb
bridgeclimb.com

Summiting the Rooftop of Africa
Micato Safaris
micato.com/tanzania-safaris/

Hang Gliding Atop the Appalachians
Hyner Hang Gliding Club
hynerclub.com/index.php

Heli-Hiking through the Purcell Range
Canadian Mountain Holidays
canadianmountainholidays.com/summer.aspx

Hot Air Ballooning at Albuquerque's Mass Ascension
Albuquerque International Balloon Fiesta
balloonfiesta.com

Climbing onto the South Peak of Seneca Rocks
Seneca Rocks Climbing School
climbseneca.com

Open-Cockpit Barnstorming above Dutchess County
Hudson Valley Air Tours
oldrhinebeck.org/ORA/biplane-rides/

Mountaineering on Granite Spires in the Bugaboos
Canadian Mountain Holidays
canadianmountainholidays.com/summer/our-trips/high-flying.aspx

SOAKING WATERS

Paddling a Dugout to Venezuela's Angel Falls
Eco Adventures
adventurevenezuela.com/angelfalls-eng.htm

Snorkeling between Spawning Salmon on the Campbell River
Destiny River Adventures
destinyriver.com/raft-and-snorkel-salmon

Piloting a Pinasse Down the Niger River to Timbuktu
Mountain Travel Sobek
mtsobek.com/private_adventures

Floating in a Survival Suit on the Frozen Gulf of Bothnia
Sampo Arctic Icebreaker
visitkemi.fi/en/sampo-icebreaker

Traversing the Grand Canyon by Dory
Grand Canyon Expeditions
gcex.com/dory.html

Swimming with Whale Sharks in the Indian Ocean
Four Seasons Explorer
fourseasons.com/maldivesfse/

Sea Cave Kayaking through the Palawan Archipelago
Wilderness Travel
wildernesstravel.com/trip/philippines/palawan-snorkeling-kayaking

Tall Ship Sailing along the Trade Winds of the Caribbean
Sea Cloud
seacloud.com/en/the-yachts/sea-cloud/

TRACKING WILDLIFE

Icebreaking to Antarctica's Remote Emperor Penguin Colony
Oceanwide Expeditions
oceanwide-expeditions.com/destinations/destination/weddell-sea/highlight/emperor-penguins-the-weddell-sea/

Spotting the Amazon's Mystical Pink Dolphin
Ariau Amazon Towers Hotel
ariauamazontowers.com/packages.html

Encountering Tigers on Elephant Back in Chitwan National Park
Tiger Tops
tigertops.com

Rattlesnake Hunting in West Texas
Sweetwater Jaycees
sweetwatertexas.org/rattlesnake-round-2014

Gorilla Tracking into the Rain Forests of Uganda
Natural Habitat Adventures
nathab.com/africa/the-great-african-primate-expedition/

Caressing Gray Whales inside San Ignacio Lagoon
Baja Expeditions
bajaex.com/whale.html

Night Safariing within Zambia's Luangwa Savannah
Robin Pope Safaris
robinpopesafaris.net/safaris/zambia-classic-safari.php

Stalking Jaguars along the Golden Stream in Belize
Natural Habitat
nathab.com/central-america/ultimate-belize-adventure/

Submerging under Palau's Jellyfish Lake
Fish n' Fins
fishnfins.com/v2/en/dive-sites/jellyfish-lake.html

Verifying the Existence of the Spirit Bear
Spirit Bear Lodge
spiritbear.com

EXPLORING FRONTIERS

Orienteering Toward the Wave at Coyote Buttes
Bureau of Land Management
blm.gov/az/st/en/arolrsmain/paria/coyote_buttes.html

Ice Caving the Apostle Islands
National Park Service
nps.gov/apis/mainland-caves-winter.htm

Penetrating Methane Death Zones at Kilauea Volcano
National Park Service
nps.gov/havo/planyourvisit/lava2.htm

Wagon Train Pioneering Across the Dakotas
Fort Seward Wagon Train
covered-wagon-train.com

Canyoneering inside Rock Slots of the Colorado Plateau
Tom's Utah Canyoneering Guide
canyoneeringusa.com/utah/escalante/

Ice Climbing in a Rocky Mountain Gorge
San Juan Mountain Guides
mtnguide.net/ouray-ice-climbing/

Goat Packing into Grand Staircase-Escalante
High Uinta Pack Goats
highuintapackgoats.com

Pursuing Icebergs off the Labrador Current
Twillingate Island Boat Tours
icebergtours.ca

SMASHING SPEED

Mountain Biking the Slickrock Trail
Rim Cyclery
rimcyclery.com/trail-info/slickrock-bike-trail/

Iceboating along the Hudson River
Hudson River Ice Yacht Club
hriyc.org

Race Car Driving in the Poconos
Bertil Roos Racing School
racenow.com/home.htm

Tobogganing In the Endless Mountains
Eagles Mere Toboggan Slide
eaglesmere.org/emslide.html

Tornado Chasing across the Great Plains
Cloud 9 Tours
cloud9tours.com

Land Yachting through the Mojave Desert
U.S. Manta Association
nalsa.org/Manta/MantaIndex.htm

Tidal Bore Surfing on the Bay of Fundy
Shubenacedie River Runners
tidalborerafting.com

Dogsledding across Minnesota's Boundary Waters
Boundary Country Trekking
boundarycountry.com/dogsled.html

LODGING INSANITY

Sleeping in Arctic Sweden's Ice Hotel
ICEHOTEL Jukkasjarvi
icehotel.com/accommodation/

Camel Caravaning to a Saharan Oasis
Travcoa
travcoa.com/style-of-travel/journey-types/custom-journeys-individually-designed-luxury-travel

Lodging with Headhunters at a Borneo Longhouse
CPH Travel Agencies
cphtravel.com.my/tours.php

Scuba Diving to a Bedroom under the Florida Keys
Jules Undersea Lodge
jul.com

Camping with Walruses in the Aleutian Islands
Walrus Islands State Game Sanctuary
adfg.alaska.gov/index.cfm?adfg=walrusislands.main

Ascending Trees to Lodge in the Shadows of Mount Rainier
Cedar Creek Treehouse
cedarcreektreehouse.com

Confronting Polar Bears from a Tundra Bunkhouse
Frontiers North Adventures
frontiersnorth.com

Canoeing through an Alligator Habitat
to an Everglades Chickee
North American Canoe Tours
evergladesadventures.com

ACKNOWLEDGMENTS

Enormous thanks is due to Fabrizio La Rocca for selflessly sharing his
innovative vision, tireless artistic efforts and, most importantly, his warm
friendship. Deep appreciation also goes to Audrey Jonckheer at Kodak Alaris
for her invaluable encouragement and support during a long stretch of my
recent career. A nod of gratitude goes out to Pro Image Photo in New York
for their efforts scanning the rich colors etched onto film, the sole source
of this book's images. At Skyhorse Publishing, hearty applause goes out to
Tony Lyons for his steadfast faith in my work, Bill Wolfsthal for his unflappable
supervision, Emily Houlihan for her tenacious editing skills, and Nick Grant for
his exuberant approach to the book's creative design. Finally, this book was
made possible only by the roaring waves of shining personalities, generous
outfitters, accommodating models and exciting moments that seemed to
constantly crash ashore, leaving me humbled and awash in deep gratitude.